Lost Interiors
Beauty in Desolation

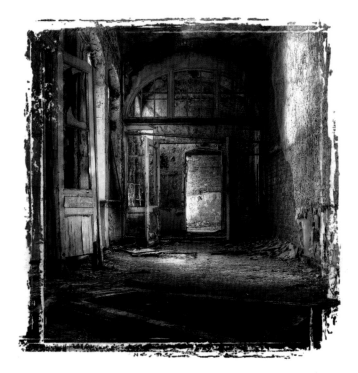

Publisher and Creative Director: Nick Wells
Project Editors: Polly Prior and Laura Bulbeck
Art Director: Mike Spender
Layout Design: Jane Ashley
Digital Design and Production: Chris Herbert
Copy Editor: Karen Fitzpatrick
Proofreader: Dawn Laker
Indexer: Helen Snaith
Special thanks to: Carly Laird

FLAME TREE PUBLISHING
6 Melbray Mews
Fulham, London SW6 3NS
United Kingdom

www.flametreepublishing.com

First published 2017

17 19 21 20 18
1 3 5 7 9 10 8 6 4 2

Image Credits: © **Photoshot**: 92; and the following: Michael Debets/Pacific Press via ZUMA Wire 93; Construction Photography 100; Mimmo Frassineti/AGF 111; Caro 144; TTL 161. © **REX/ Shutterstock**: 183 and the following: Sipa Press 3 & 86; Matt Lambros/Solent News 14; Matt Lambros 16, 18, 20; Ingo Sxhulz/imageBROKER 24; Martin Gerten/Epa 38; Stevie Ronnie 50; Christian Prandl 65; Christian Handl 78; Design Pics Inc 106; Stock Connection 119; Aaron Favila/AP 126; Michael Nolan 128; imageBROKER 129; Martyn Aim/SIPA 130; Image Source 150; Harry Laub 151, 185; Britt M. 156, 157, 158, 167, 187; Dedi Sahputra/Epa 170; Quirky China News 173; Helmut Fohringer/EPA 175; Laurens Corijn 180; Imaginechina 188. © **Shutterstock. com** and the following: Grischa Georgiew 1 & 96, 138, 165; Zhukov Oleg 4; Ppictures 8 & 186, 36, 40, 42, 44, 92, 99, 152, 181; Sergey Dzyuba 9 & 62; Marco Barone 21, 166; CHENALLEN 26; Milosz Maslanka 27, 47, 52; Fotokon 29; Stefan Schierle 30, 124; Michel Godimus 37, 74, 134; CCat82 48; New Punisher 54; saoirse2013 59; Cristian Lipovan 66, 178; Cartela 68; Josh Cornish 76; Mariusz Niedzwiedzki 88, 135; Michal Ninger 102; Ilona5555 107; Vladimir Mulder 112, 136; Catwalk Photos 113; Valentin Agapov 114; Anna Vaczi 117, 141 & 192; Benjamin Beech 118; TSpider 133; Oleg Totskyi 145; Kanuman 148; COLOMBO NICOLA 154; kou2341 174. © **SuperStock** and the following: Pixtal 6 & 83, 132; Cultura Limited 7 & 64; David Pinzer Photogra 10; Michael Schwan 12, 35, 51, 58, 73, 104, 108, 140, 168; Christian Richter 15, 95; MAURITIUS 22, 28; Hamid Ebrahimi 32; Russ Bishop 34; Enrique Algarra/age fotostock 39; Guido Koppes/age fotostock 43; Funkystock 56; PhotoAlto 61; robertharding 70; Keith Kapple 77; Mandy Stegen 81, 87, 162, 176; Michael Schwan/Mauritius 82; James Hackland/age fotostock 84; Biosphoto 85; imageBROKER 90; Ron van Briemen/age fotostock 91; Christian GUY 98; Kevin M Law/All Canada Photos 120; agf photo 121; Jose Miguel Alfonso/age fotostock 122; Jason Langley 142; Paul Horsley 143; Image Source 146; dan Leffel/age fotostock 155; Paul Horsley/All Canada Photos 159; Design Pics 160, 172; Peter Blahut 182.

ISBN: 978-1-78664-529-6

Printed in China

Lost Interiors
Beauty in Desolation

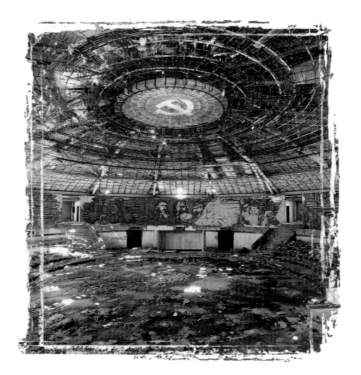

Michael Kerrigan

FLAME TREE
PUBLISHING

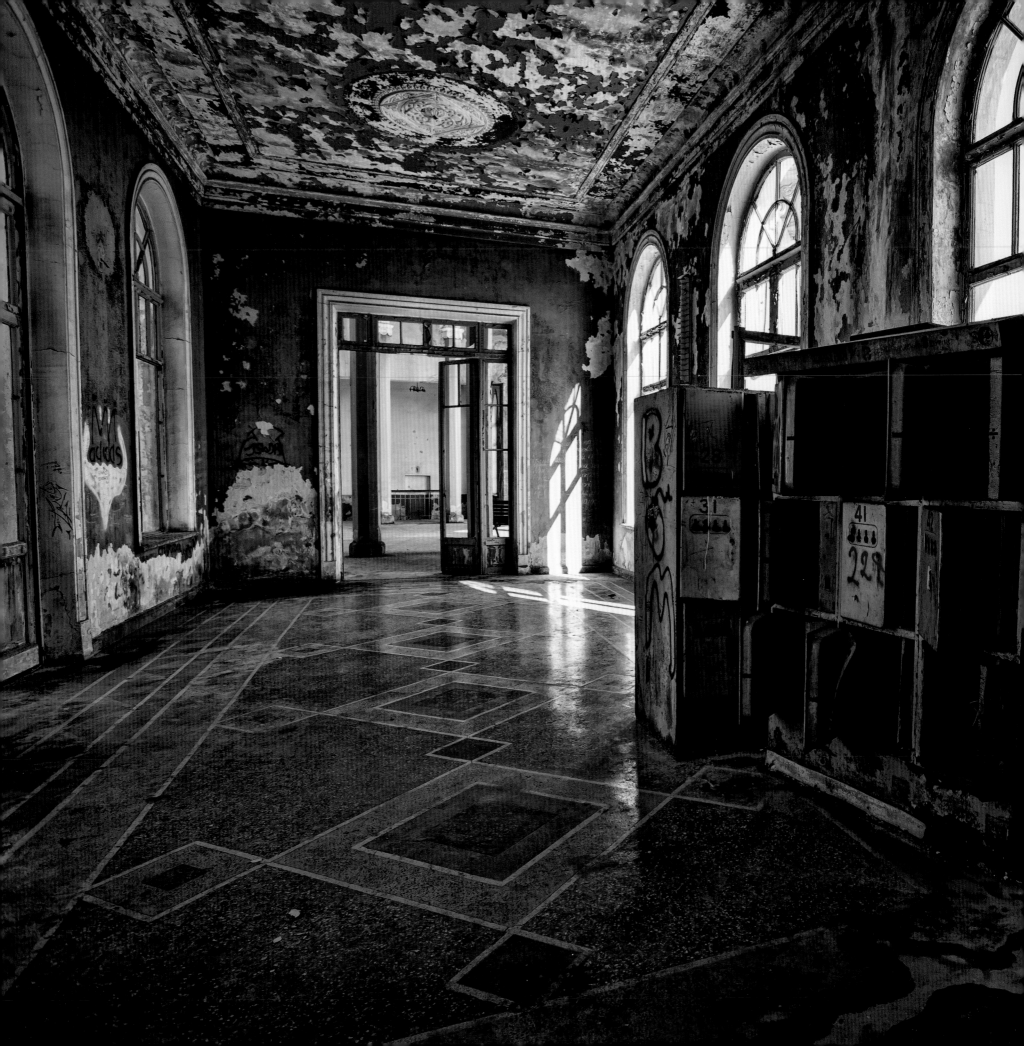

Contents

Introduction

Some time towards the end of the first millennium AD, an Anglo-Saxon poet is believed to have wandered through what was left of the southern English city we know as Bath. A few centuries before, the centre that the Romans had called *Aquae Sulis* had been a grand and luxurious holy place and spa. The magnificent baths themselves, sacred to the Celtic goddess Sulis – whom the Romans had identified with their own Minerva – had been built around natural hot-water springs. A substantial settlement had slowly spread out across the surrounding hills.

By the beginning of the fifth century, though, the imperial tide had turned; the legions had left, with the wealthiest and most influential of the local settlers. *Aquae Sulis* had gradually gone to rack and ruin. New waves of Germanic invaders and immigrants had arrived and, within a few generations, it was as if Romano-British society had never been. Now flocks were grazed and livings scratched amidst a collection of vast but dilapidated structures, whose provenance and purpose could only be guessed at. The poet's words were preserved in the *Exeter Book*, put together in the tenth century. They sum up the awestruck incomprehension the already ancient cityscape now inspired:

> *Wondrous is this wall-stone, dashed by destiny;*
> *Battlements burst; the work of giants broken.*
> *The roofs are ruined, the towers toppled,*
> *The barred gate gone; the plaster frosted over,*
> *The walls laid open, brought low, destroyed,*
> *undermined by age …*

So far did ruins like these lie beyond the understanding of England's new inhabitants that they could be comprehended only quasi-mythically,

as 'the work of giants'. Their scale must have been daunting to villagers living in small, thatched huts; so must their majestic arches and their stately colonnades. As the poem 'The Ruin' makes clear though, as impressive as these constructions were, the destruction wrought by time was just as striking.

Other Lives

Utterly alien these Roman relics may have been for the Anglo-Saxons, but they stirred their imagination – that's quite clear. That haunting sense they gave of other lives being lived; of different identities taking shape; of desires and aspirations other than their own. They didn't just represent a forgotten past but an alternative present – one that wasn't but might have been; a 'road not taken', to quote a much more modern poem.

And something of the same can surely be said for the other ruins that surround us day-to-day. Even if they lack the historical prestige of Roman Bath. All bear witness to the ravages of time; all, as surely as any ancient ziggurat or temple, say to us *Sic Transit Gloria Mundi* ('Thus passes the glory of the world'). If we have to look quite hard before we see the 'glory' in a derelict gasworks or a shut-down shopping mall, these recent ruins still speak to us of human endeavour – and limitation.

Other Histories

They're also every bit as eloquent as the great antiquities in what they tell us. A crumbling castle built by King Edward I during his conquest of North Wales in the 1380s; a grassed-over abbey shut down in Henry VIII's Dissolution of the Monasteries; a martello tower from the era of the Napoleonic Wars …All illustrate the familiar narrative of history. Sometimes seeing the story requires a little more imaginative effort. What are we to see in a semi-derelict cinema? What lesson should we take from a shut-down school? What should we read into an abandoned public library? That rat-infested factory site may monumentalize a market collapse – or just a shift in consumer habits or in economic policy; that glass-strewn 'ghost station' a wholesale switch in transport strategy. A terrace of tinned-up houses waits while some city-redevelopment scheme is argued-over – perhaps for years. The vast halls of an old telephone exchange echo empty, their banks of switches and relays rendered redundant by some digitalized system a fraction of the size.

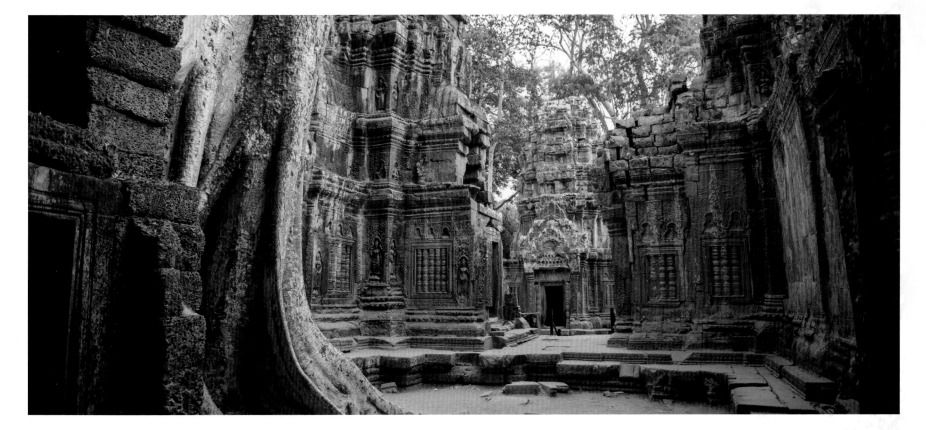

key, the 'dying fall', ruins seemed to suggest the inherent melancholy of human life. The artistic vision that could capture the crumbling away of all men and women might attain was establishing something much more perfect and more lasting. Or, as the English artist-poet William Blake was to put it in 1800, 'the ruins of time build mansions in eternity.'

Friedrich Schlegel, the leading philosophical spokesman for German Romanticism, went so far as to claim that some sense of 'incompleteness' was essential to artistic beauty. And where better to find that incompleteness than in a venerable ruin? J.M.W. Turner was famously to paint the hollow shell of Tintern Abbey, Monmouthshire, just a few years before William Wordsworth came this way.

Monuments of Modernity

The 'Romantic Moment' came and went, and with it the vogue for the artistic ruin. But the impulse that had given rise to it remained. In some ways it was intensified in the later nineteenth and twentieth centuries by the accelerating pace of economic change. 'All that is solid melts into air,' Karl Marx had written in his *Communist Manifesto* (1848) on the impact of modern capitalism on breaking down old certainties and customs. But the new industrial structures were certainly 'solid', as was the ruinous residue they left behind them when bust followed boom – or when their technology became outmoded and plants were closed.

Visiting the industrial belt of central Scotland in the early years of the twentieth century, G.K. Chesterton felt overwhelmed by:

… a vision of higher and higher chimneys taking hold upon the heavens, of fiercer and fiercer fires in which adamant could evaporate like dew. Here were taller and taller engines that began already to shriek and gesticulate like giants.

Poetic Licence

Intriguing as such quasi-archaeological insights may be, they can't account for the hold these modern monuments have upon our minds. Like the Anglo-Saxon poet, we're moved to wonder by what we see of the collision of human enterprise with human limitation; between the 'can-do spirit' and by Shakespeare's 'devouring time'. Its runways cracked and overgrown; its control tower and terminal buildings battered by the years, an abandoned airfield can launch innumerable flights of the imagination; an old dock basin can be the point of departure for a million musings. If archaeological interest cannot explain how these sites haunt us, architecture is still more inadequate. This is why the comparisons with poetry seem so compelling.

Romantic Ruins

Wolfgang von Goethe was so fascinated by the idea of the ruin that he had one built at his Weimar home; he was only the most famous of those who built such 'follies'. For the Romantic poets and painters, with their penchant for the minor

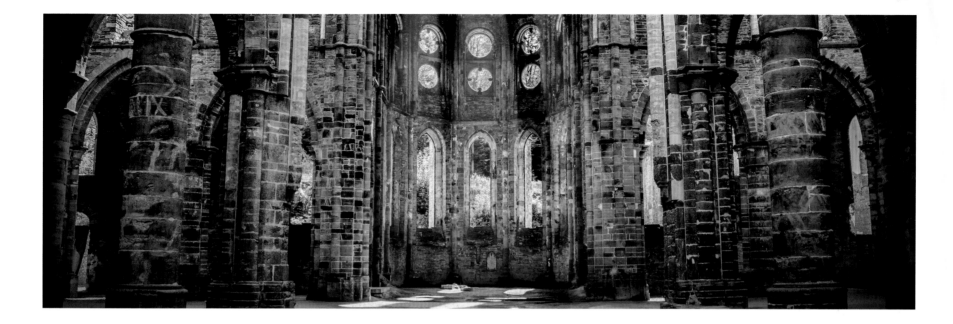

Like the Anglo-Saxon poet, put in mind of giants, he attributed semi-mythic status to the awesome scale and power of what was actually the very engine of the economy of his day. The destructive effects of time; the crumbling of all that had seemed so permanent: capitalism's cycles seemed to have thrown these age-old rhythms into fast-forward. New mines were dug; old ones exhausted. New mills were opened; others abandoned. New canals were dug and railways laid.

Wear and Tear

Great Britain had, of course, been the cradle of industrialism, but the 'revolution' was soon taking hold around the world. In North America and Europe, new enterprises sprang up, along with the roads and railways required to service them. The rest of the world was raided for raw materials: rubber from its jungles; oil from desert wells; and minerals from mountain mines. Demographic changes brought people streaming to the cities. Public housing schemes; transport systems; leisure complexes and places of entertainment – everything from sports stadiums to concert halls; from theatres to amusement parks. All going up at a dizzying speed – and, it could seem, coming down still faster. The result, throughout the rest of the twentieth century and into

the twenty-first, a continually growing stock of abandoned installations, from steelworks to subway stations, from grain silos and stone quarries to textile mills. And, of course, the residential accommodation left behind as local requirements changed, from single 'haunted houses' to whole 'ghost towns'.

Ebb and Flow

Sometimes breath is barely drawn before these abandoned buildings are pulled down, their sites redeveloped, in a palimpsestic over-layering of replacement and renewal. Often though, the 'invisible hand' doesn't find new uses and these places are effectively handed back to Mother Nature. At first, a bit of moss; a bunch of weeds; a sprig of grass – next, perhaps, a bush that then becomes a thicket – at last what was a machine-tools plant or mental hospital is left looming out of thick woodland like a Mayan temple in the jungle.

'Time and tide wait for no man,' we say, but the tide at least has ebbs and flows. The 'Lost Interiors' in this book show how exquisitely these may be poised. Time may be destructive, but its action, inexorable as it is, can confer a beauty all its own; stir a special chord in us as we contemplate our own mortality.

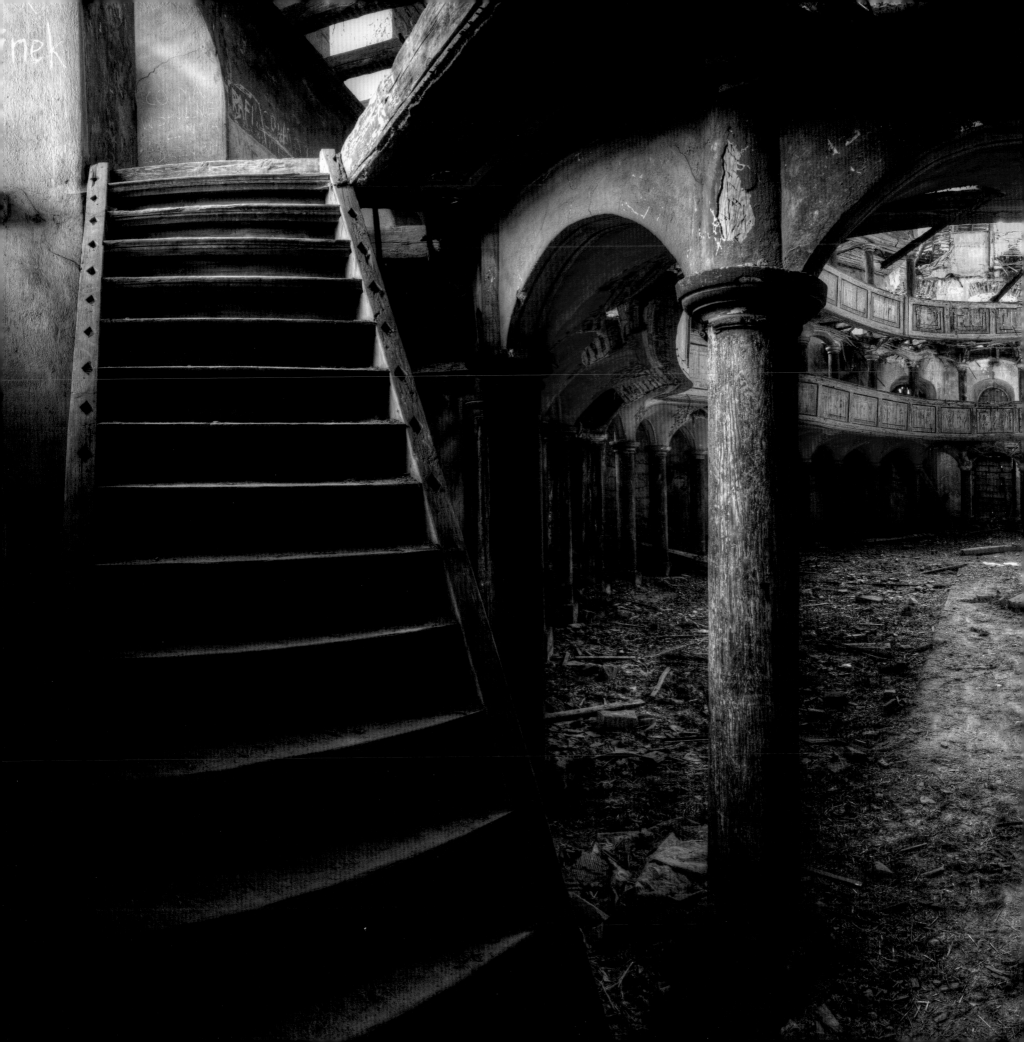

Cultural Places

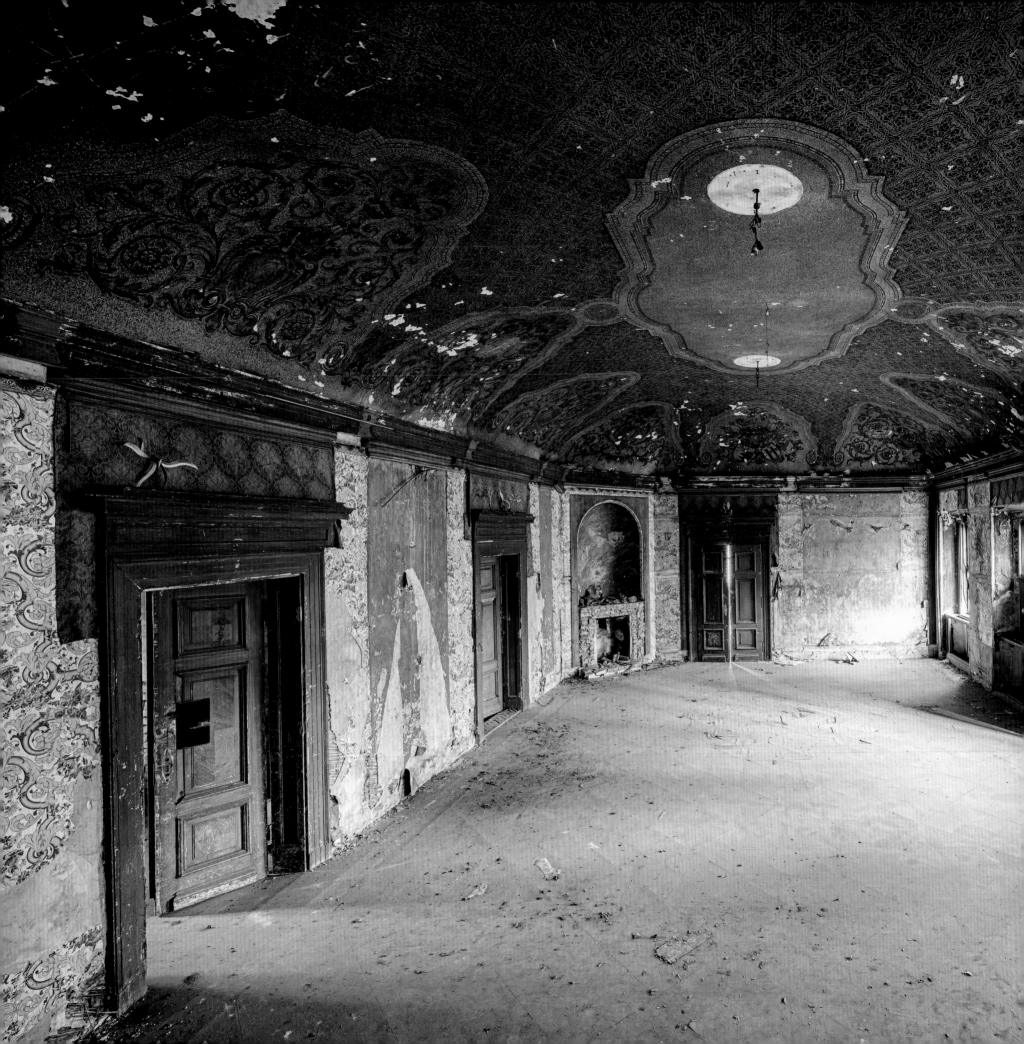

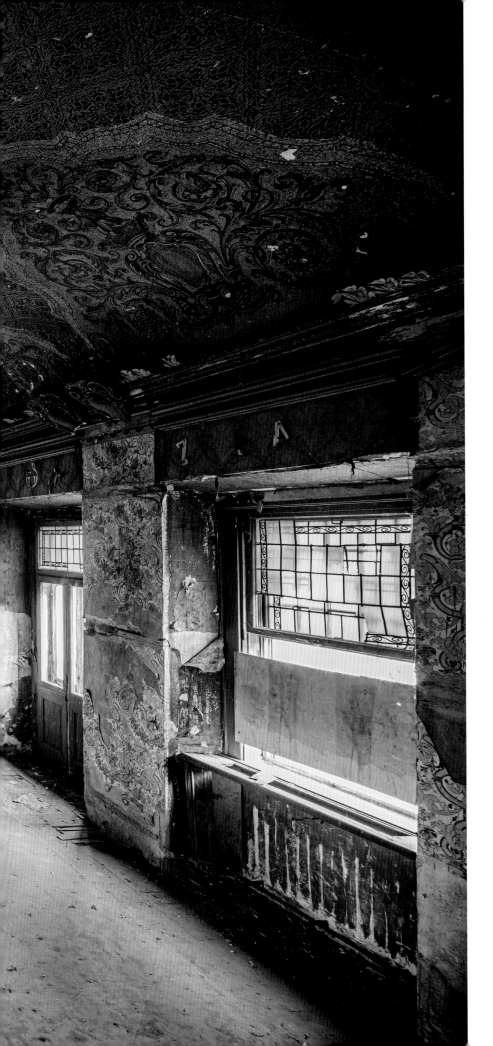

The Party's Over

An abandoned swimming pool, drained of clamour, shouts and laughter as well as water – all those acres of bare tile and no sound to echo. A sometime cinema, its raking rows of seats apparently awaiting one last showing on the silver screen that's now no more than a ragged hole. A deserted shopping mall, no longer bustling but eerily empty, sheer silence replacing all the muzak and the chat. A hotel lobby, the guests all gone; a cafeteria in which only earwigs and spiders lunch; an amusement arcade where it's 'game over' now for good.

The more energetic and intense the life, the more shocking the stillness when it's over – and that's as true for places as it is for people. Nothing can be more melancholy than the scene of fun and leisure once the life has gone, the contrast between what was and what is too poignant to be ignored.

Cultural Closures

Every abandoned site brings its intimations of mortality, embodies the end to which one day we all must come. We know we're finite beings; we know that life is limited. But the desolation of a place once given over to fun and leisure; a place previously dedicated to conviviality and culture (the 'finer things in life'), brings home the limitation of those things that make life worth living. Our sense that, even in our most fulfilling moments, we're liable to experience a certain sense of let-down, a yearning for something still more; to run up against the insufficiency

Previous page: Stairways and arches in an abandoned building.
Left: Ballroom in a derelict European castle.

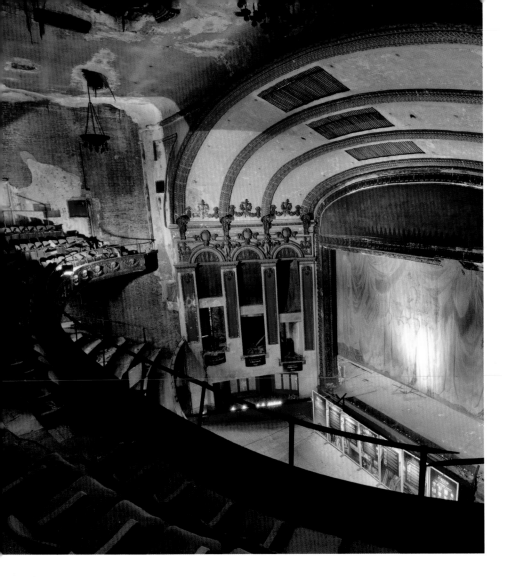

Above: Lyric Theatre in Birmingham, Alabama, USA.

of any contentment we may achieve. An abandoned ballroom (*see* page 12), its sparkling chandeliers and polished parquet gone; its grubby blue ceiling its only pretension now to elegance, its floor an expanse of grey-white plaster-dust, gives concrete expression to the idea of 'the morning after the night before'. A funfair ride, now and for ever at a standstill (*see* page 24): where did life's adrenalin and excitement actually *take* us? A disused gym (*see* page 47), frozen in time, a symbolic resting place for human energy and optimism. If, as James Joyce's Stephen Dedalus said, a pier is 'a disappointed bridge', how much more cast down must it be to end up in a state of dereliction?

Right: Abandoned library in North Rhine-Westphalia, Germany.
Next page: Paramount Theatre in Newark, New Jersey, USA.

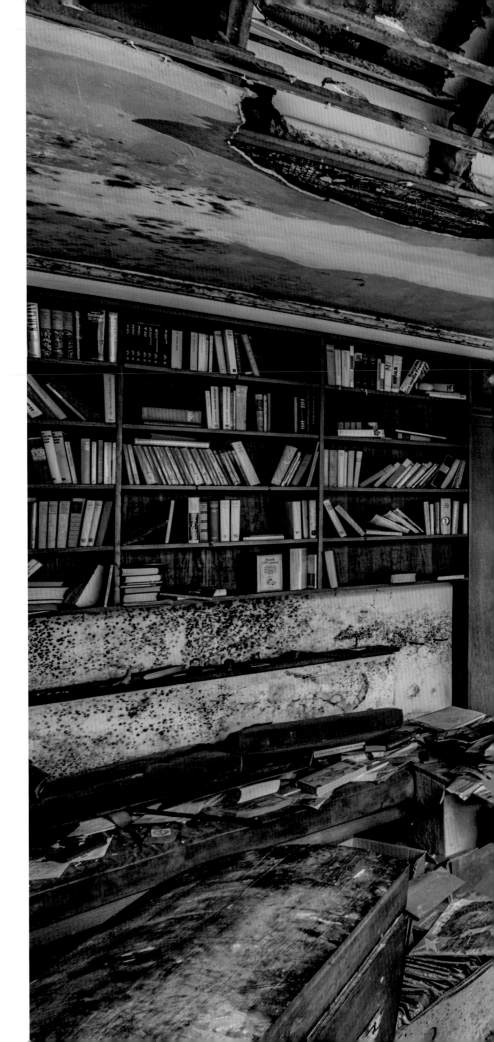

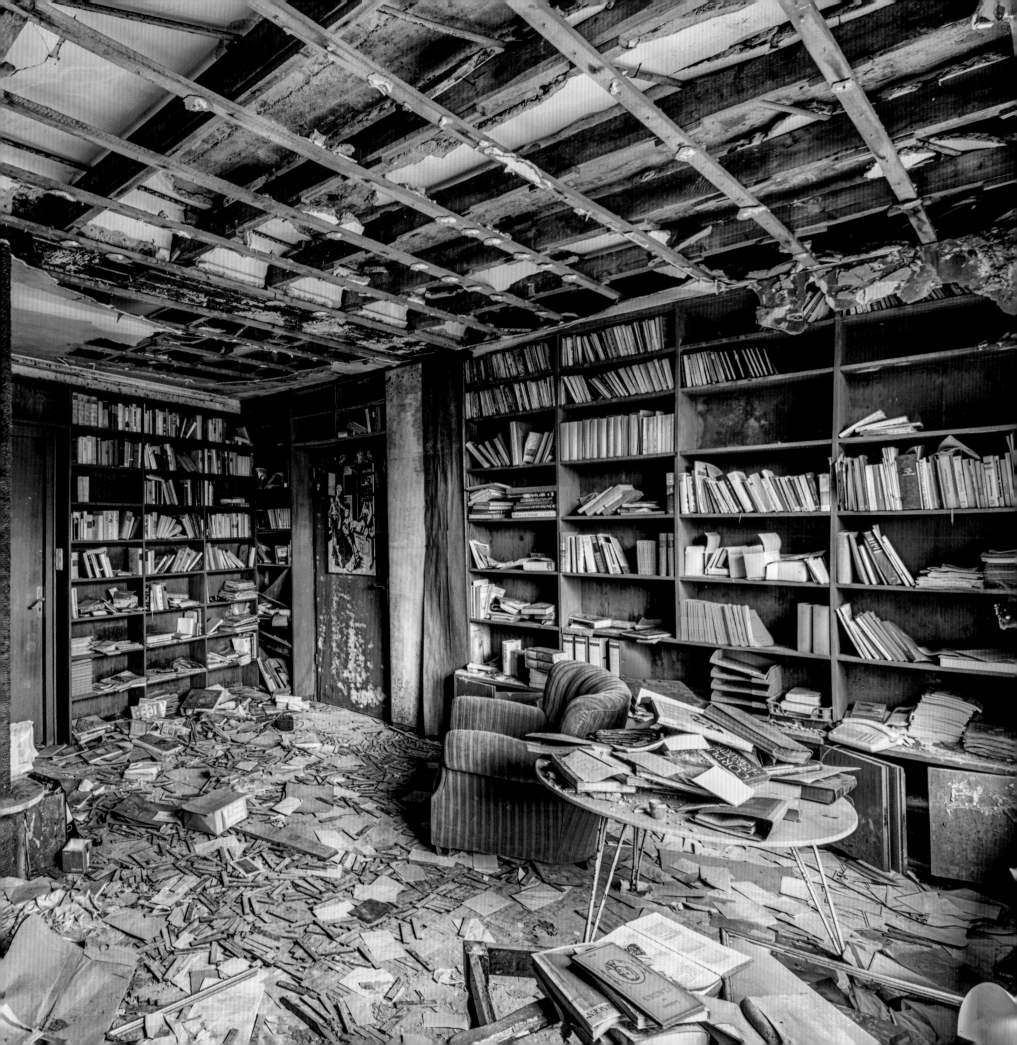

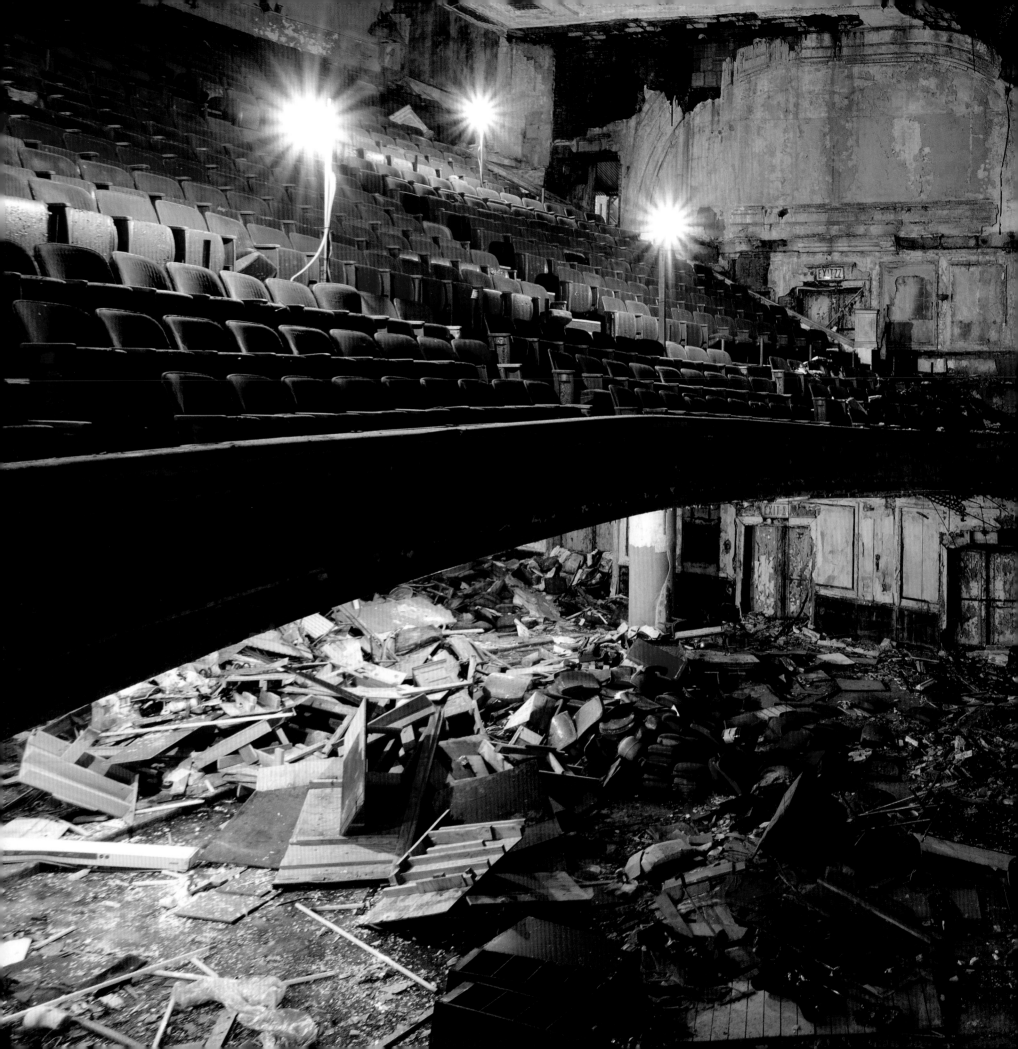

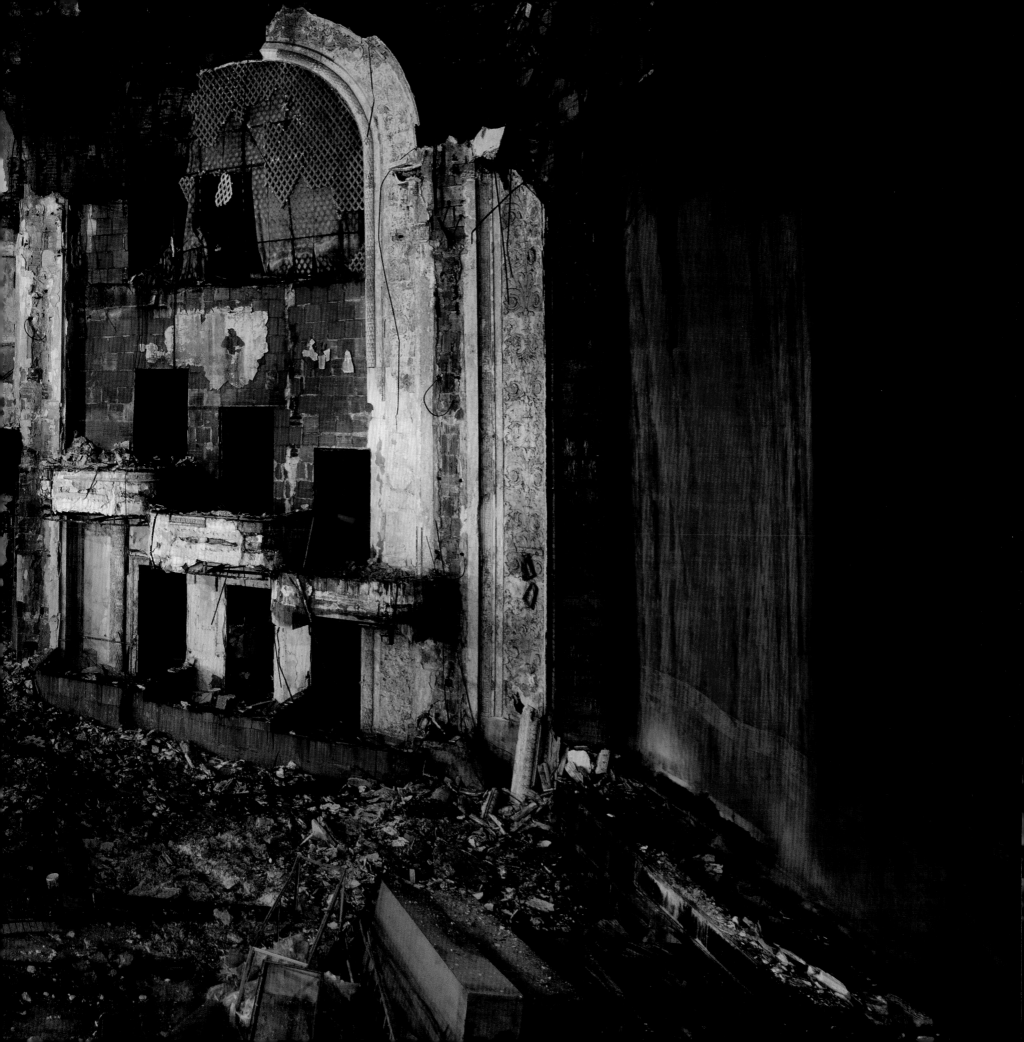

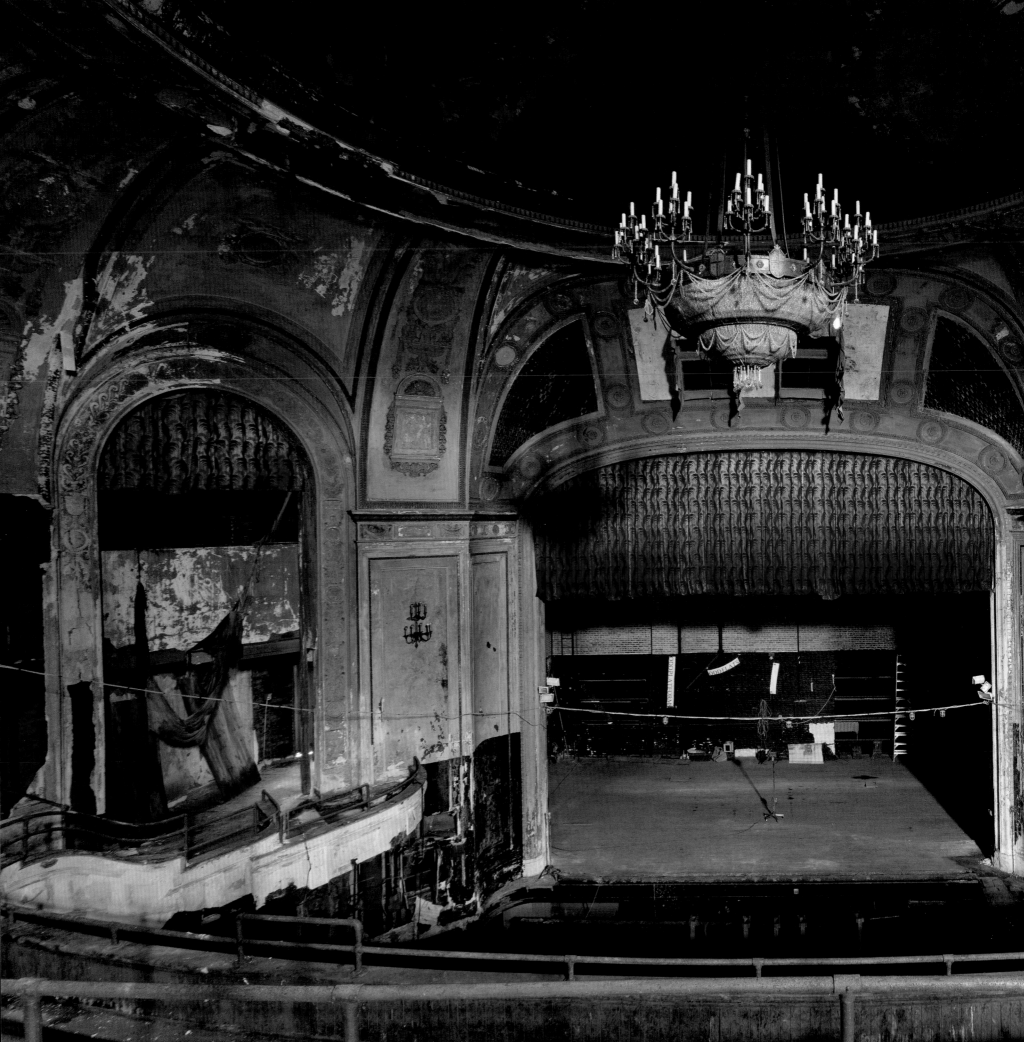

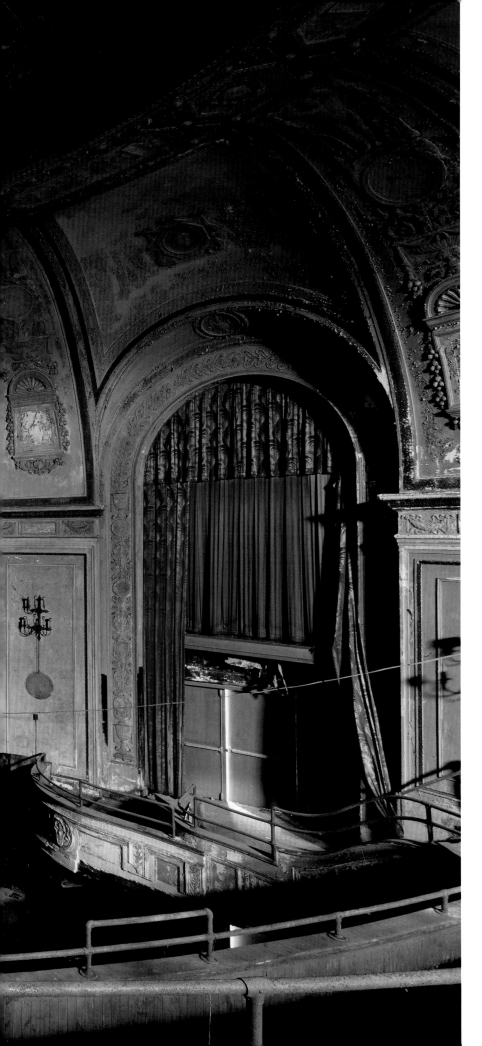

Theatres & Cinemas

'**All the world's a stage**,' says Shakespeare – who should surely know. 'And all the men and women merely players.' An ingenious insight – profound, perhaps – in the great Elizabethan playwright-poet, for us it's both something less and something more. Less, because the sense that life (dramatic as it may be) isn't quite as it is presented has become second nature to us in the 'postmodern' era. More, because …well, for just about the same reason really. This is an age in which we see not just national and ethnic characters, but the most intimate aspects of identity as 'constructed' by culture and conventions; in which even gender is viewed as a matter of 'performance'.

Stage Left

This, perhaps, is what makes the experience of visiting an abandoned theatre so especially unsettling. Every building obviously represents some sort of balancing out of form and function. But take away the theatre's function – as a venue for presenting plays and shows – and how extraordinary its form appears. The tapering walls, the tiered seating and the seashell shape of the auditorium seem strange enough in themselves. Add in the stage and the high-spaced fly loft up above and that labyrinth of staircases, corridors and foyers front-of-house and it seems utterly eccentric, if not perverse. Only in performance does any of it make any sense at all. To see an empty stage from an empty stalls or circle; to experience the silence and know that it's fallen for ever; is to feel a powerful shock – however long we've had to prepare ourselves. Now the curtain has fallen and the stars are gone, we get to go backstage and explore the now-derelict dressing rooms, get some sense of the artifice that made the great illusion possible.

Left: Embassy Theatre in Port Chester, New York, USA.

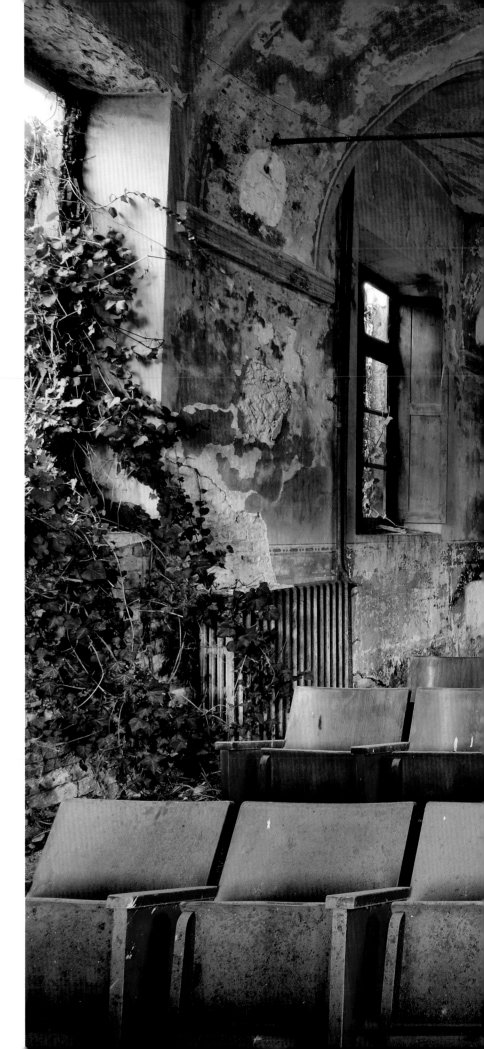

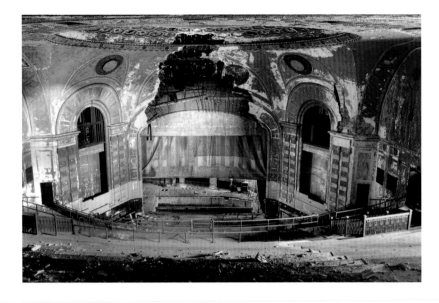

To see an old theatre is to think immediately of past play nights: quaint variety shows, creaky melodramas, prurient pantomimes. And to imagine their audiences, the men in anything from frock coats to reefer jackets; the ladies in everything from mink stoles and pearls to hoodies and jeans. *Autres temps, autres moeurs*: The abandoned Lyric Theatre in Birmingham, Alabama (*see* page 14) was a monument not just to stilted vaudeville and over-declamatory Shakespeare but to the racial segregation of those times.

Smokescreen

You would have strained to see the screen in that old cinema in its heyday through the well-nigh impenetrable cloud of cigarette smoke – but then the life of the place wouldn't have been quite so limited as it is now, to cinematic content, coke and popcorn. An evening at the movies was a social and erotic highlight, a night of action and romance onscreen and in the 'one-and-nines', a truly treasured memory for those of a certain age. You get some sense of that old promise in the still-just-about-sumptuous surroundings of an old big-city 'picture palace', or in some small community cinema, slowly being colonized by creeping plants.

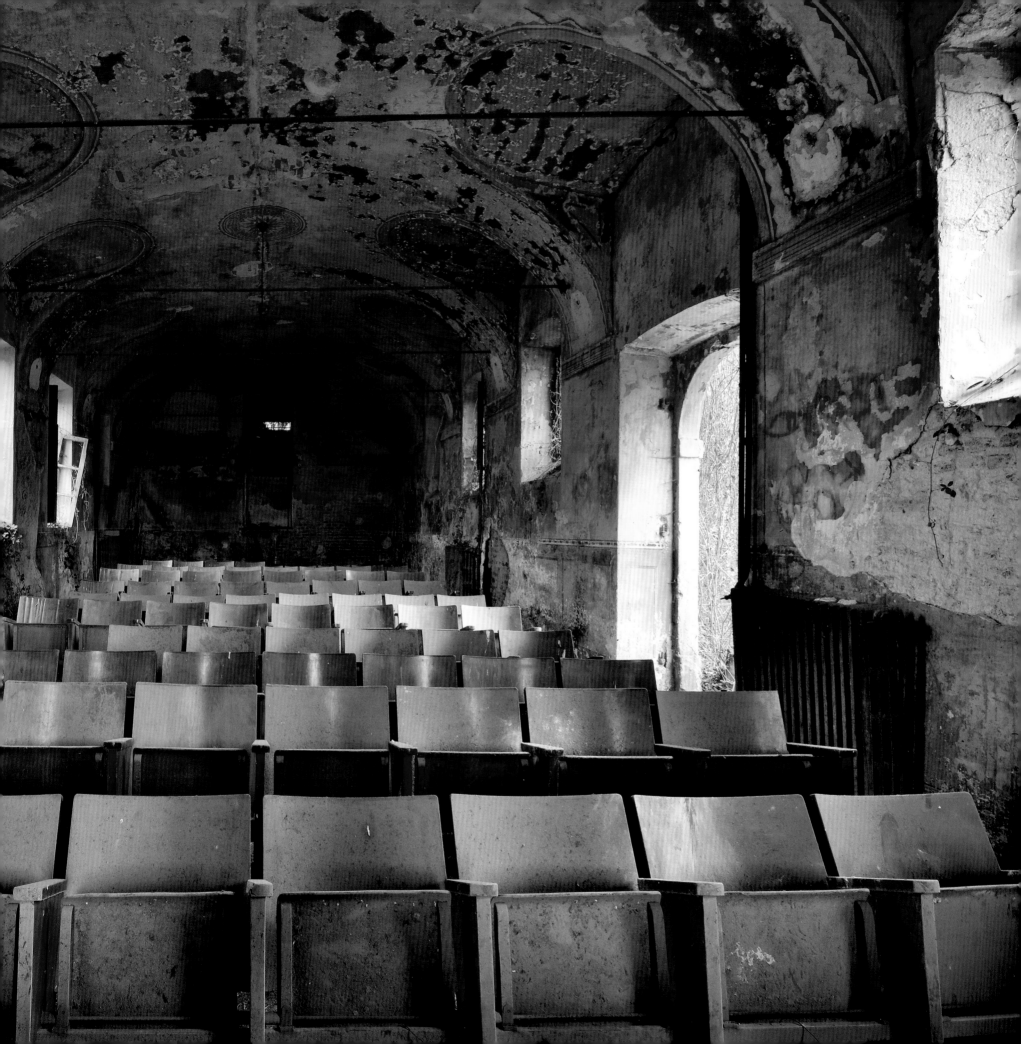

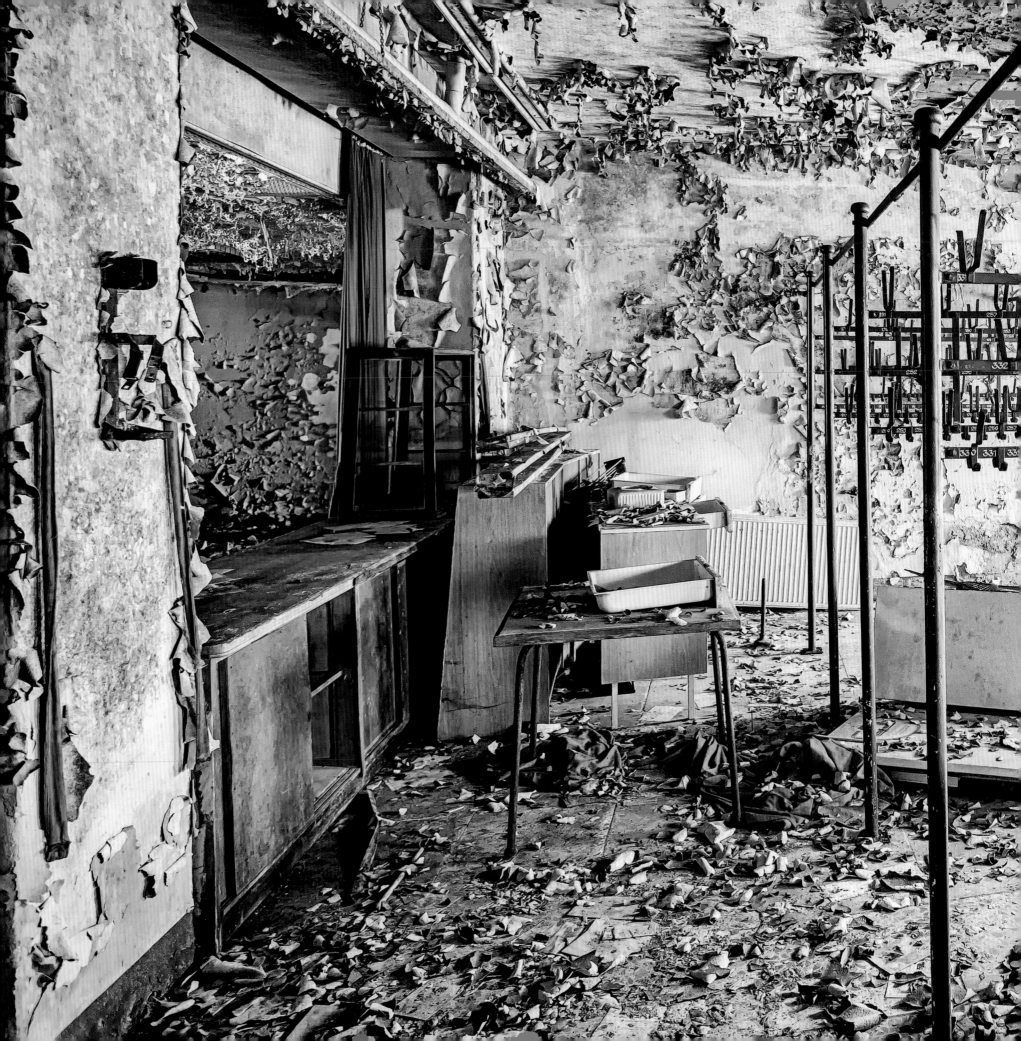

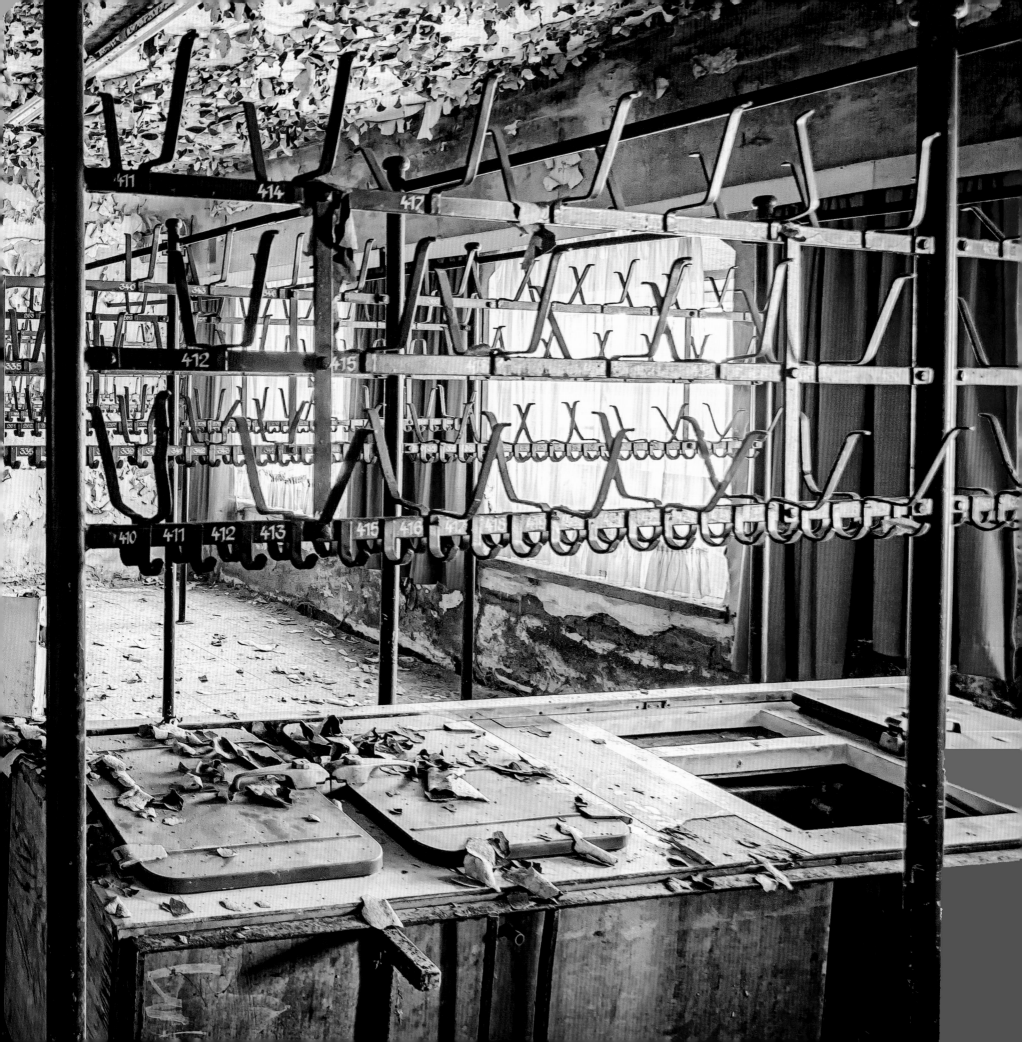

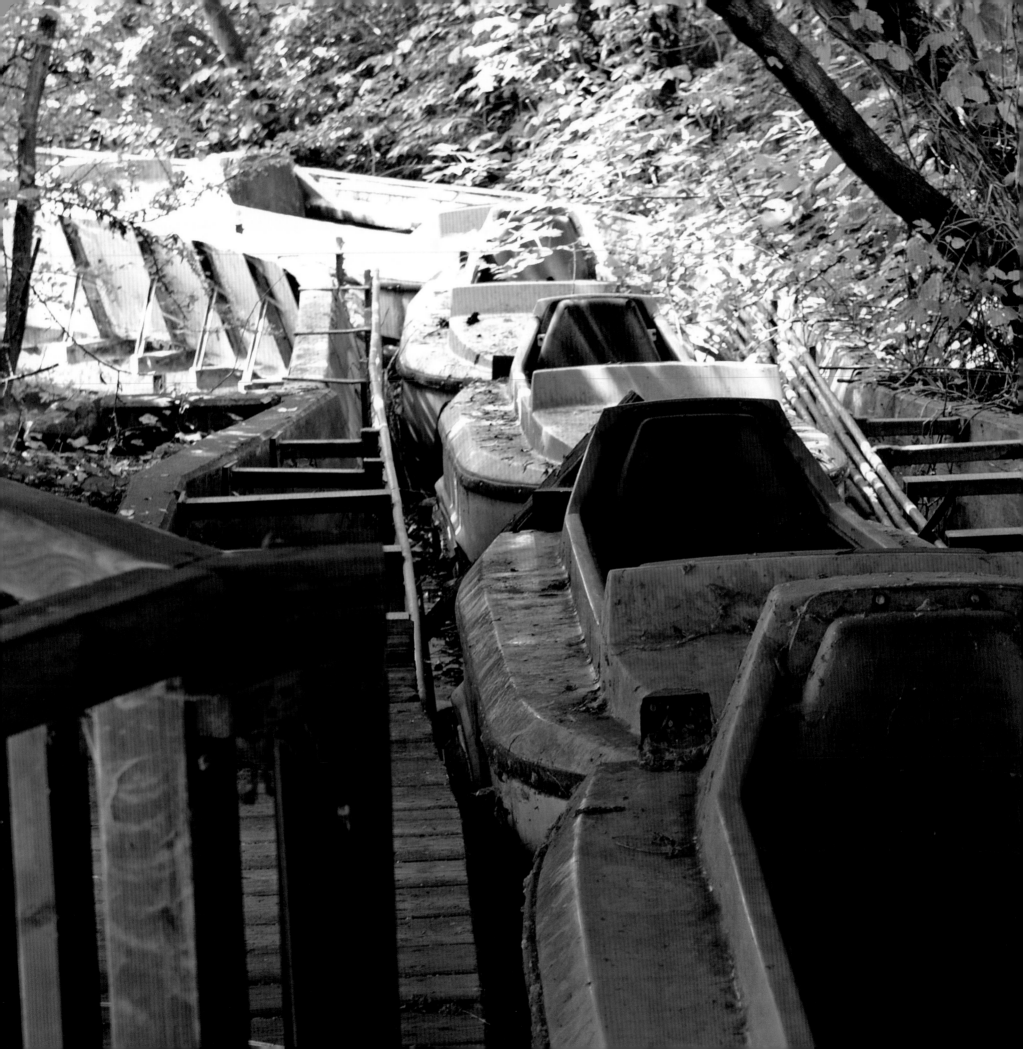

The Fun of the Fair

As vulnerable as we may be when we're overcome by strong emotions such as sorrow, fear or anger, there's a case to be made that it's the act of enjoying ourselves that leaves us most unguarded. When we let our hair down at a dance or party; when we mess about with our kids at our local swimming baths; or when we submit to the thrills and spills – and sheer silliness – of a funfair.

Vanity Fair

There's a special innocence about our exhilarated terror as we soar and swoop on a rollercoaster, spin on a waltzer or find ourselves flung this way and that on some other fairground ride. The frivolity is key: there's a paradoxical purity about a pleasure which makes absolutely no claim whatsoever to being educationally improving, health-promoting or otherwise character-building in any way. Quite the contrary indeed: such attractions positively revel in their lowest-common-denominator decadence; they are places of unabashed vulgarity – and unbridled fun. Diehard moralists may disapprove, but for most of us – however high-minded – the fairground is a place of treasured (if not necessarily vaunted) memories.

Conversely, in its derelict state – and the economic crises, changing leisure patterns and demographic shifts of recent decades have brought a great many closures – the abandoned amusement park is one of the saddest sights there is. Like the theatre building, its structures are unmistakeably specific –

Left: Abandoned Water-ride, Spreepark, Berlin: The Kulturpark Plänterwald, beside the River Spree, was the pride of Communist East Germany. As the 'Spreepark', it survived the transition to democracy, but by 2002 it had failed completely and closed down.

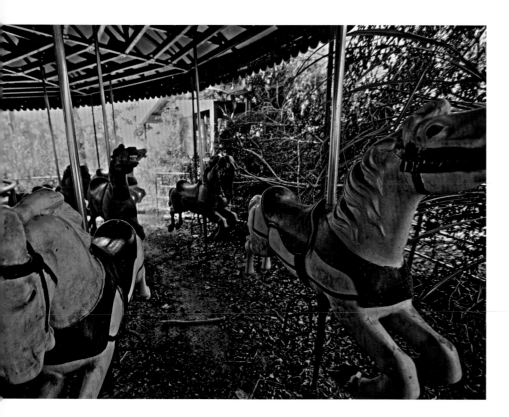

a disused water-ride or rollercoaster quite simply couldn't be anything other than what they are, serve any other purpose; their rusting, rotting forms pretty much epitomize redundancy.

At Home with Alienation

Our citizenship is in heaven, says St Paul (Philippians 3:20), the world no more than a place we pass through; an inn we travellers stop and lodge at along our way. His Christian faith enabled him to see as a purposeful pilgrimage what might otherwise have seemed a brief and ultimately pointless stay on earth. This has indeed seemed so for many struggling, like the French philosopher Albert Camus, to 'live without appeal' to higher powers to confer meaning. Just to begin to think, he continues, is 'to begin to be undermined'. What can it all conceivably be about? What's it all *for*?

Above: *An abandoned carousel.*
Right: *An amusement park ride is reclaimed by nature in Pripyat, Ukraine. The Pripyat amusement park has become an iconic image of the Chernobyl disaster.*

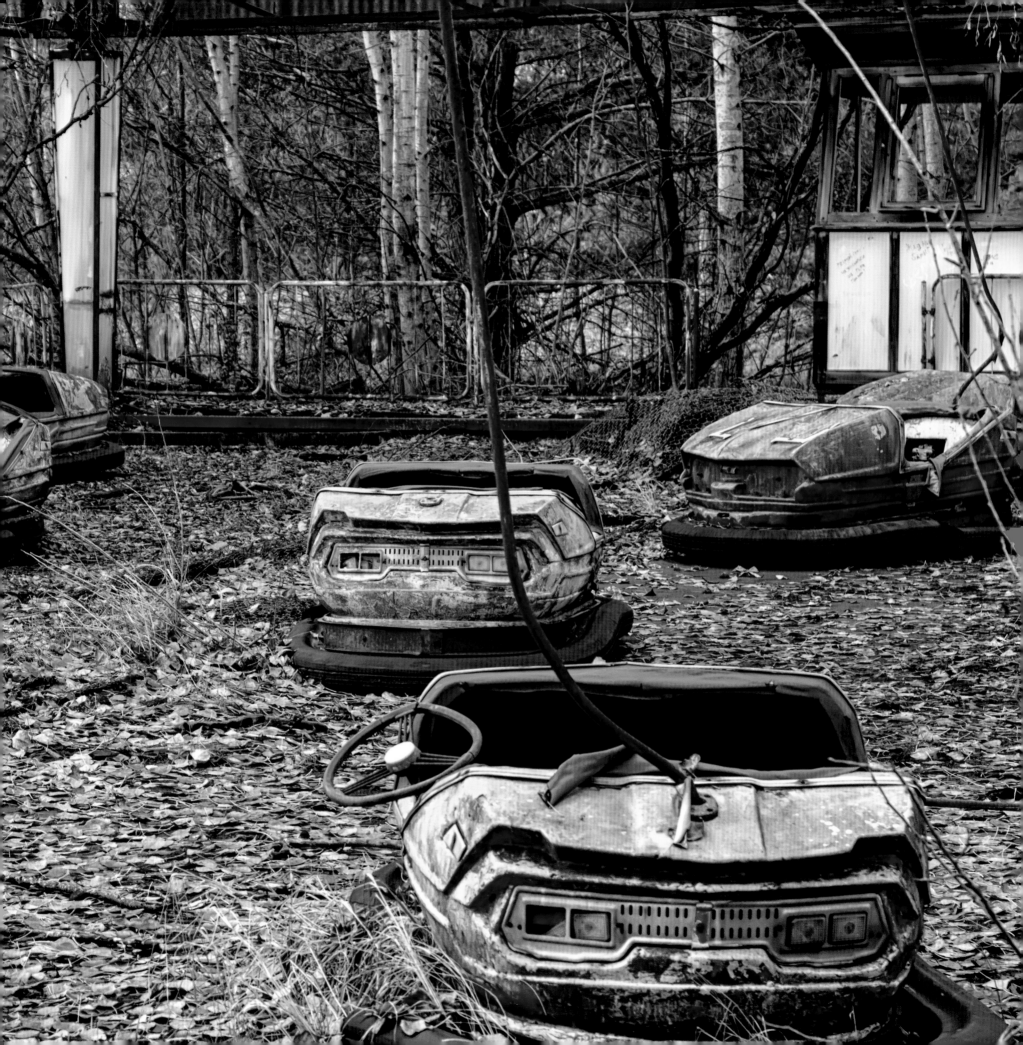

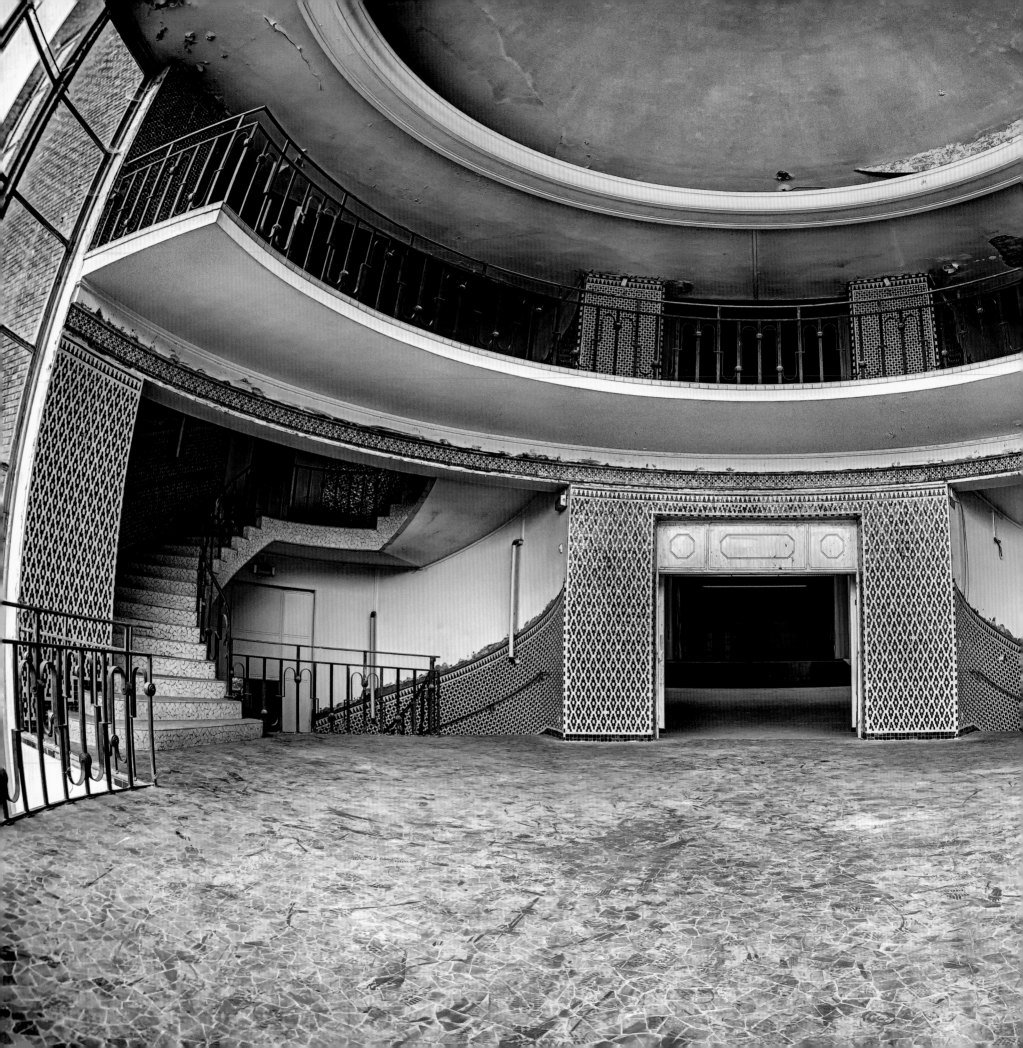

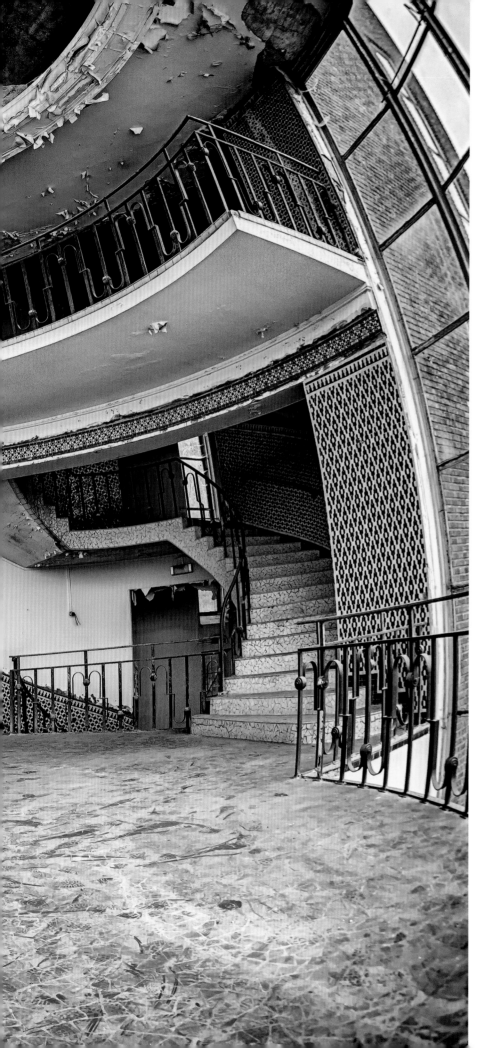

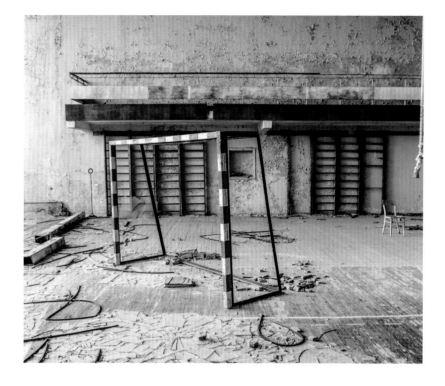

Above: Sports equipment stands at crazy cubist angles in the Energetik gym, in Pripyat's Palace of Culture, left behind in the rush to leave after the Chernobyl Disaster, 1986.

And what becomes of us when it's over? His walks among the Roman ruins at Tipaza, on the Algerian coast, prompted astonishment that 'while we have such refined ideas about other subjects, we are so deprived about the subject of death'. Like St Paul, Camus was forced to the conclusion that he was a 'stranger …to the world' – unlike the Apostle though, he felt 'a stranger to myself' as well. 'What', he asked, 'is this condition in which I can have peace only by refusing to know and to live, in which the appetite for conquest bumps into walls that defy its assaults?'.

The conjunction in the human condition of a thinking and would-be rational being and an existence without reason or real meaning made life for us essentially 'absurd', he said. Our resulting alienation – cast adrift, left to make our own way in a world which can't make any real sense to us – was characterized by Camus as 'dereliction'.

Left: An abandoned entrance hall.
Next page: Broken chairs lie collapsed on the floor of a deserted hall.

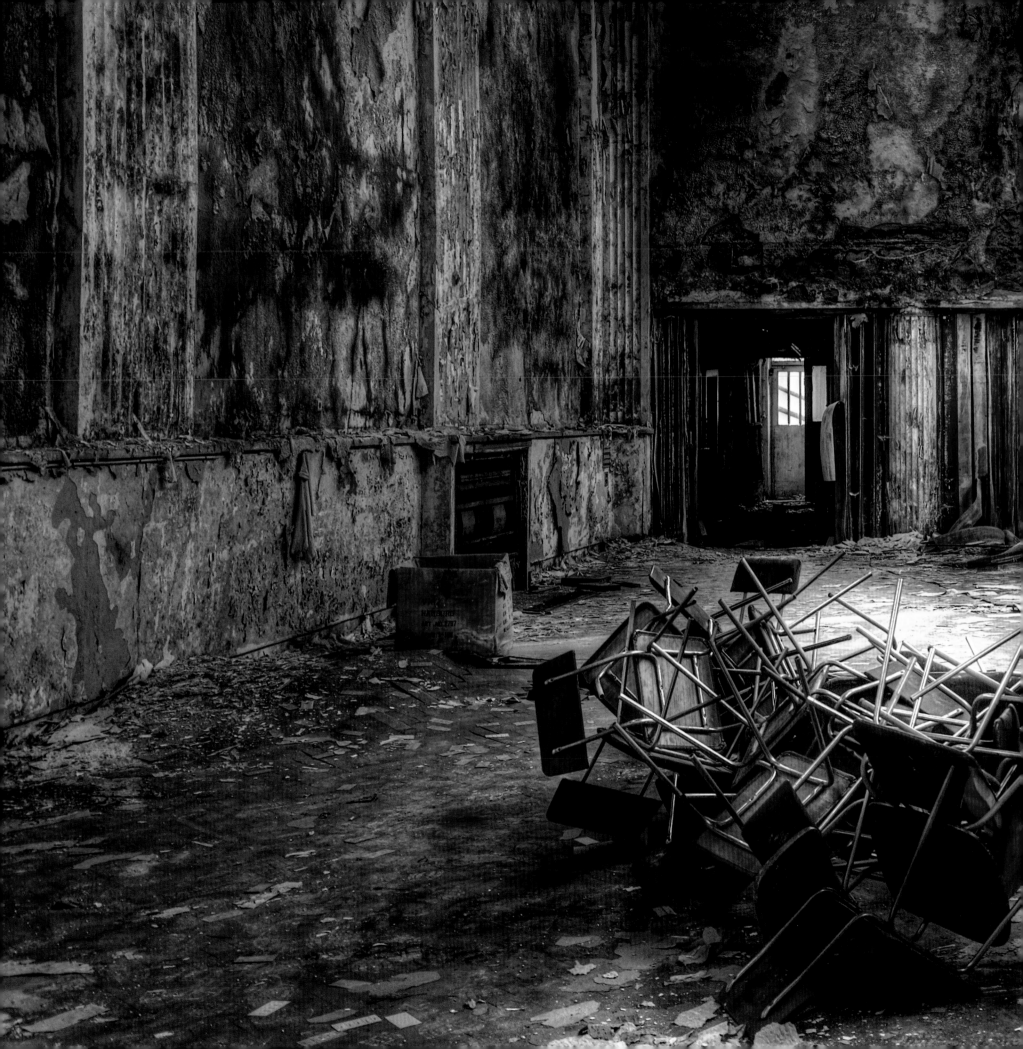

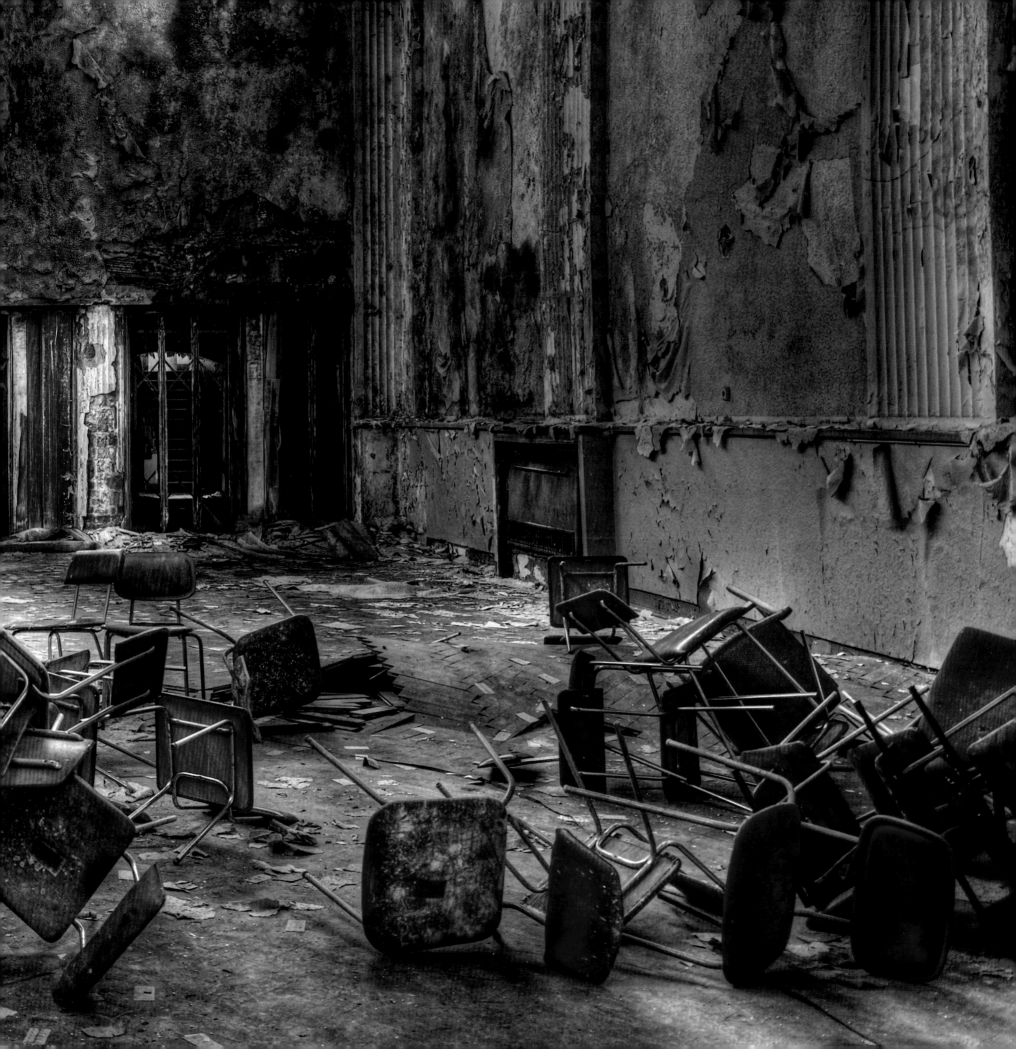

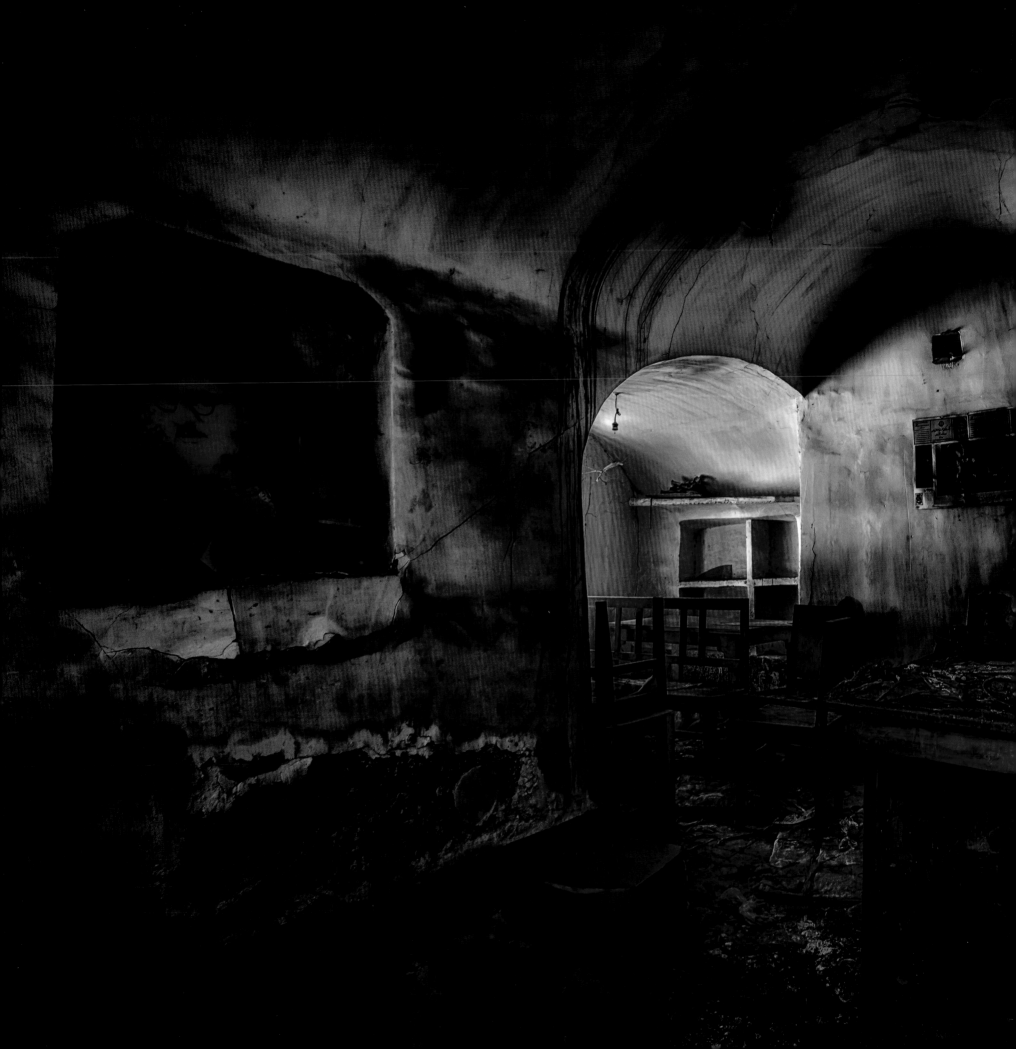

Leisure & Retail

Hotels, restaurants and shops are typically places full of life and teeming with luxury, leisure, hospitality and consumerism; but they lie eerily vacant in their quiet desertion.

Unwelcome Guests

If any abandoned site can summon up our feelings of dereliction in Camus' sense, a ruined hotel evokes the imagery of St Paul. Not that this necessarily brings us comfort, of course: it takes the faith that moves mountains to find so destroyed and desolate a sight consoling; to find reassurance in this reminder of the shortness of life and the utter mystery of what lies beyond. Hotels are places of passage: even when open and fully functional, they can crush us with their anonymity, their impersonality. At their very best, there's a bleakness about being there. However many stars a hotel may have for physical luxury, at some psychological level we can't be at home there; we're left outside. George Sand wrote in her novel *Indiana* (1831):

[There's something] in the appearance of the unaccustomed furniture, to which your idle glance turns in vain in search of a memory and a fellow-feeling, something freezing and repellent. All these objects belong, as it were, to nobody, by dint of belonging to all comers; no one has left any trace of being there, except for an unknown name sometimes left on a card in the frame of the mirror; this bought refuge has sheltered so many poor travellers, so many lonely strangers, but was hospitable to none of them; it has seen the passage of so many agitated human beings but cannot say anything about them.

Left: Ruined shop office in Kerman, Iran.

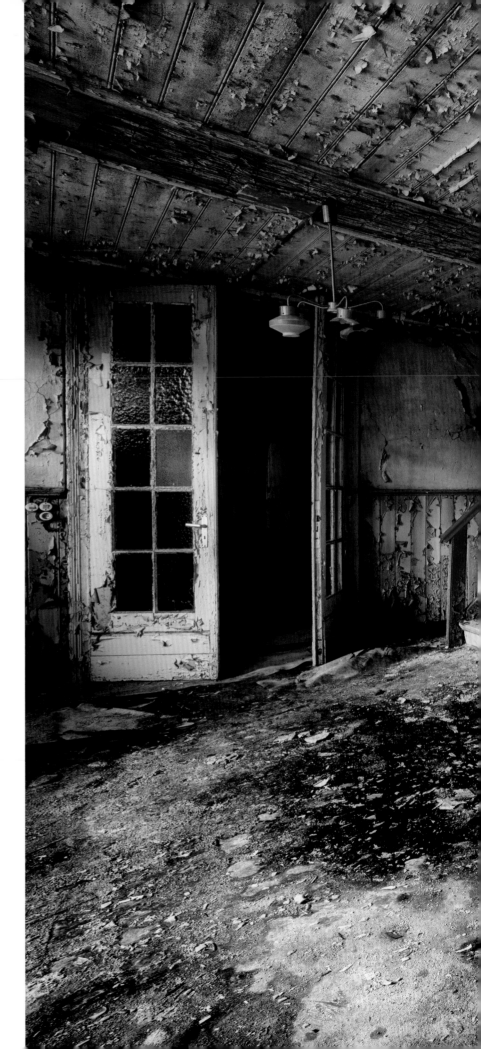

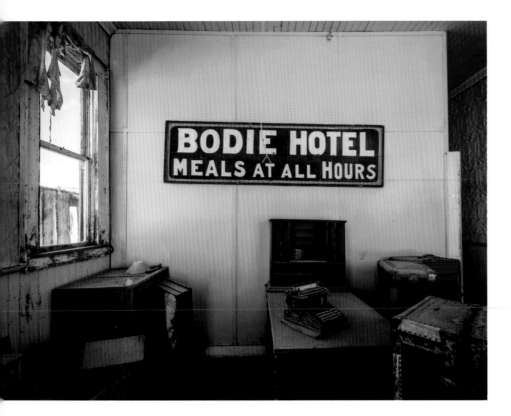

When a hotel has fallen into disuse, that feeling of repulsion is compounded. We're invading all these strangers' lack of privacy. The impersonality of the rooms is reaffirmed when they are actually unpeopled. Signs remain that this place once welcomed guests – soft chairs in the lobby; a swinging sign; a wardrobe door ajar; the little table upon which a pot plant withered … This only underlines the hollowness of the hospitality that once was.

Fine Dining

Its curtain rails coming gradually adrift; its ceiling slowly crumbling; an abandoned restaurant in Luxembourg is a health-and-safety nightmare (*see* page 36). Even in its day, one can't help feeling, those velvet drapes must have been a little too much – even if they hadn't clashed with the carpet (a sickly looking green), and contrasted unfortunately with the tacky lamination of the overwrought wood-framed chairs. But the tables are still set – and, the

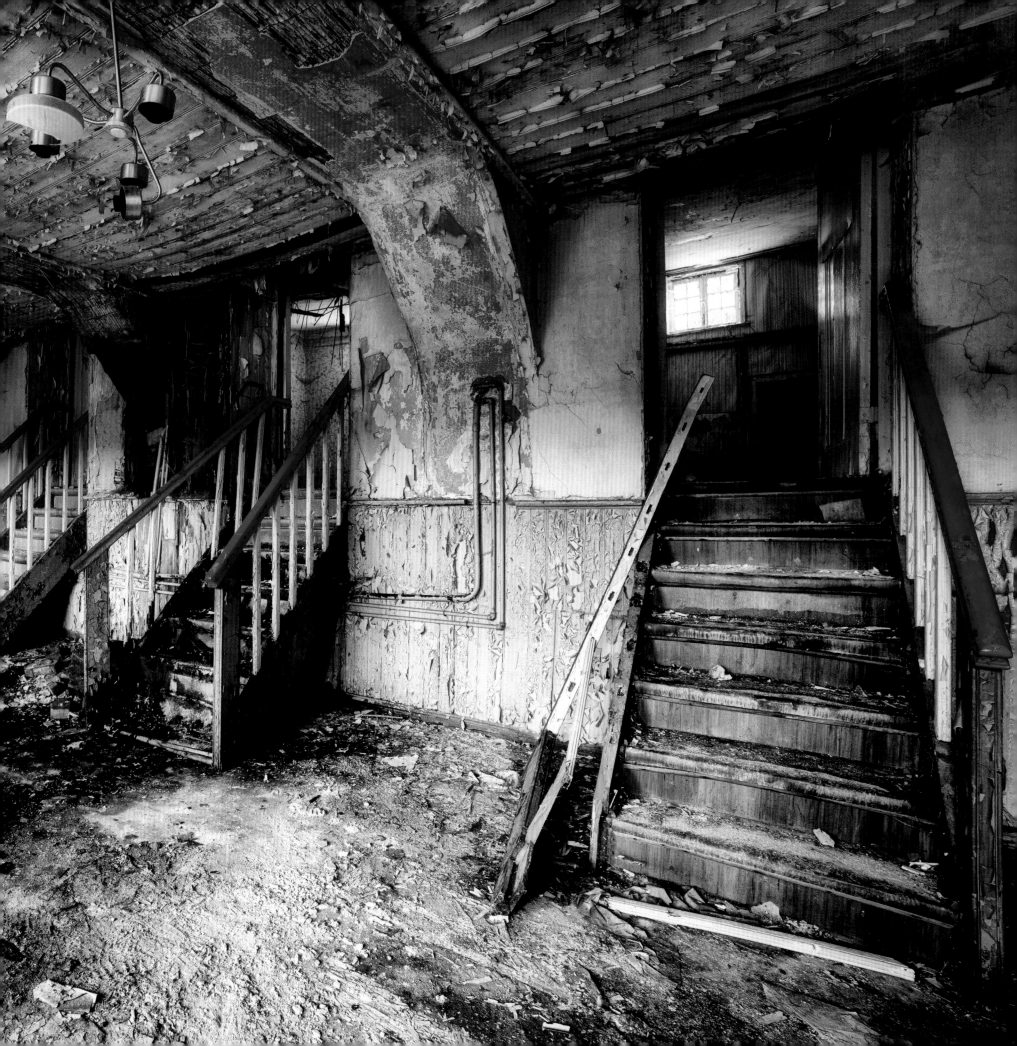

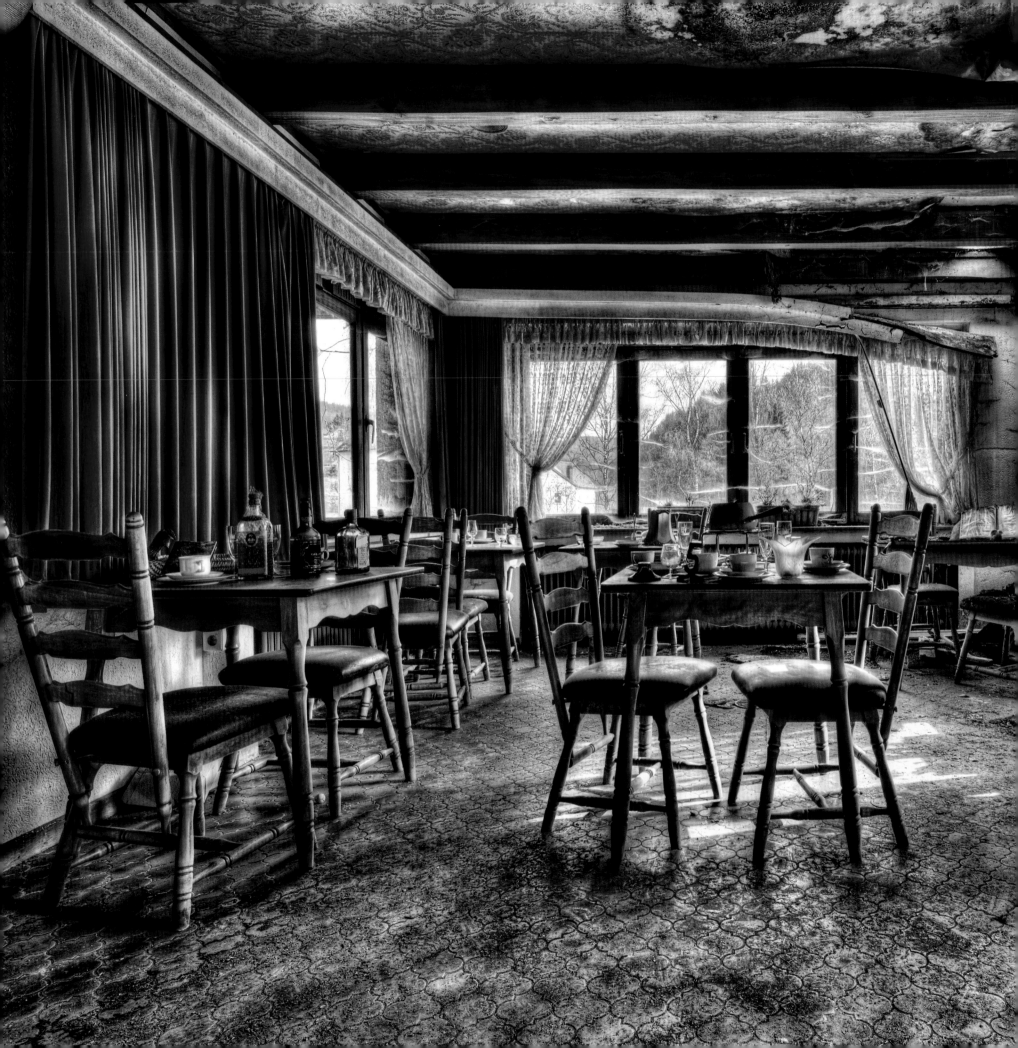

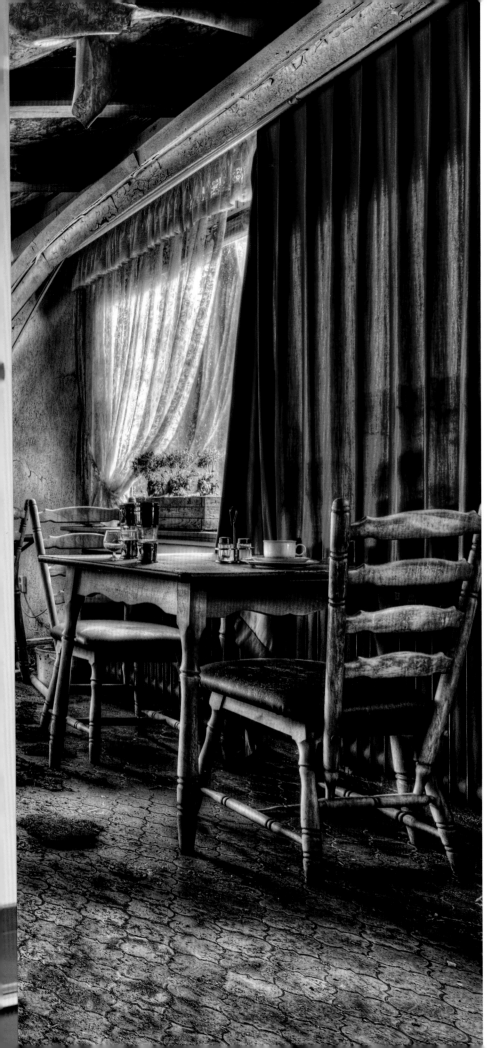

Above: Plants creep through a window in an abandoned building.

sheer eeriness of this apart, we can't help thinking of all the encounters and the conversations that must have taken place here: the business lunches; the family celebrations; the romantic trysts.

Patrons of Pripyat's old harbour café ate and drank under the surveillance of a heroic-looking flying woman – a pattern in the stained glass window; those in other, bleaker, Soviet-era diners were less lucky.

Shop Shock

'I shop, therefore I am,' proclaimed the artist Barbara Kruger, claiming an ironic status as the Consumerist Descartes. As appropriate as the comment may have been when she first made it in the 1980s, it could arguably have been made at any time. For those who could afford it, shopping was always a leisure activity: for the women and girls in Jane Austen's novels,

Left: Abandoned restaurant dining room in Luxembourg.

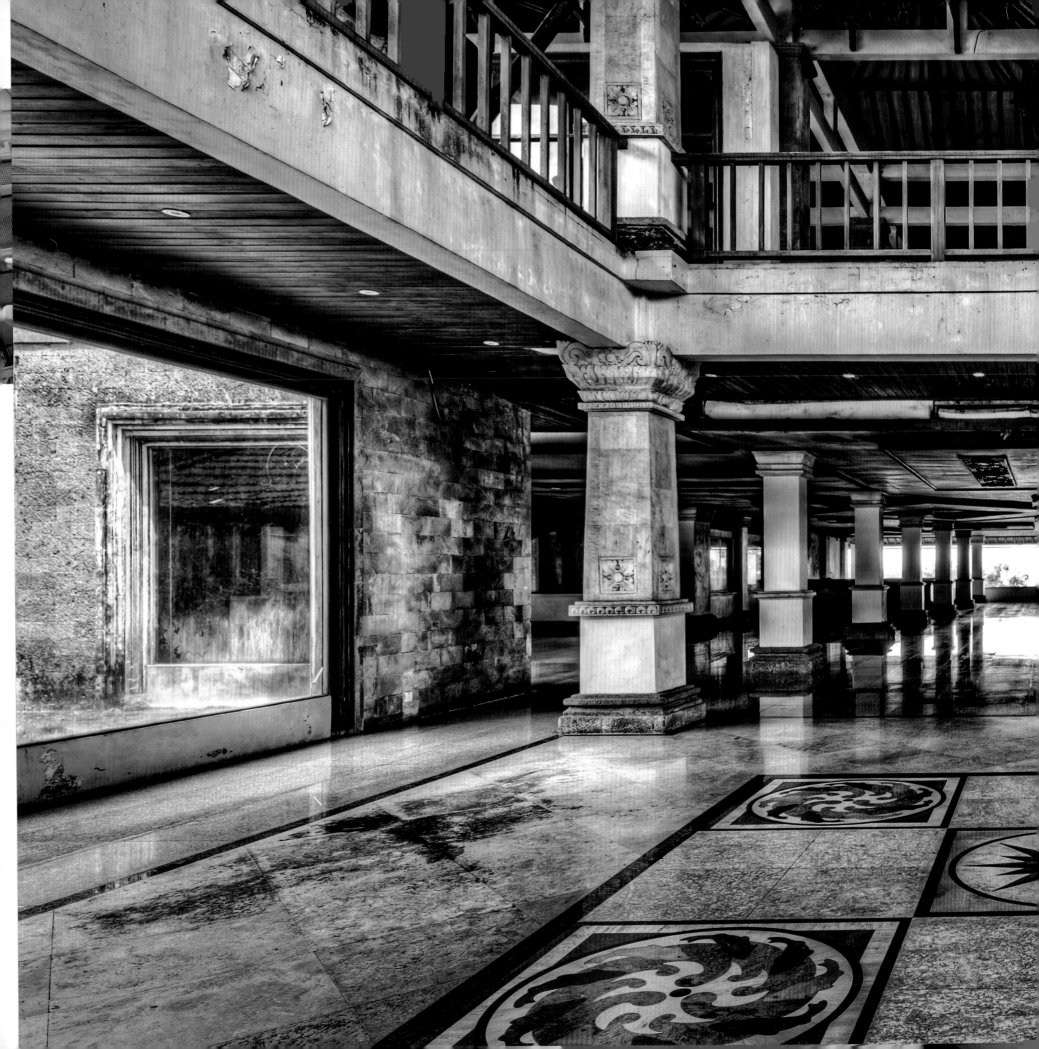

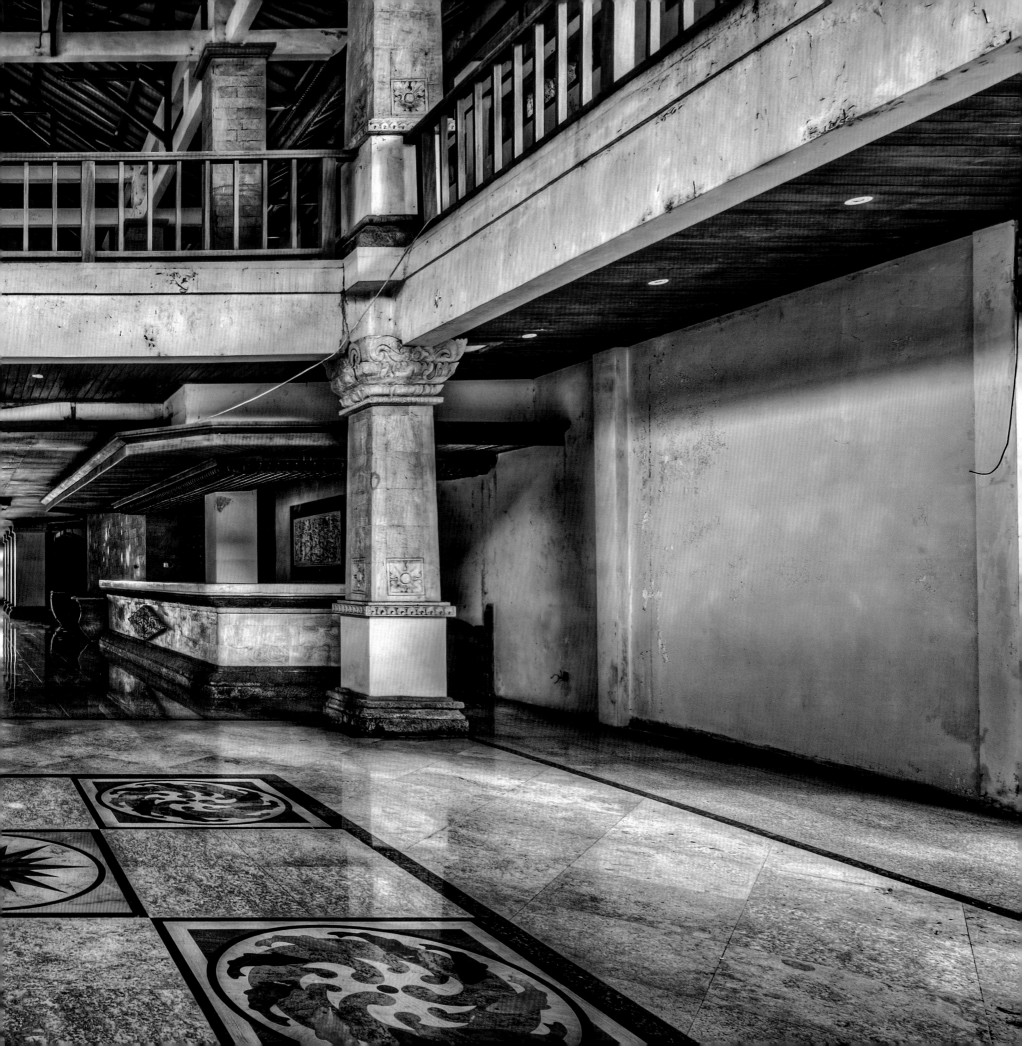

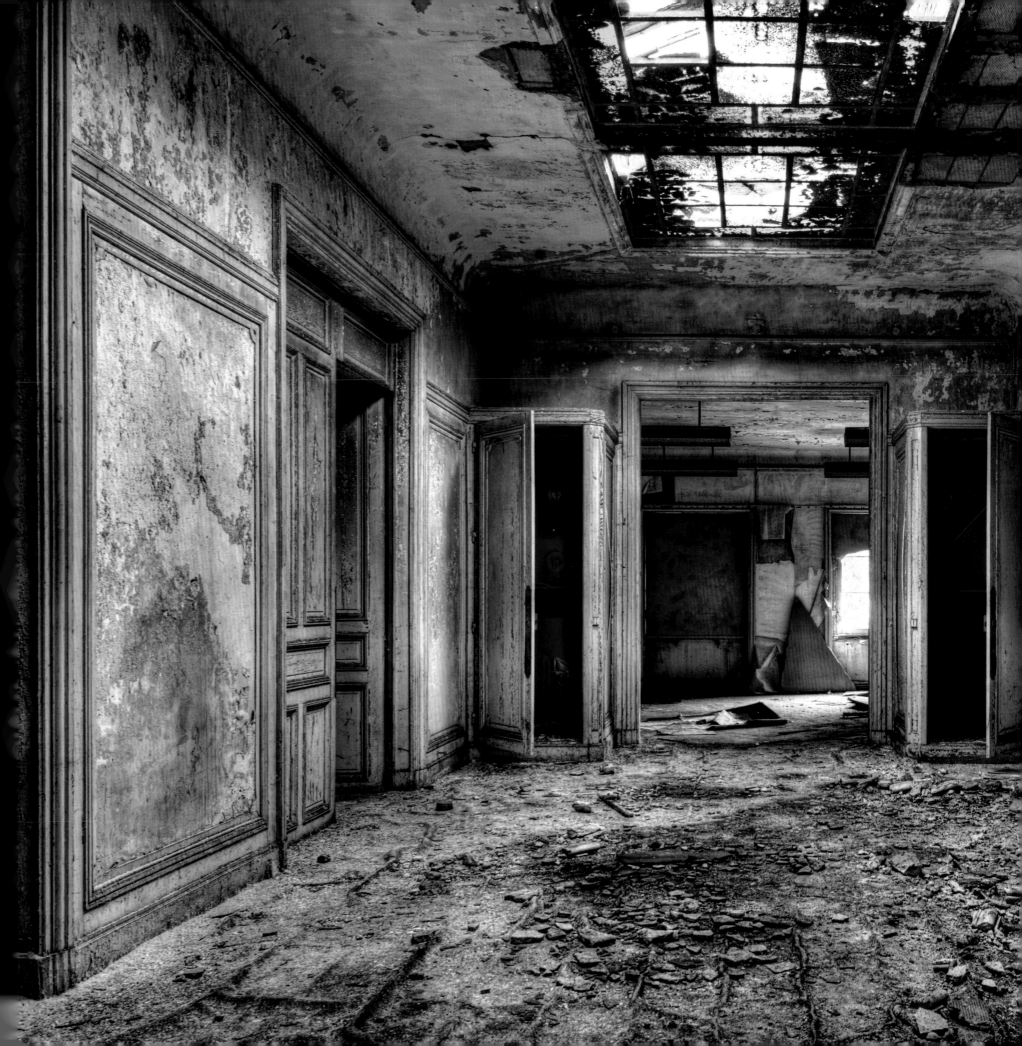

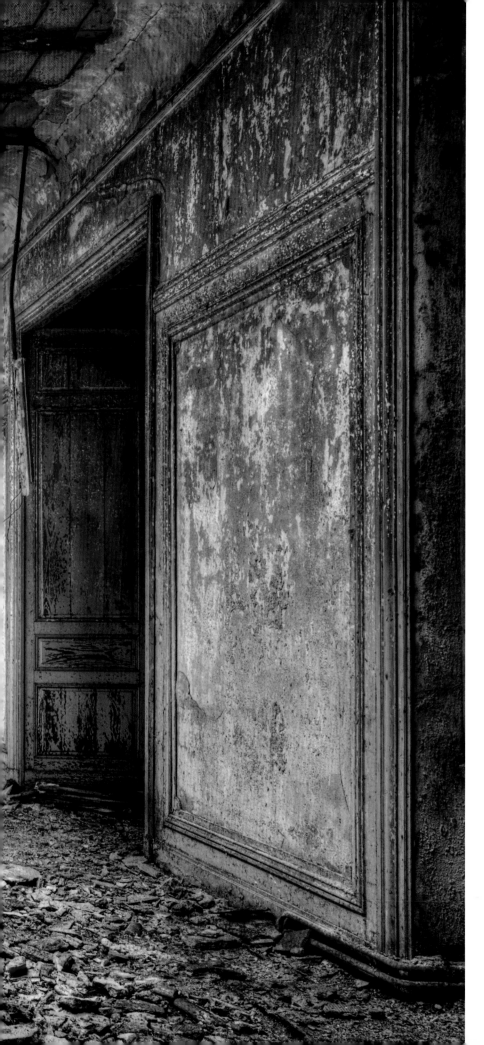

Above: Hotel Rouge in Huy, Belgium.

Not that we don't genuinely enjoy an evening watching avant-garde cinema, reading Dante or listening to Beethoven, but those enjoyments have been cultivated, involve application and to some, can feel like work. When we are drawn by the fresh leather pheromones of a jacket; crumple a new silk scarf between ecstatic fingers; 'fall in love with' a dress or look longingly at a laptop, we're at our most spontaneous – in some ways, at our most 'real'.

And, consequently, at our most ingenuously shocked when we see what was once such a store of cherished yearnings reduced to the bare, gaunt bones of its former self. Nothing could be more grotesquely naked than an unclothed mannequin; nor does anything seem so bereft as an abandoned sales floor.

Or so startlingly stagy. Without either stock or staff there, we see how consciously an elegant store is designed to set off what it is selling; how much care and contrivance went into framing all that merchandise, into packaging that perfect experience for the shopper. And we see how shallow the illusion was, when the tapestry is turned round to reveal the reverse; the functional and even ugly beside our dreams of sophistication and of style.

Left: Rubble litters the floor of a forsaken corridor.
Next page: Elevator in an abandoned hotel lobby.

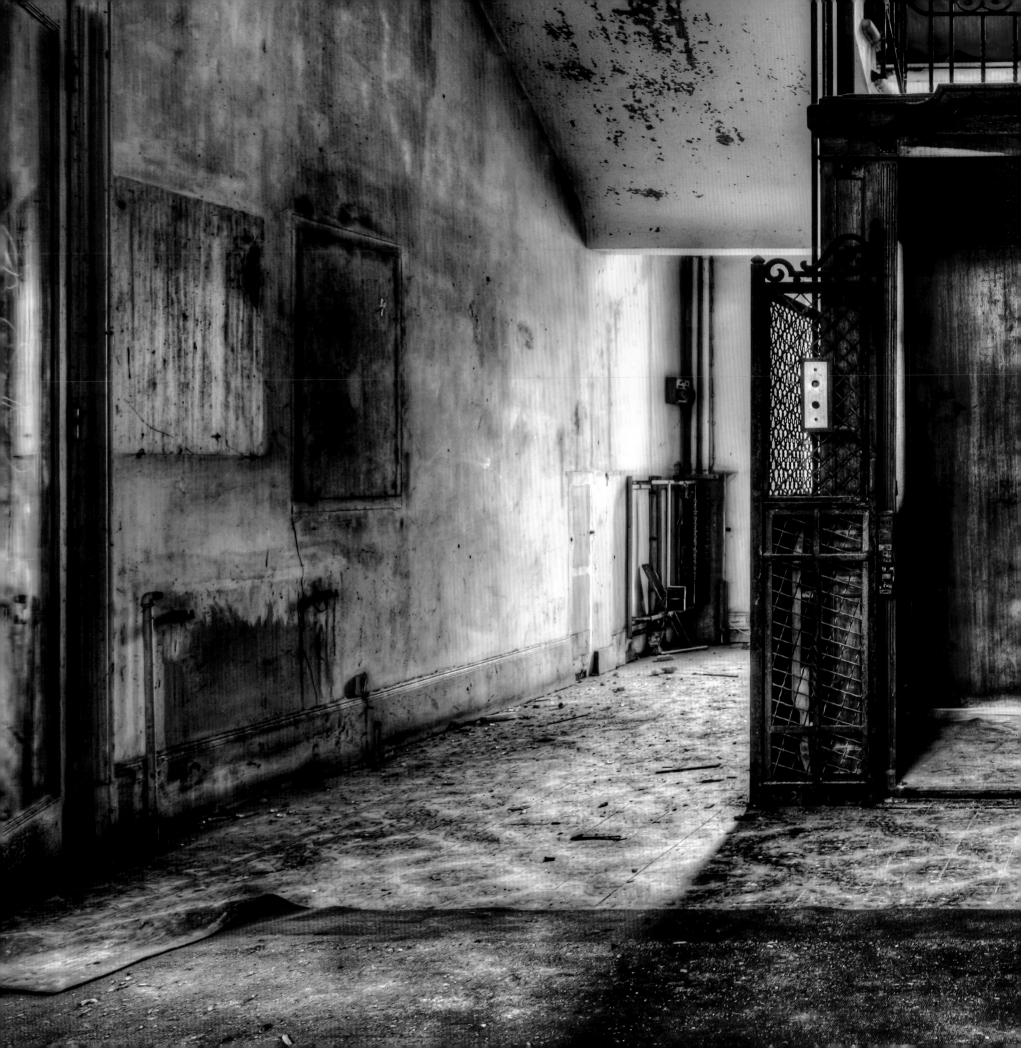

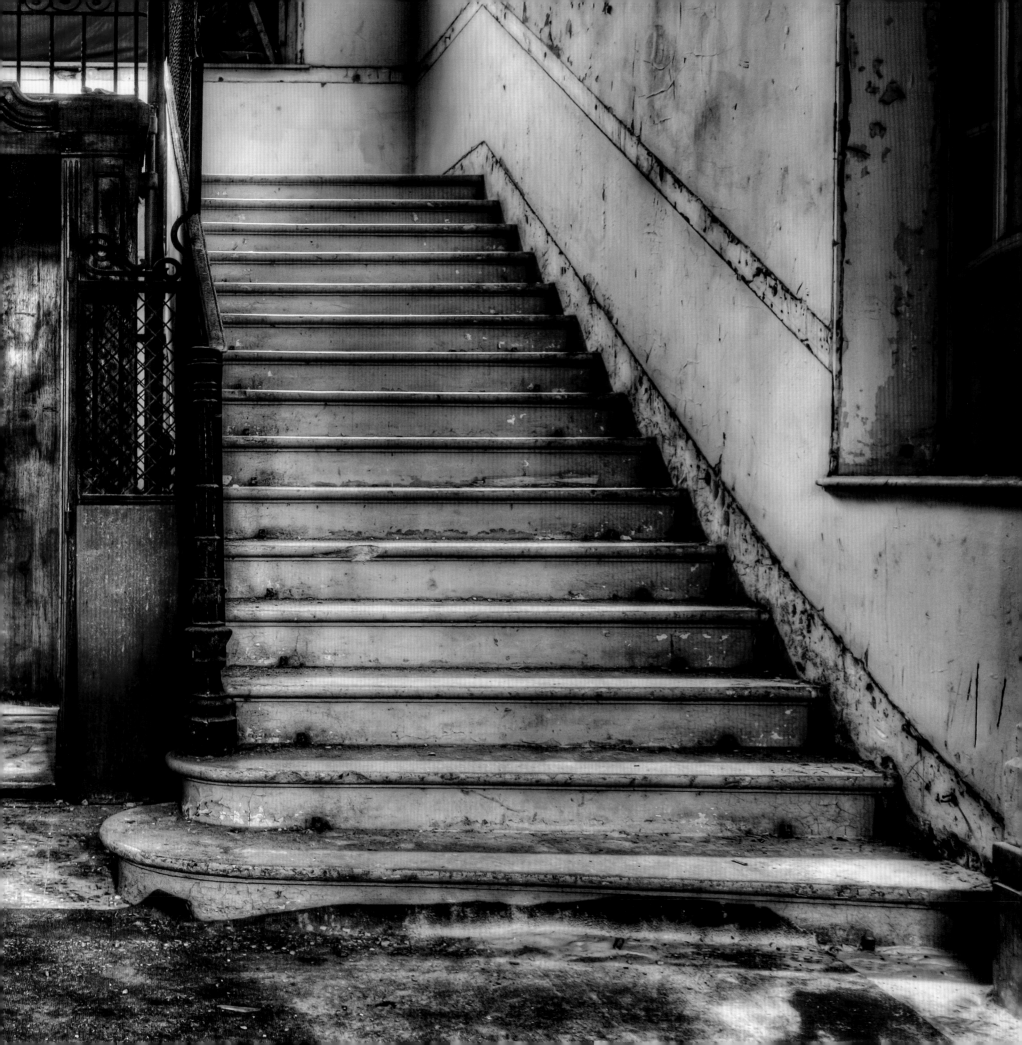

Sport & Recreation

'A champion', said Jack Dempsey, 'is someone who gets up when he can't.' Never giving in is the first rule for success in any sport, so it strikes a particularly melancholy chord with us when we see a sports facility out for the count, left unused and unmaintained in terminal decay. A walk in the woods ends abruptly at a chain-link fence: it turns out to contain a tennis court. You would barely know from the thicket of sapling trees rising out of the serving boxes, but look hard and you can just make out the net supports. Dust and detritus mar the maple surface once kept shiny-bright for basketball; a swimming pool stands empty, a vast, rectangular, tiled hole.

After the Final Whistle

Life, health, vigour, fitness, stamina and spirit: these are the qualities we associate with athletic endeavour. They're conspicuously absent in a disused stadium or gym. Where are the guts, the energy, the style and flair, the sheer charisma of those who played? And what of the dreams – the euphoria and the woe – of those who watched? Saturday afternoons are silent now, the terraces a tip for old oil drums and supermarket trolleys, the rails rusted, the hallowed turf waist-high with weeds.

Rain seeps in through a leaky roof, beading every surface with sweat-like water-drops; cold air streams bracingly through a broken window. Wooden wall bars rot; weights rust in their racks; rowing machines seize up and treadmills languish: a fitness centre slowly goes to seed. Disused changing rooms have their greatest impact on us when, ironically, they

Right: Abandoned gym in Pripyat, Ukraine.

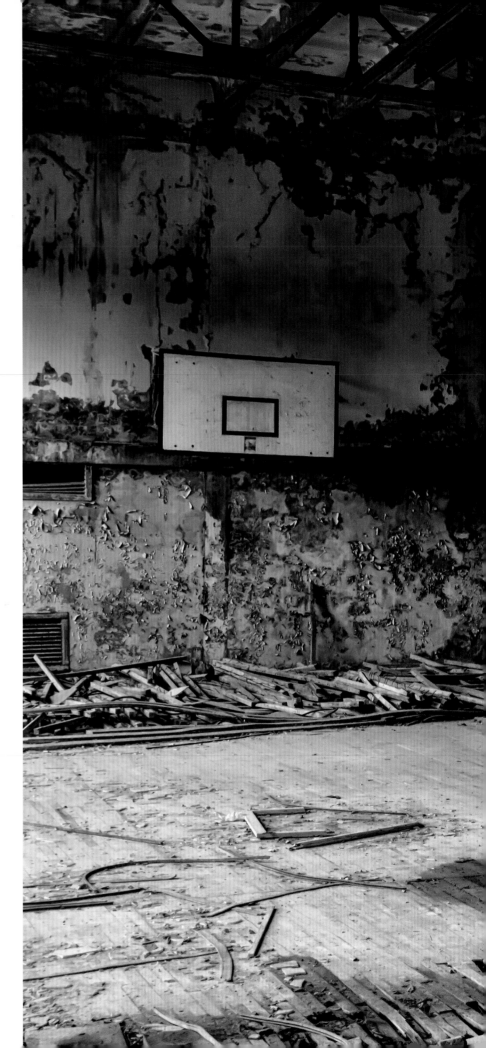

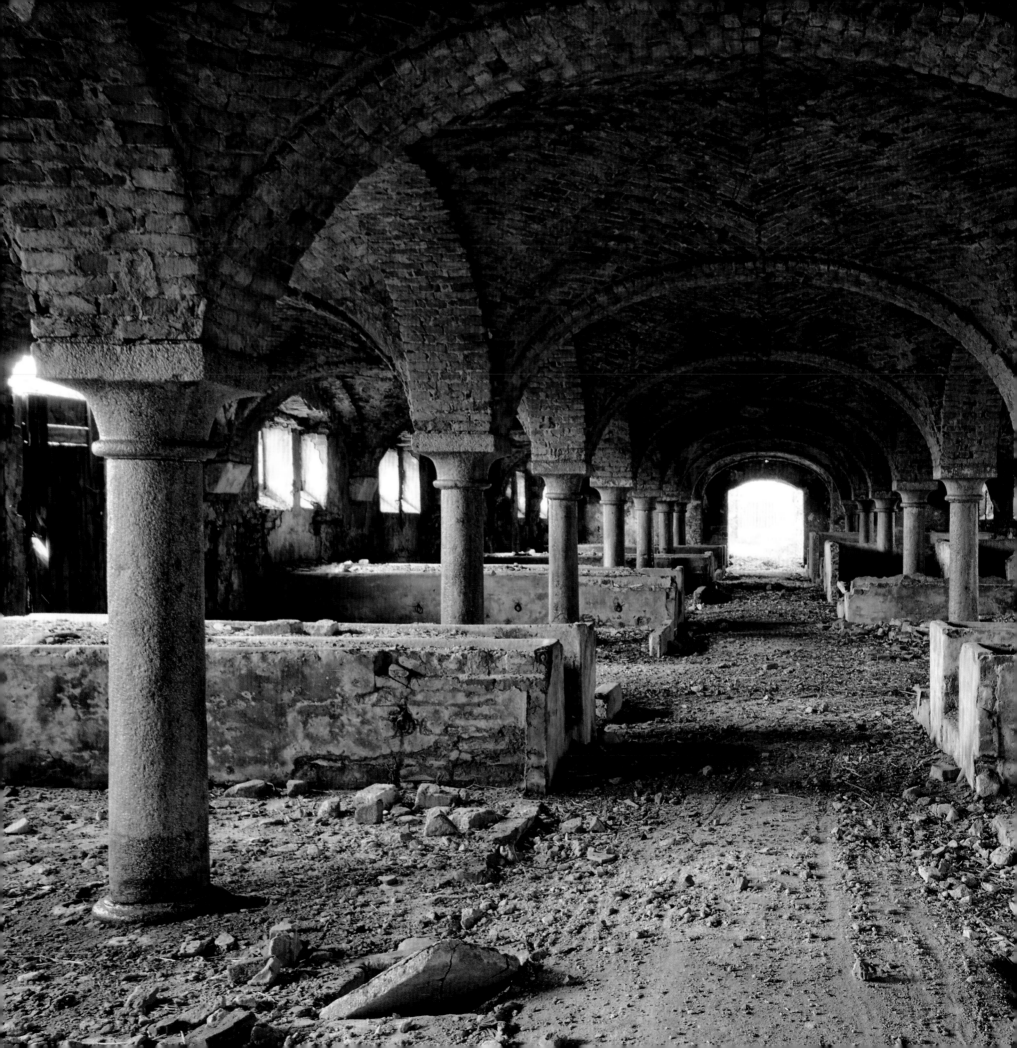

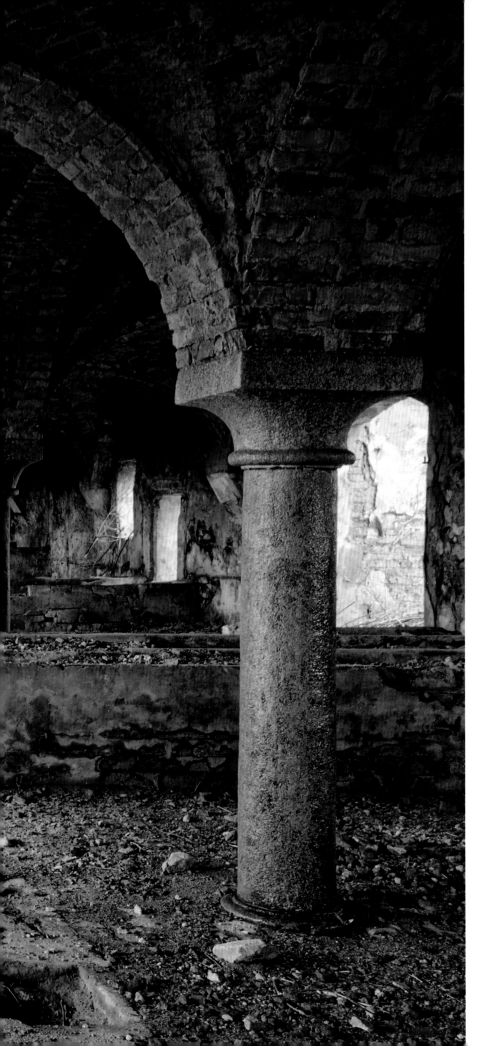

remain unchanged. Once they were places of transition: a woman would come in, a weary administrative assistant, and walk out kitted up to kick ass in five-a-side football or aerobics; a man, ground down by his week at work, would walk out a hero to shoot hoops with his old boyhood friends. Now no one comes here; nothing will ever change.

Olympic Ideals

'The Greatest Show on Earth' for some, the Olympic Games bring together competitors from over 200 countries to chase the ideals exemplified in the motto *Citius, Altius, Fortius* – 'Swifter, Higher, Stronger'. As conceived by its founder, Baron Pierre de Coubertin, in 1894, the modern Olympics creatively reimagined the originals of ancient Greece to celebrate the power and potential of humanity at large. The reality has been more cynical, of course: participating nations have inevitably been more interested in besting each other than in promoting humanity as a whole, while the competition's insistence on amateurism caused controversy almost from the start (controversy only dampened by the rule's abandonment in recent decades). The Games' unrivalled status as a running, jumping, throwing, catching symbol of the limitations of human idealism have found physical expression in some of the world's most extraordinary abandoned real estate.

It's not been about the winning but the falling apart, it seems: most recent Olympics, their 16 days of glory gone, have been followed by the slow but inexorable disintegration of facilities constructed at vast inconvenience and cost. Not just vast stadiums and swimming pools, but specialized venues for everything from kayaking to beach volleyball – not to mention villages for the athletes, administrative offices and media centres, plus innumerable ancillary structures, from new highways to public transport hubs. (The intervening Winter Olympics have their own exacting set of requirements.)

Left: An old ruined stable with beautiful arches.

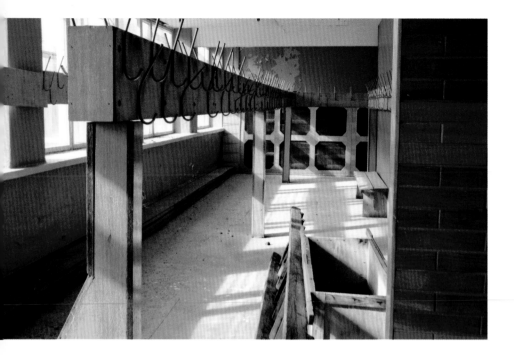

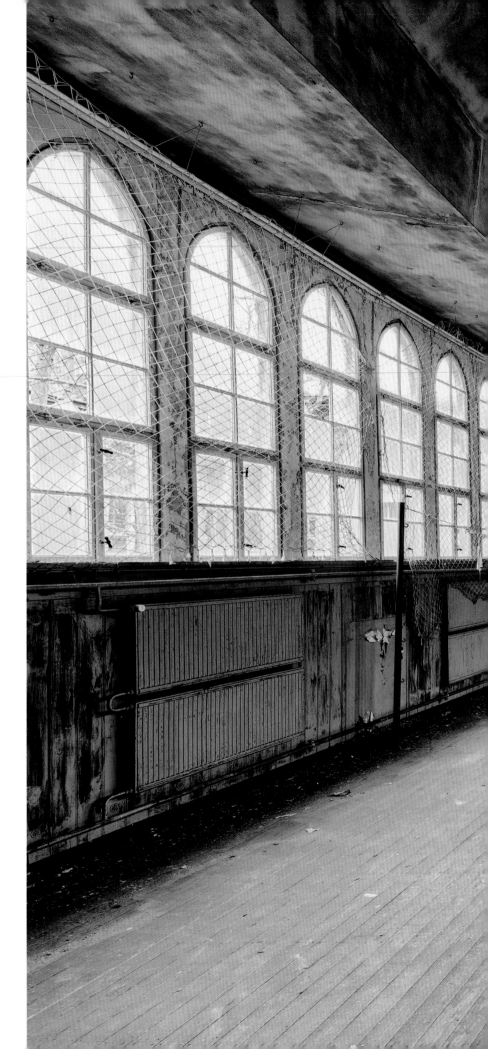

Above: *Abandoned changing room, Pyramiden, Svalbard: Sold to the Soviets by Sweden in 1927, developed as a major mining centre, then abruptly abandoned in 1998, this ghost settlement remains remarkably intact.*
Right: *A volleyball net hangs across a derrelict gymnasium.*

City authorities bidding to host the games and committing the fantastic sums involved have conventionally argued that the Olympics will win international prestige and boost investment; often as not, indeed, they've insisted that the games will help 'regenerate' areas of inner-city decay. In some places, such as Barcelona, that vision has to some extent been realized. By and large though, in a series of cities from Berlin to Beijing and Athens, and from Sochi to Sarajevo, they've only helped create their own new brand of urban blight.

'New Ruins'

If city officials bidding for the Olympics have too often obviously been bewitched by the economics of wishful thinking, 'hard-nosed' capitalists don't necessarily prove any more clear-sighted. 'New ruins' around the world – ambitious residential, retail or leisure complexes built to cash in on a new consumerist demand that simply never came – testify to this. That so many exist says something general about the capitalistic spirit, and the wasteful

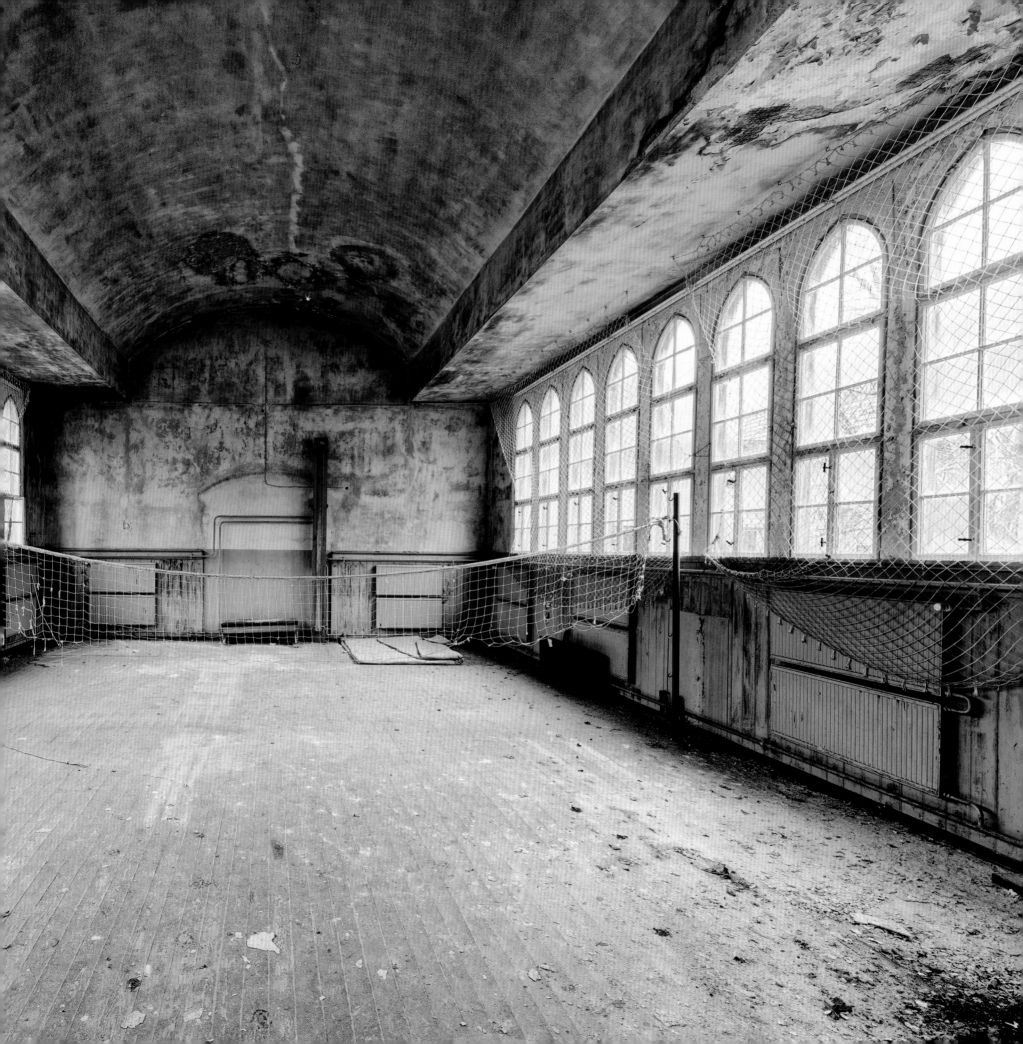

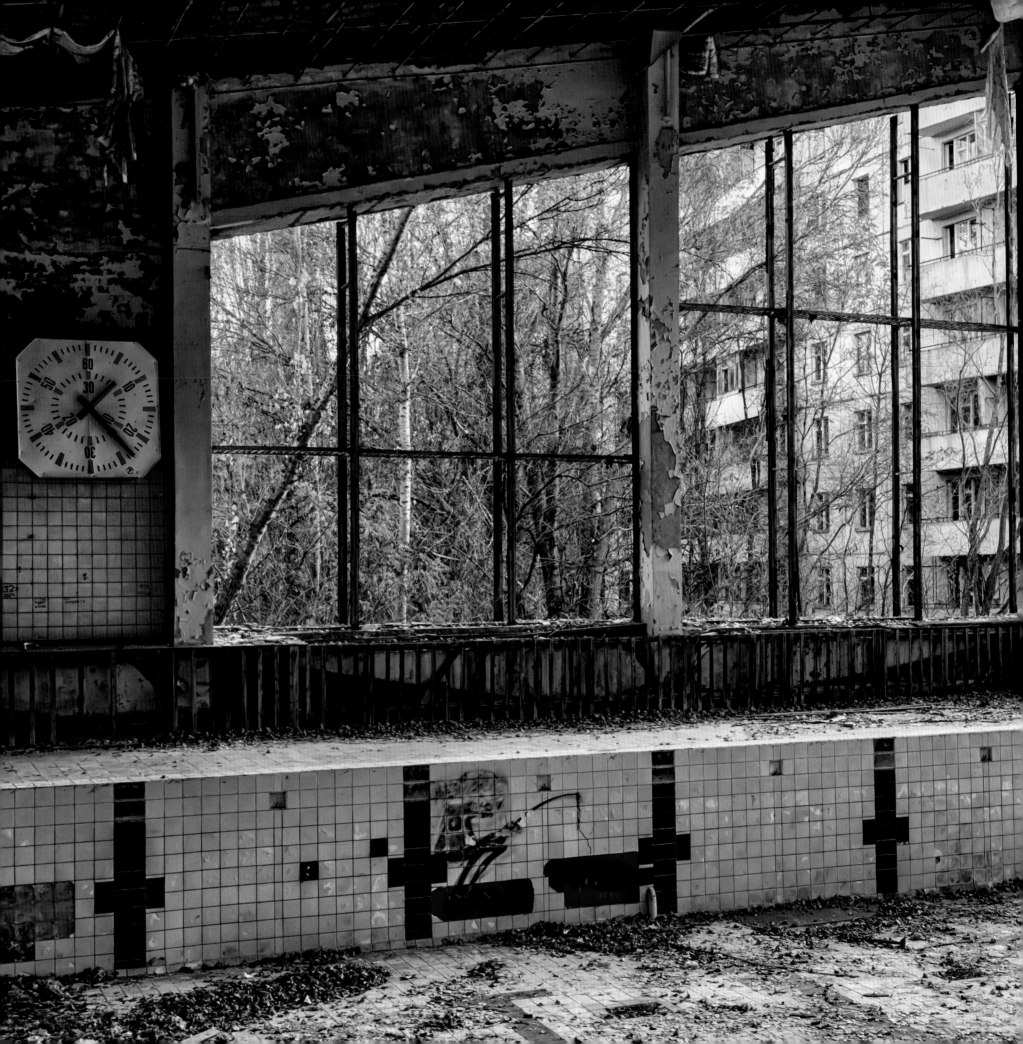

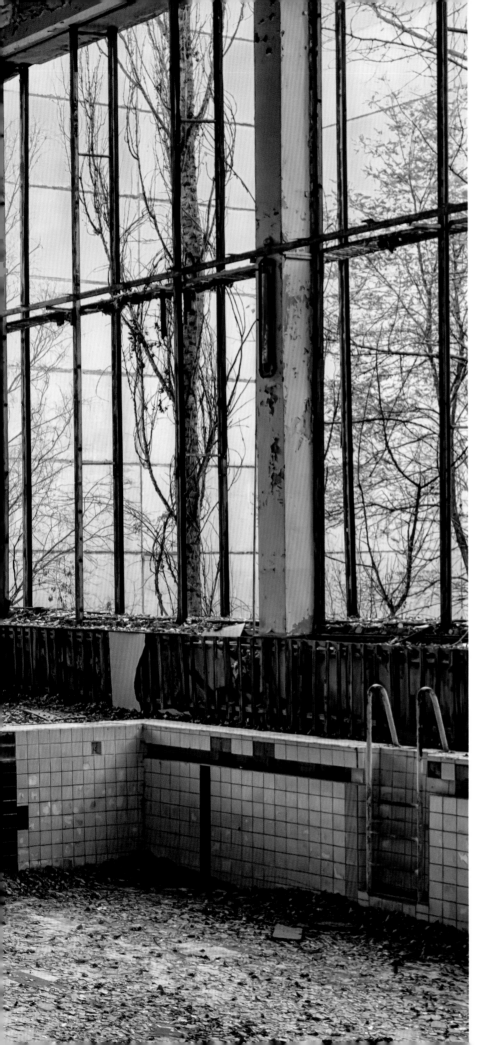

duplication that can all too easily accompany its drive to generate choice and competition – as well as something particular about the crazy cycles of the last few years. Developments which had looked irresistibly appealing in the run-up to the global financial crisis of 2007 to 2008 suddenly seemed toxically untouchable in its aftermath.

The result, around the world, was an extraordinary range of new industrial, residential and retail developments all dressed up with no commercial place to go. Especially in those developing countries which were racing to make up for several centuries of time lost to colonialism and catch up with the Western economies in all their confident prosperity. China's Communist rulers for example brought to free-market development a buccaneering zeal and ruthlessness. When the economic tide turned, these new ventures were left high and dry.

Defining Dereliction

If such reverses obviously raise questions of economic policy and planning, they suggest some intriguing philosophical ones as well. Can a building be both brand-new and derelict? Is it 'disused' if it was never used to start with? At what point do we deem an unopened building 'abandoned'?

And if a beautifully built mall in pristine condition can qualify as derelict, what, conversely, of a place that was arguably never new? What of a temporary settlement pieced together provisionally, for the short-term, from 'found' or hastily provided materials: a shanty-town, for example, or a squatter camp? When whole communities are left derelict by natural disaster, economic catastrophe, political instability or war, their experiences too will help shape the architectural fabric of our age, just as they will the historical legacy we will all hand on to those who follow.

Left: Pripyat, Ukraine: When a reactor fire at the Chernobyl Nuclear Plant caused a large-scale leak of radiation in April 1986, a mass evacuation left nearby Pripyat a complete ghost town.
Next page: The window of a deserted building.

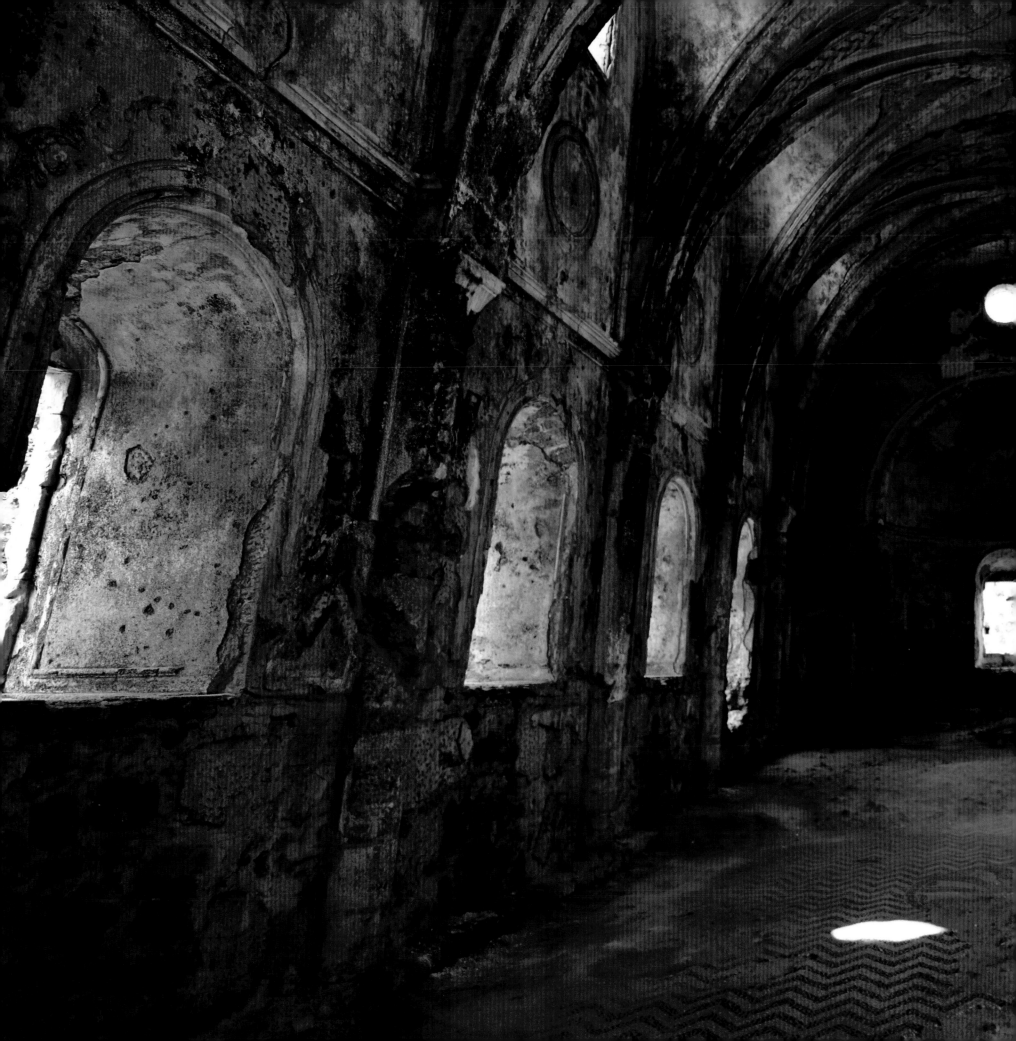

Public
Places

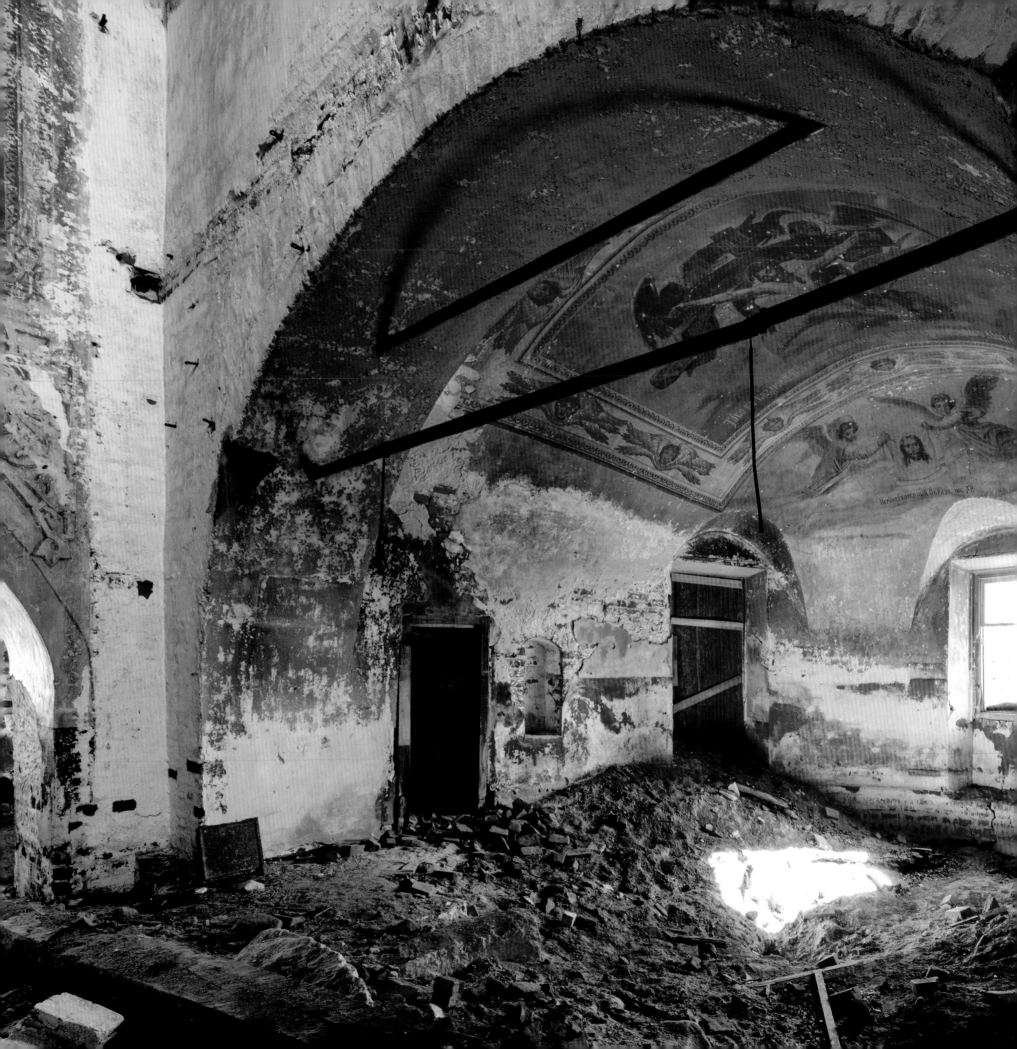

Social Decay

The shattered shell of an abandoned church; the decaying fabric of a derelict hospital; the ghostly silence of an empty classroom in a shut-down school …When what have been public places fall into ruin, they evoke their own special melancholy, over and above the usual intimations of mortality and time. We all have memories of the social environments which over the course of our lives helped to shape us – for better or worse, not just in the support it gave us. but in the slights it dealt. No man is an island. However introverted we may be, however private our controlling impulses, we all rely for our ultimate psychological security on some sense that there's some sort of society out there around us for support. To see its institutions neglected, their physical structures allowed to decay and collapse makes us feel strangely vulnerable. When the 'social fabric' crumbles, so do we.

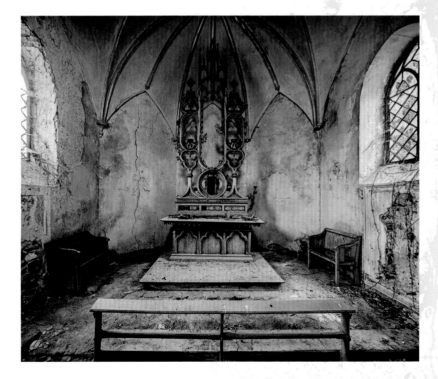

Previous page: Interior of the Orthodox High Church of Kayaköy, Turkey.
Left: *Painted ceiling in an abandoned temple.* ***Above:*** *Abandoned chapel on the roadside, Belgium.*

Places of Worship

'**W**here two or three are gathered** together in my name, there am I in the midst of them,' said Jesus (Matthew 18:20). When no one at all is gathered, where is He then? To see a church, a mosque, a temple stand derelict is oddly disturbing. Even for an atheist: it goes beyond belief. Doubly so when, as we find in Buenos Aires' La Recoleta Cemetery, Argentina (*see* page 65), it's actually a chapel of the dead that's 'died'. The mouldering ruins here appear to partake of the long last sleep of those they commemorate, never more to be awoken until Judgment Day. So much for the 'beloved memory' in which we are supposed to be holding the departed; so much for solidarity between human beings. A roadside chapel somewhere in Belgium sinks, slowly but inexorably, into disrepair (*see* page 58): once it was open to anyone who passed, a shrine to St Everyman, maintained by the community at large …What became of that sense of social spirit?

Most of us would like to think our society is about something more than individual ambition or acquisitiveness; that we're guided, if not by a higher being, then at least by higher goals. A place of worship symbolizes that 'something more'. If 'God is dead', we may not mourn Him; but we miss the unquestioning collective spirit we associate with the age of faith; our sense of a society that, if not just or equitable, was at least cohesive.

The church-turned-nightclub has become a cliché of the modern urban scene. Any strong feeling that this metamorphosis might be blasphemous – or even, really, particularly ironic – has long since been lost. On the contrary: that people are regularly still 'gathered together' here, however secular their

*Right: Majestic despite its dereliction, Gary's City Methodist Church makes a fitting flagship for a foundering – and yet still proud – post-industrial community. **Next page:** Villers Abbey church ruins in Wallonia, Belgium.*

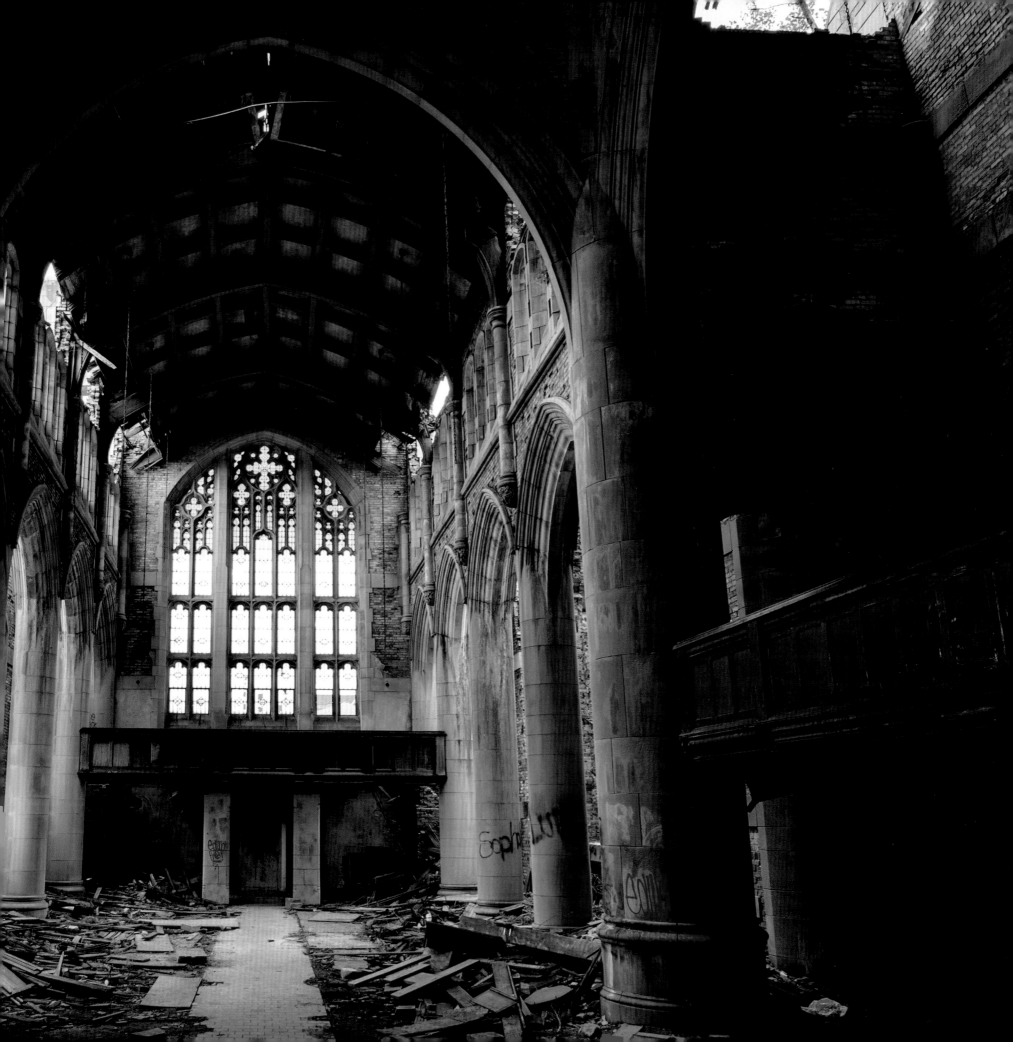

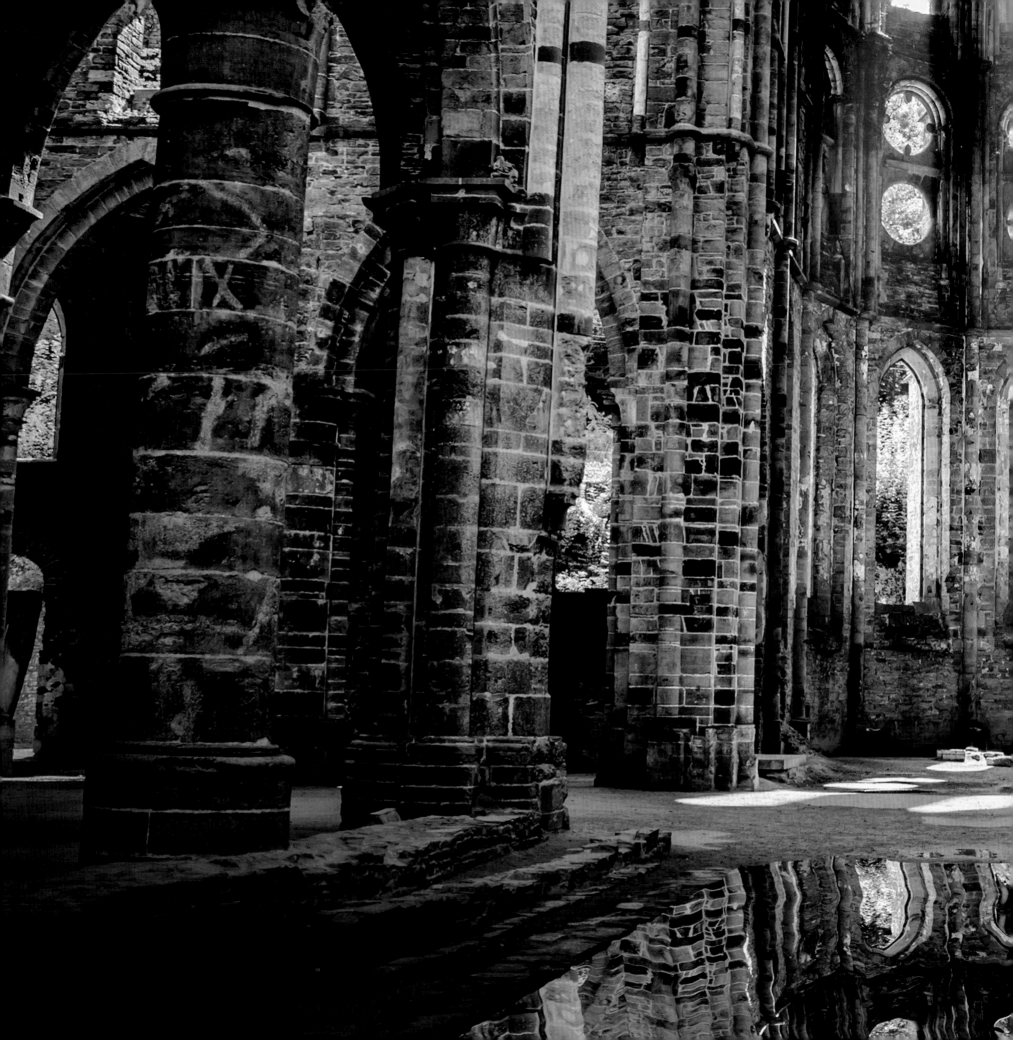

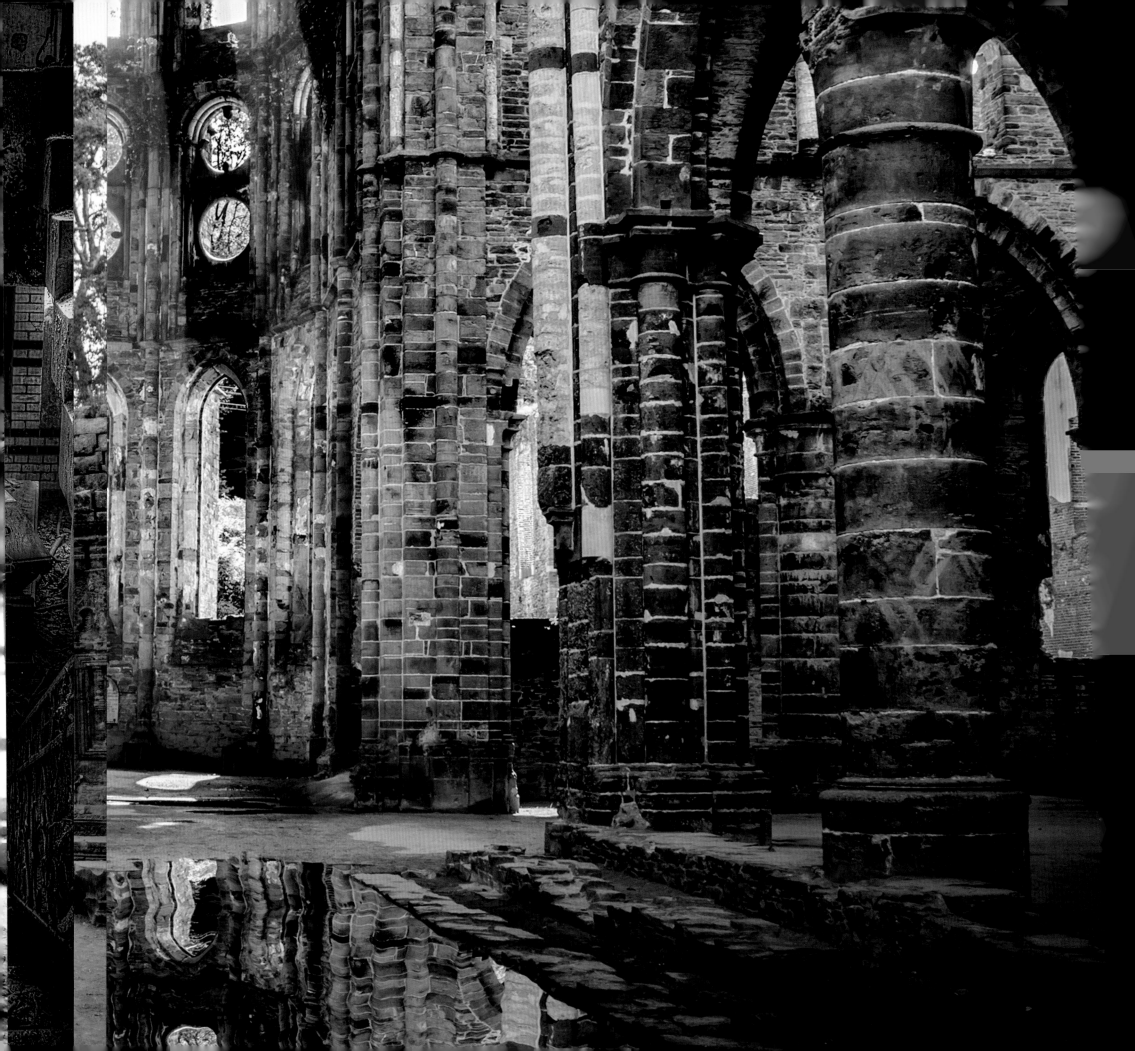

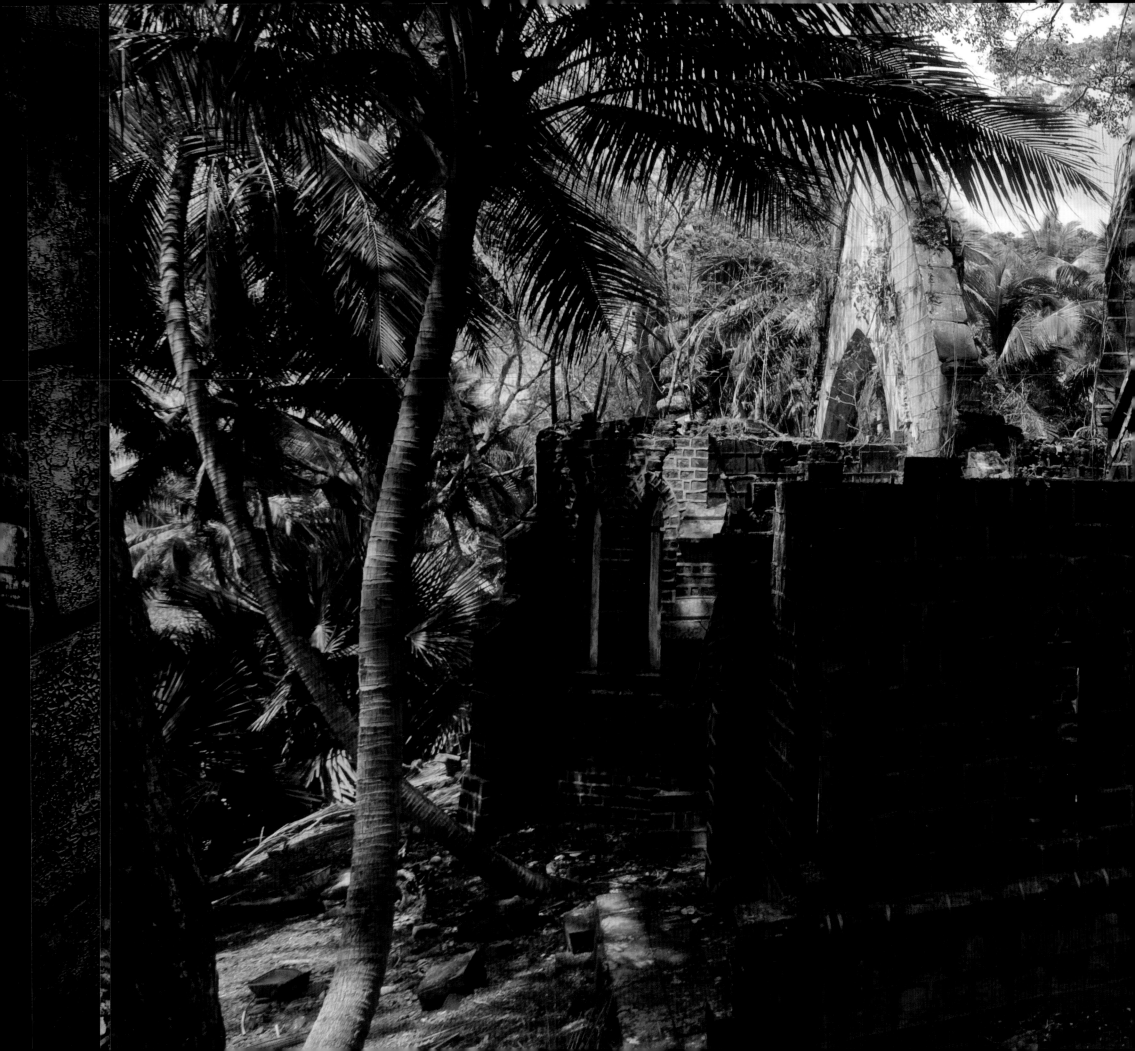

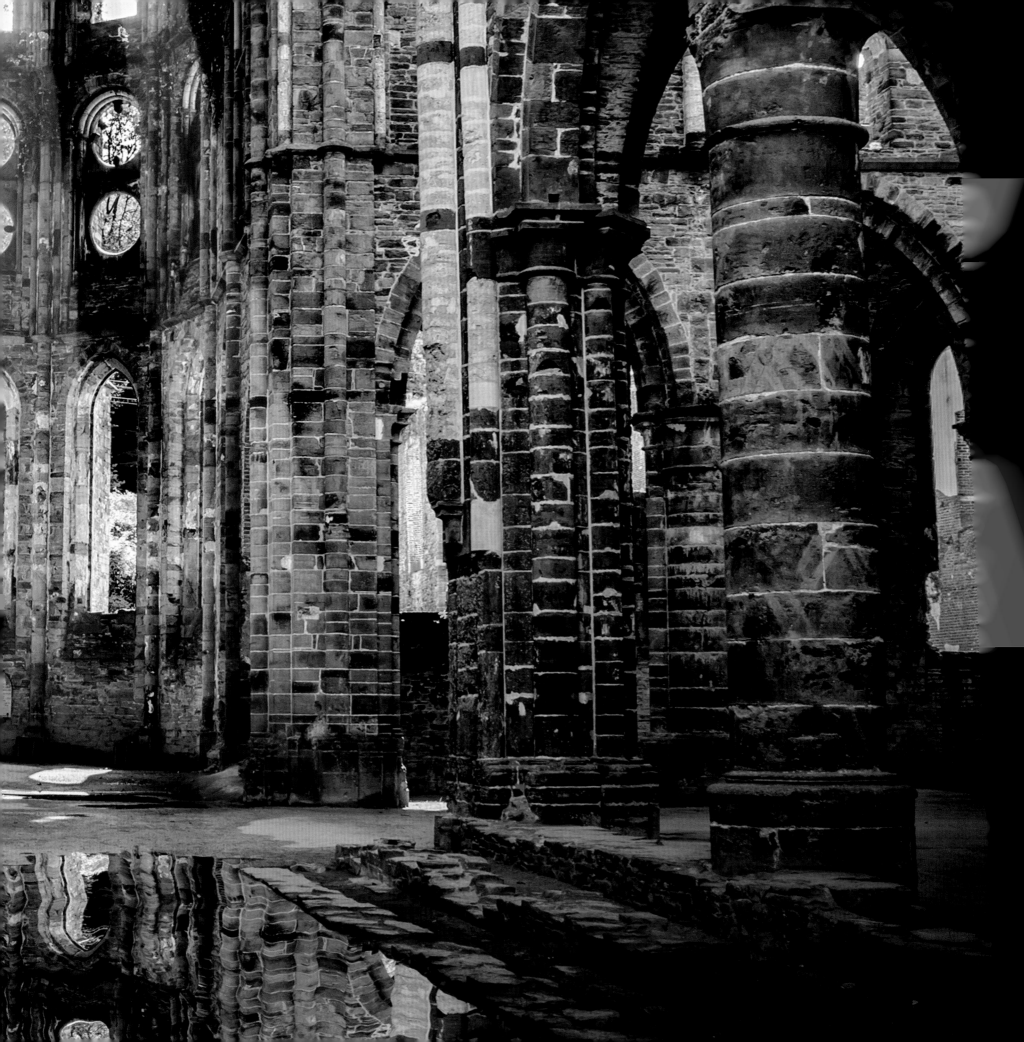

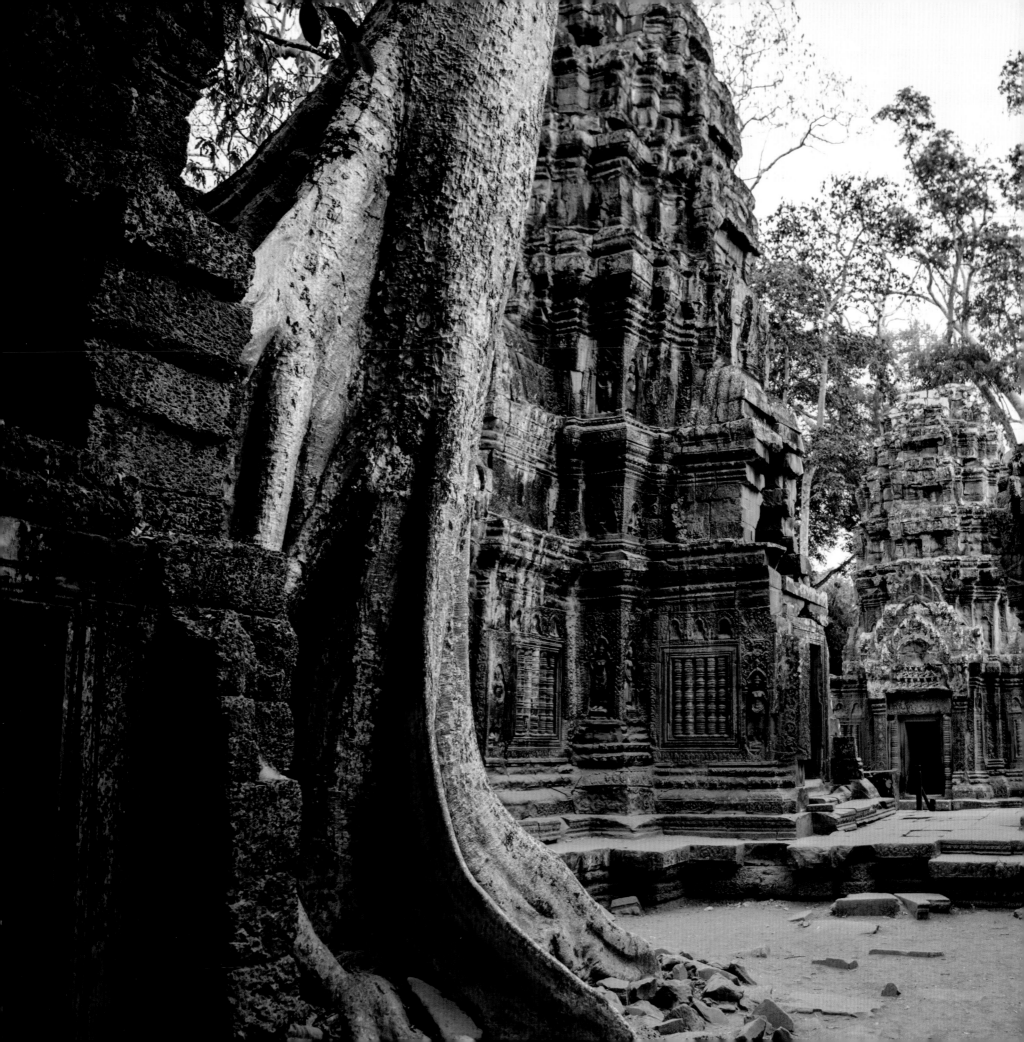

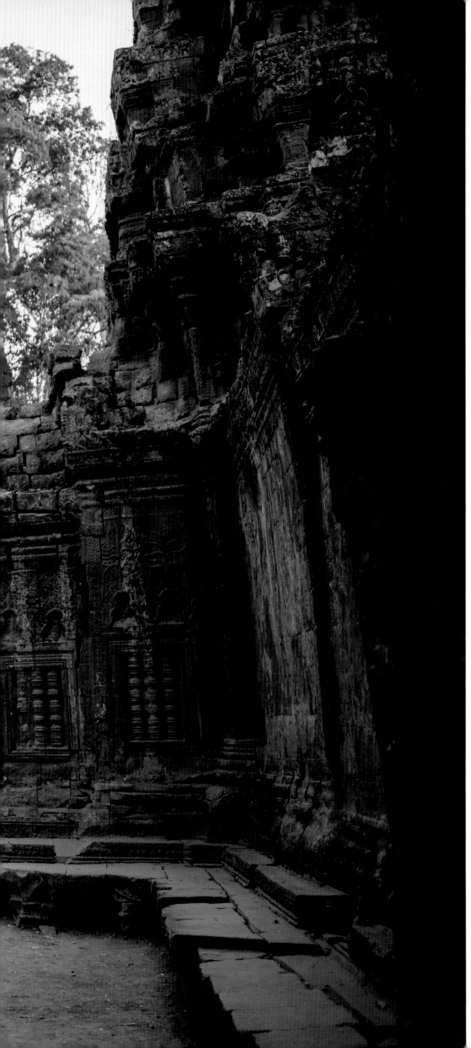

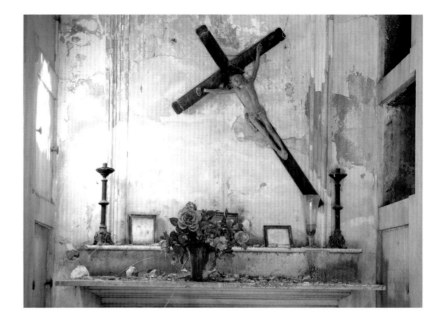

motives, seems vaguely reassuring. It's good to see that some sense of a social instinct still endures. But the sight of a place of worship left abandoned seems inherently depressing: its dilapidation speaks of some human failure.

Faith Abandoned

That failure may of course be one of generosity and tolerance: such sites have often been targeted (or just caught up collaterally) in times of conflict. Whatever our religious status, their smoking ruins stir unease in us when we see them on the TV news. Something universally human has been hit. A superficial view, perhaps: damaged houses and hospitals matter more objectively, but we're a species that deals in symbolism – that can't be helped.

And sometimes symbols seem to reach us more immediately and intimately than more apparently 'human' information can. It's not that we don't care

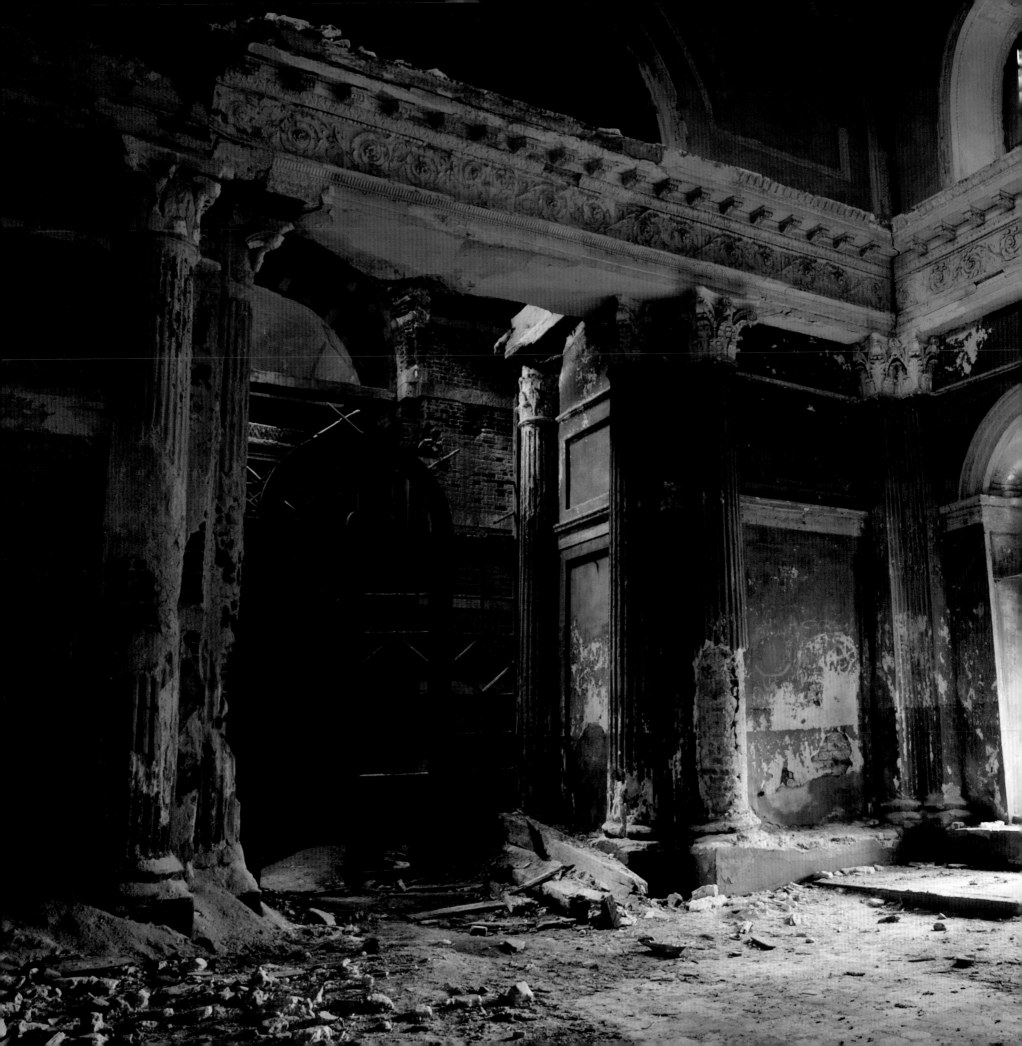

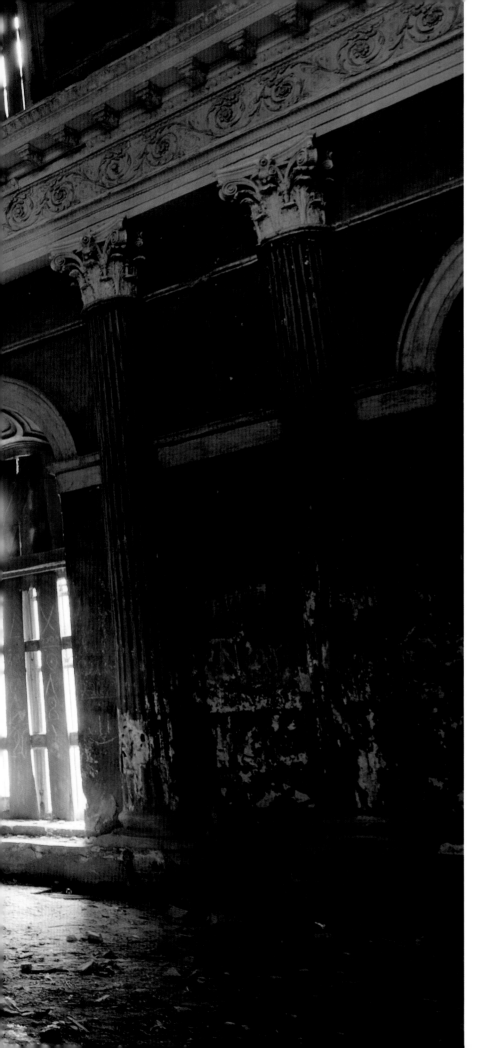

about the 90-odd German Jews who died in the violence of 9–10 November, 1938. But their sufferings are most strikingly evoked for us by a remembered assemblage of visual imagery; that of the burning buildings and broken glass of *Kristallnacht*. The church of Kayaköy, or Karmylassos, not far from Fethiye, in southwestern Turkey, stands as a sad memorial to the little Greek village that once was here (*see* page 56). Its people were moved out as part of a population exchange between Greece and Turkey in 1923, after the Greco–Turkish War. Their church, left empty ever since, speaks eloquently of a bereaved community.

Is it really so much better when, rather than being the result of violence and hatred, the failure reflects only the gradual encroachment of social and spiritual apathy? You don't have to be religious to wonder if something else hasn't been lost along with the churchgoing habit in the modern West. For the Marxist thinker Herbert Marcuse, the 'opium of the people' had merely been replaced by alternative addictions in modern capitalist society: sex and consumerism now had us all hooked. Even a more liberal voice, like that of the Nobel Prize-winning economist John Kenneth Galbraith, could complain of the new opposition arising in the post-War world between 'private affluence and public squalor'.

Unlike the chapel at La Recoleta, the City Methodist Church in Gary, Indiana, USA (*see* page 61), certainly isn't supposed to be a place of death. Since the loss of its steel industry however, Gary has been a slowly dying city: this church symbolizes both its decline and its former pride. Built in 1925, in the Neo-Gothic style, it's a splendid building by any standards – even now. Look up, transfixed, and feel the vertigo as you see its vaulting, its pointed arches soaring skywards; look down at the floor before you though, and you face a scene of chaos. Much of it is made up of large and ragged sections of the roof that have sagged to breaking point; shards of glass are heaped between broken pews.

Left: Kazan Theotokos Church in Yaropolec, Russia.
Next Page: Standing forlorn among the forest trees, a ruined church on Ross Island bears quiet testimony to European attempts to establish Christianity in the Andaman Islands in the nineteenth century.

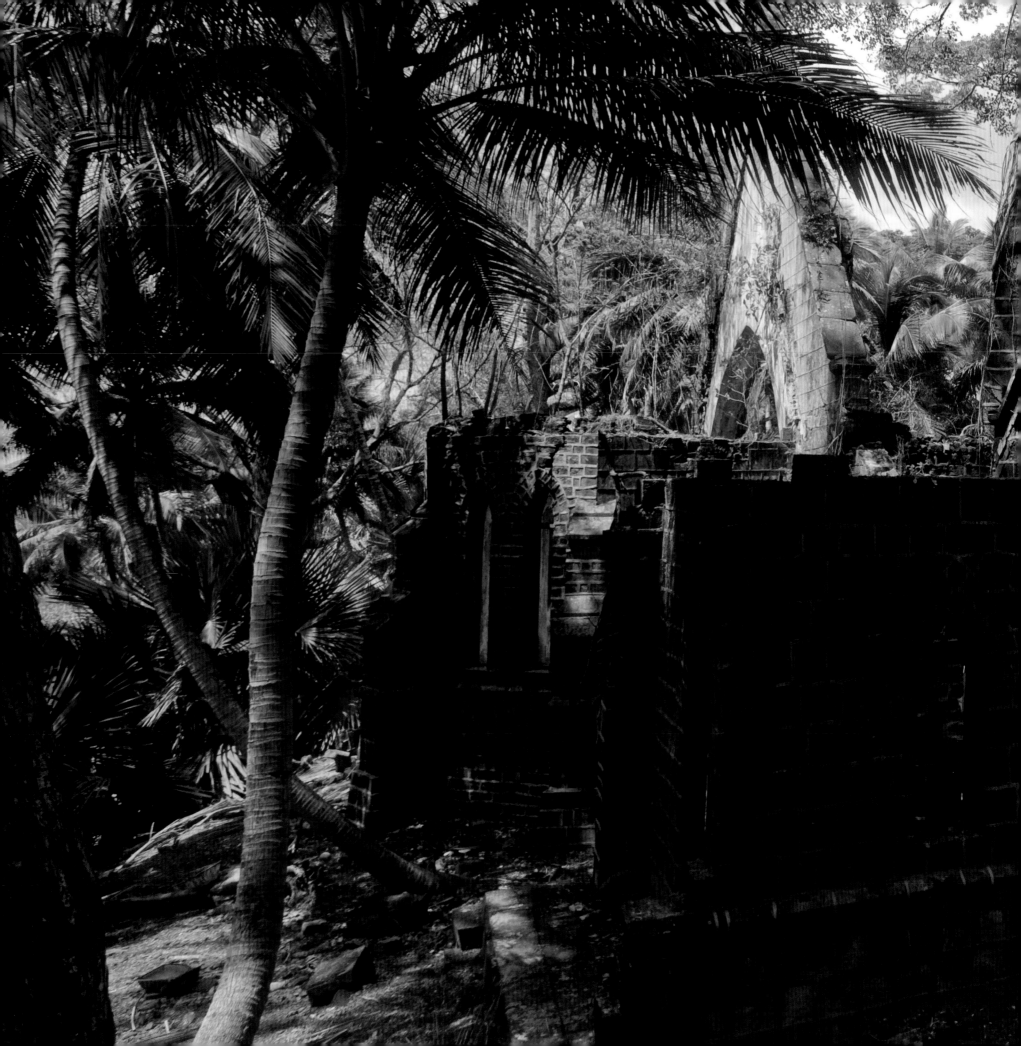

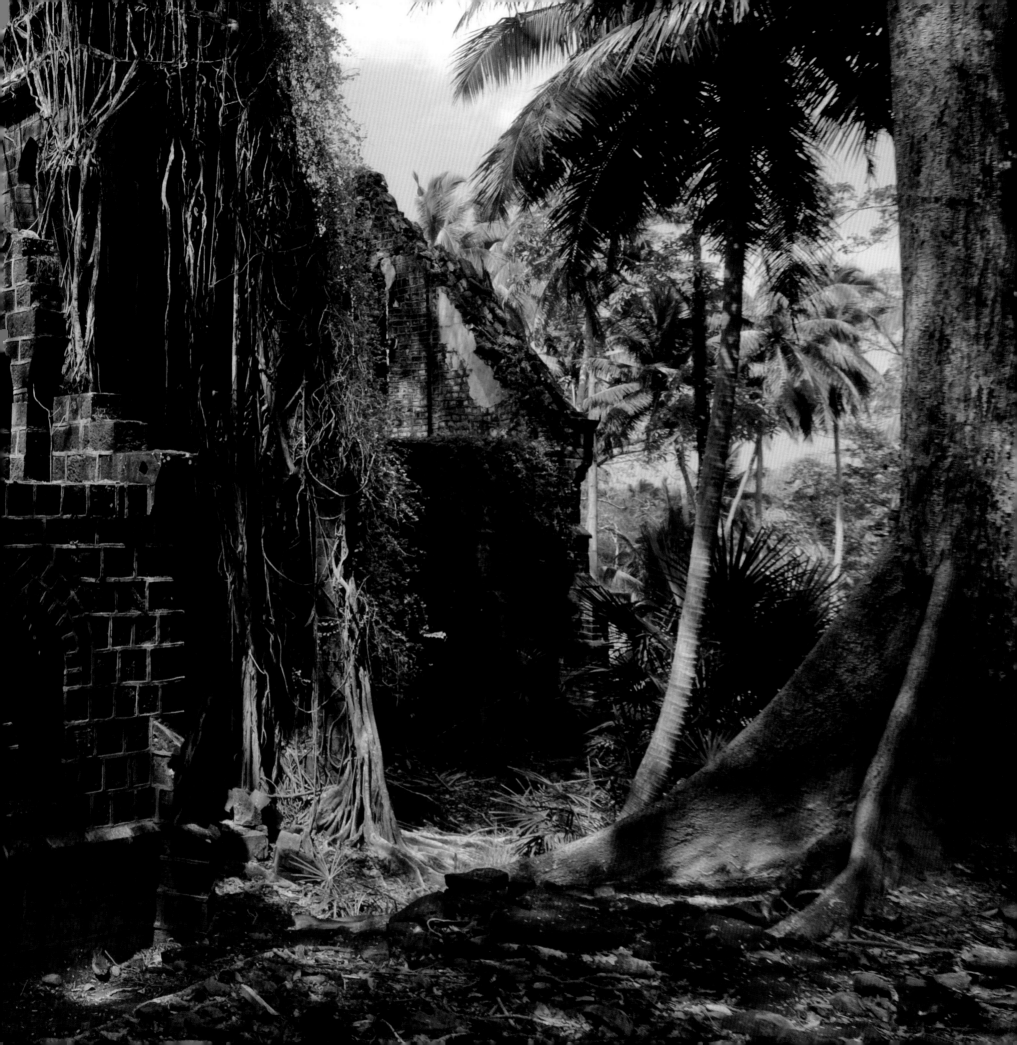

School Leavers

They may not actually have been the 'happiest days of our lives' – we may look back with relief that we'll never have to relive them – but we still tend to idealize our years at school. If for no other reason than that they belonged to a time when we could realistically look forward; hope for better – or just different – things. However unhappy we may be now, we felt then that there might be prospects, or at least possibilities, for us; before we left school – and, of course, before our youth left us. If we enjoyed our education, so much the more melancholy in some ways. Successful and fulfilled as we may feel, we may still feel a certain nostalgia, despite ourselves, for a time before our lives and circumstances – however comfortable – seemed set in stone.

To enter an abandoned school, to roam its cavernous corridors, to open the door on its vast, empty hall, is to sense the emptiness of a world in which that sense of possibility has been relinquished. To peep into a classroom cluttered with now-dusty disused desks is suddenly to stare into an abyss of expectation quashed and hope abandoned. So many futures started here; so many lives were shaped; so many discoveries made; so many emotions experienced for the first time. Now, it seems, all that is at an end.

Dying Education

Not that less appealing memories aren't preserved along with the rosier ones. In an abandoned classroom in Gary, Indiana (*see* page 76), the walls have decayed, the floor's a mess and the ceiling's falling through – but the sense of regimentation remains in the parade-ground order of the old desks and chairs. A row of

Right: *Chemical laboratory in an abandoned university.*
Next page: *Leaves cover the floor of a desolate classroom in Japan.*

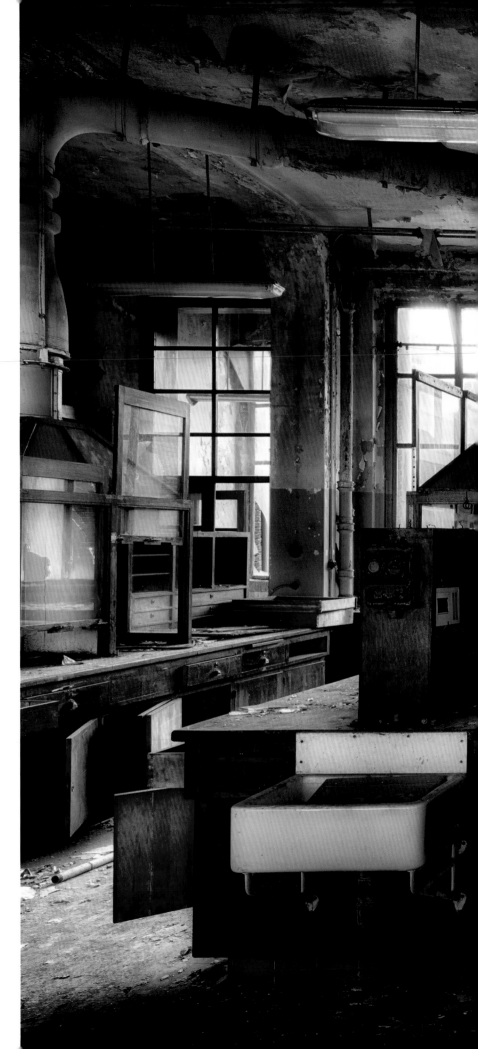

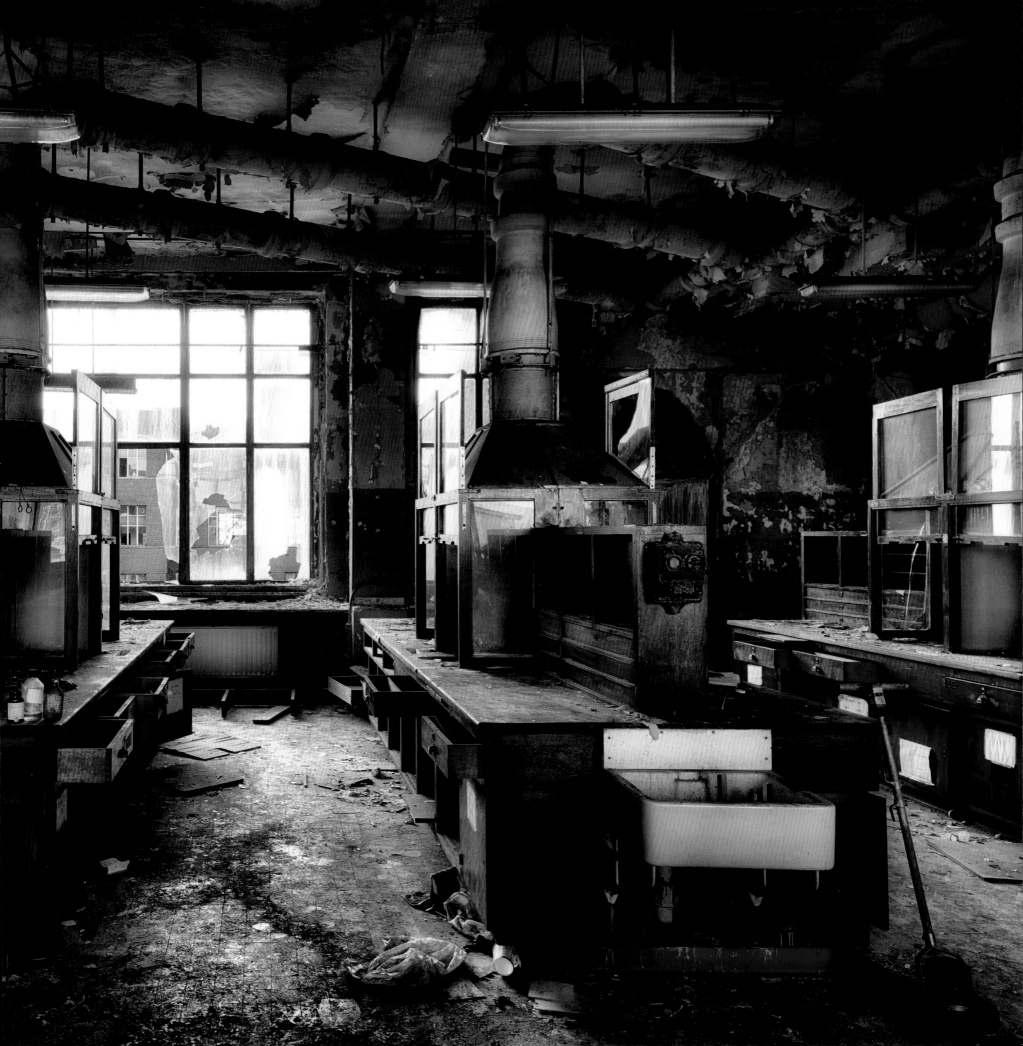

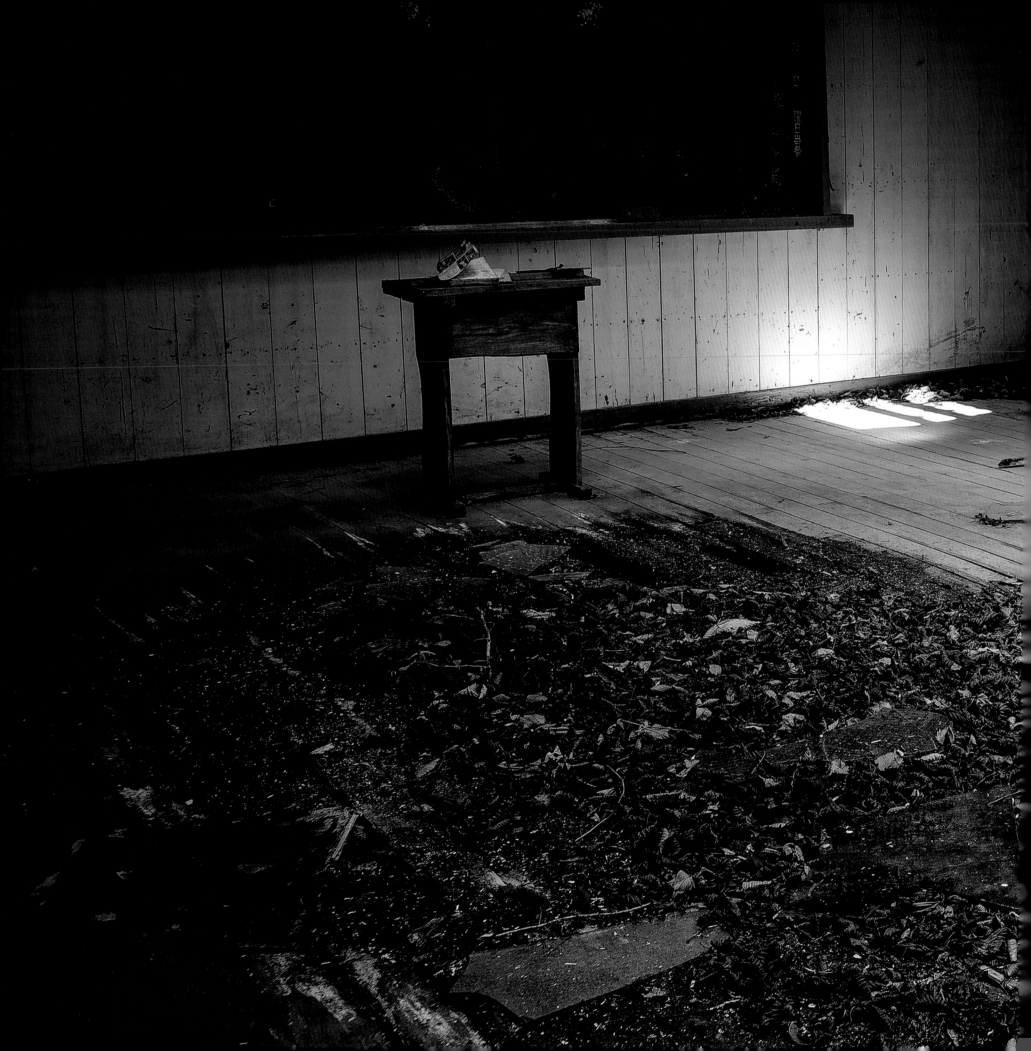

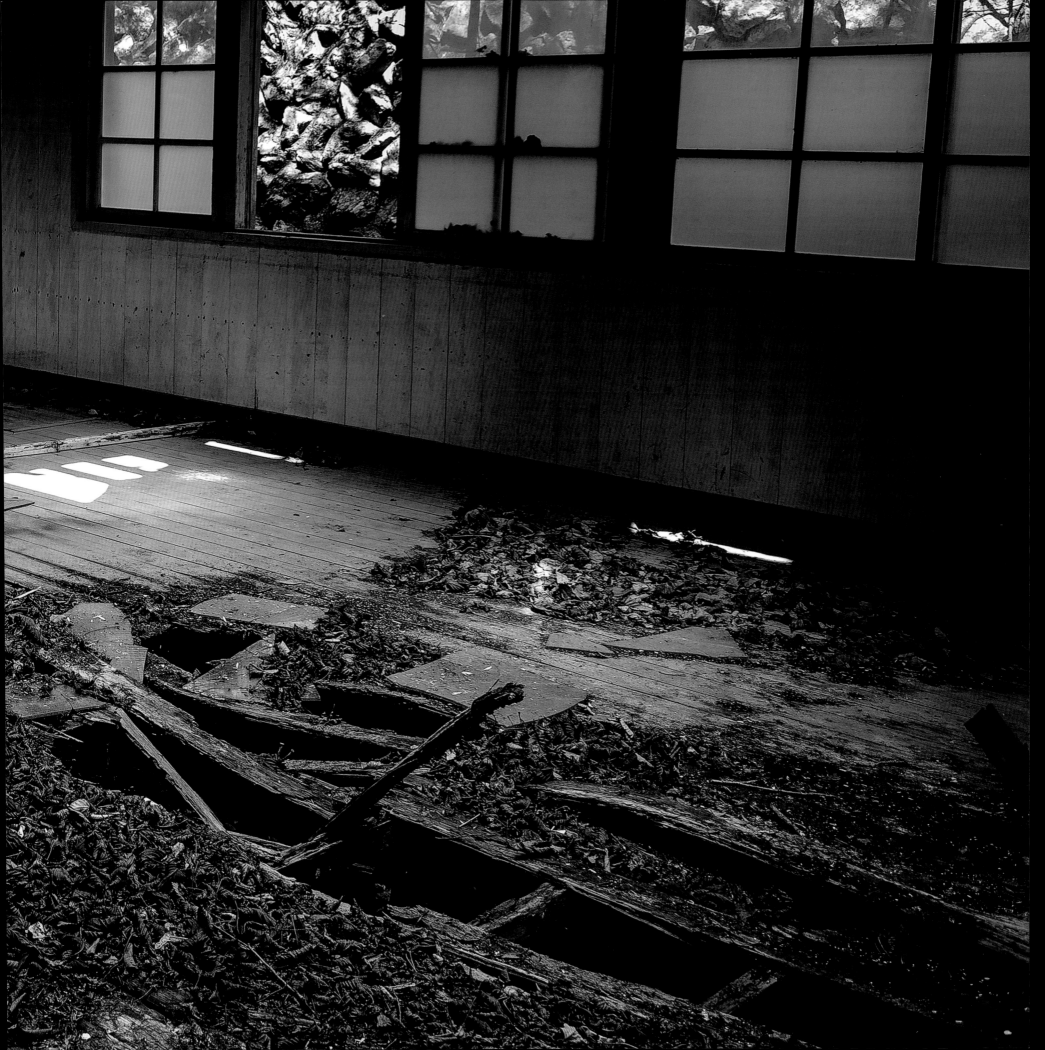

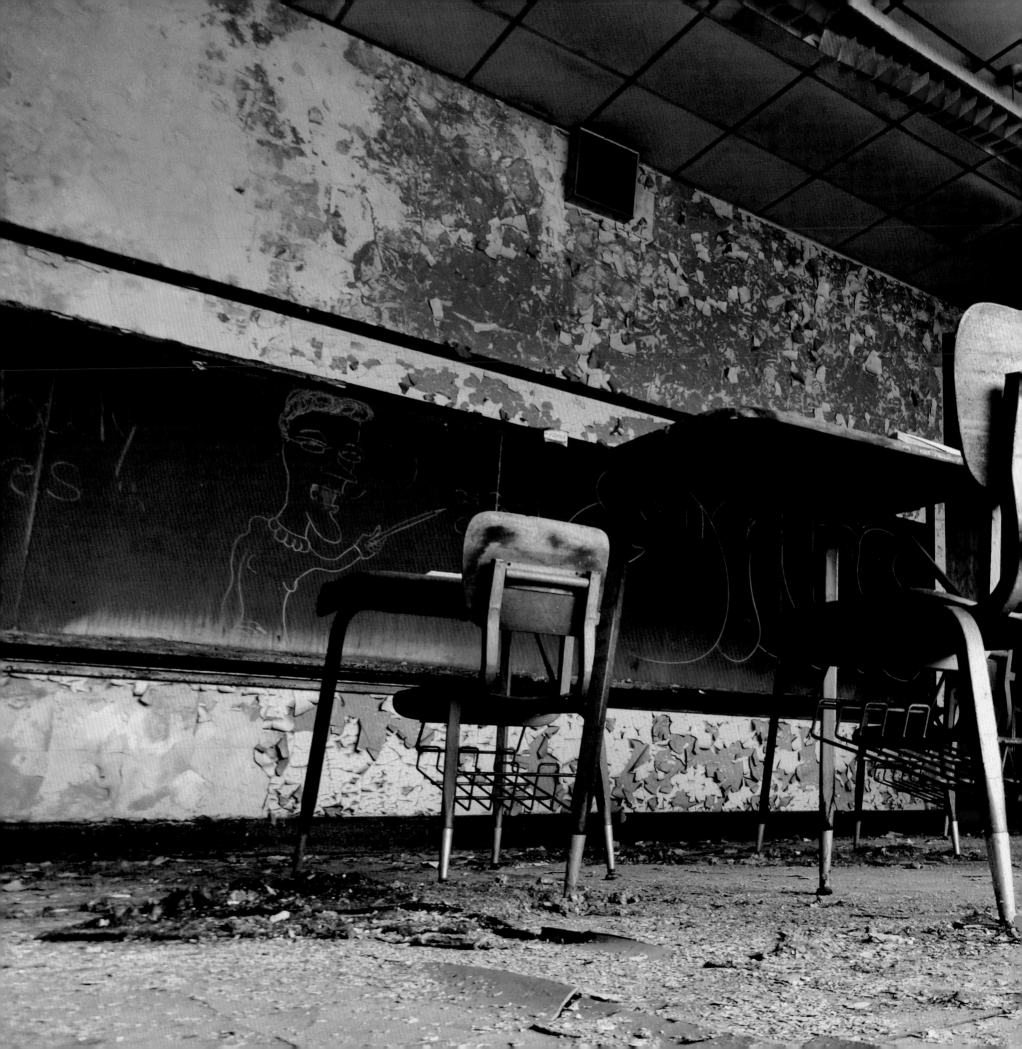

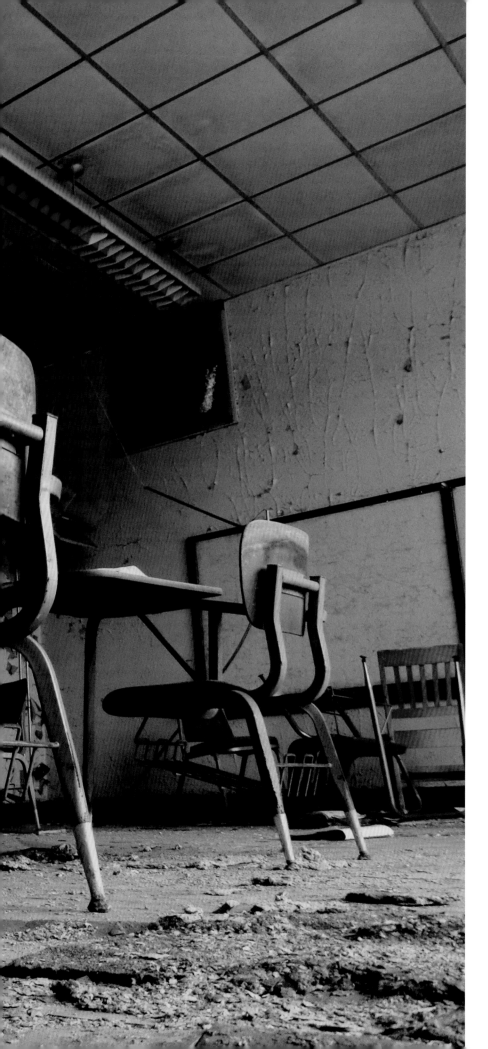

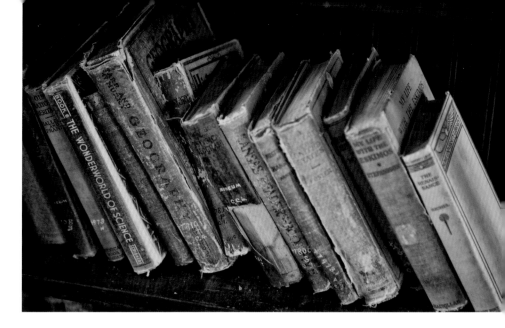

Above: Books left in an abandoned school in Kansas, USA.
Left: Abandoned school classroom in Gary, Indiana, USA.

rotting books on a shelf embodies the atrophying feel of education at its driest;

a blackboard hangs on a wall, its writing as fresh – and as dull! – as ever.

Forgotten, like so much of the learning it supposedly facilitated, a blackboard is

one of the few remains in a dilapidated classroom (*see* page 74). By contrast,

confronted with the atmospheric grandeur of an abandoned nineteenth-century

sanatorium in a school (*see* page 81), it's easy to lose sight of what its inmates

would have suffered in their daily lives. There's an ethereal calm and an eerie

light as the sun streams in through ornately pilastered windows, which makes this

place of sickness seem one of near-celestial bliss.

A cluster of chairs around a table: a university seminar room could be any

conference room. Nothing much to look at then, but a sobering reminder

of how essentially insubstantial – how eminently 'losable' – learning is.

Especially in the humanities: the science subjects tend to leave a firmer

'footprint' materially – though there may not be too much more to a college

chemistry lab (*see* page 73) than long benches, gas taps, ventilator cowls and

impressive sinks. Stands, beakers and test-tubes may confer a more distinctive

identity – until a group of kids find their way through this way and they are

left so much scrap iron and broken glass.

Next page: The island of Rhodes was occupied by Italy for much of the first half of the twentieth century.
The magnificent governor's palace was deliberately allowed to rot after liberation in 1945.

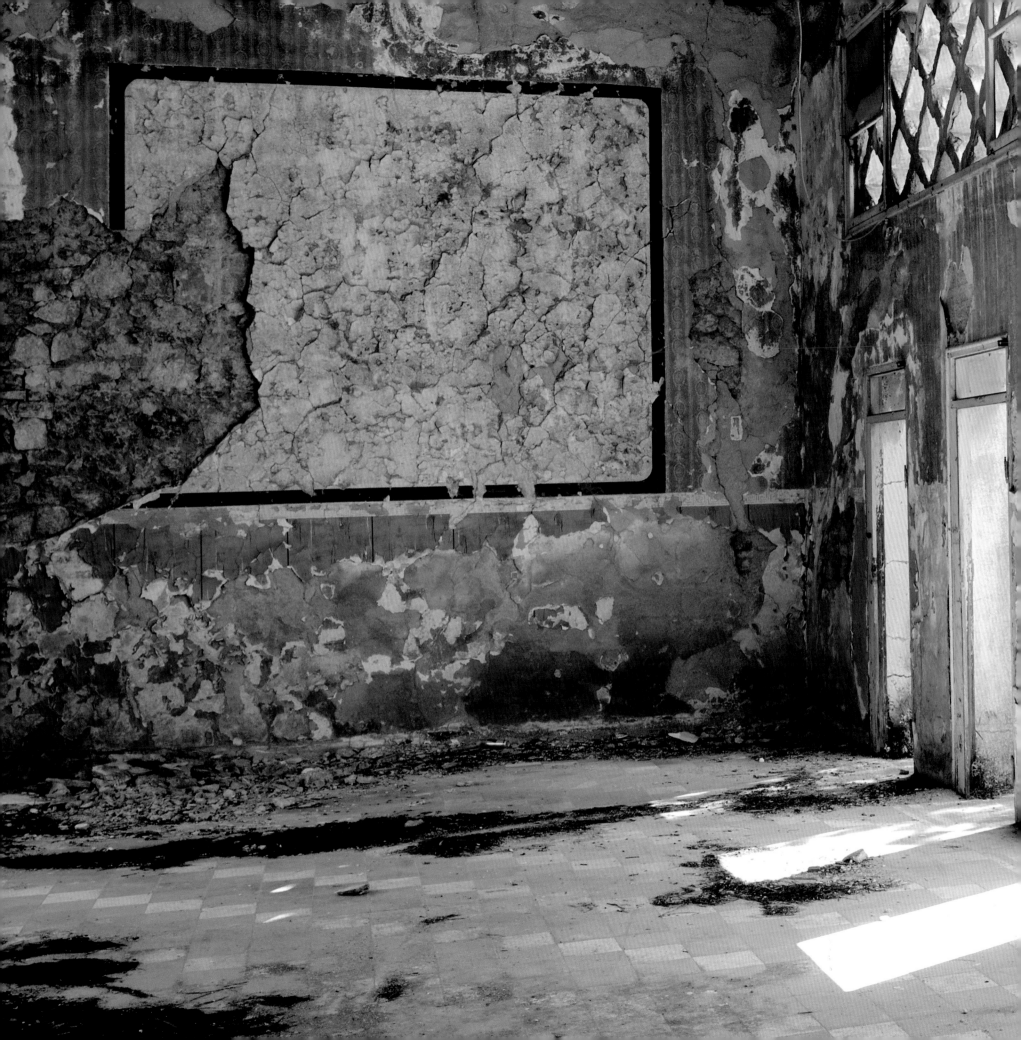

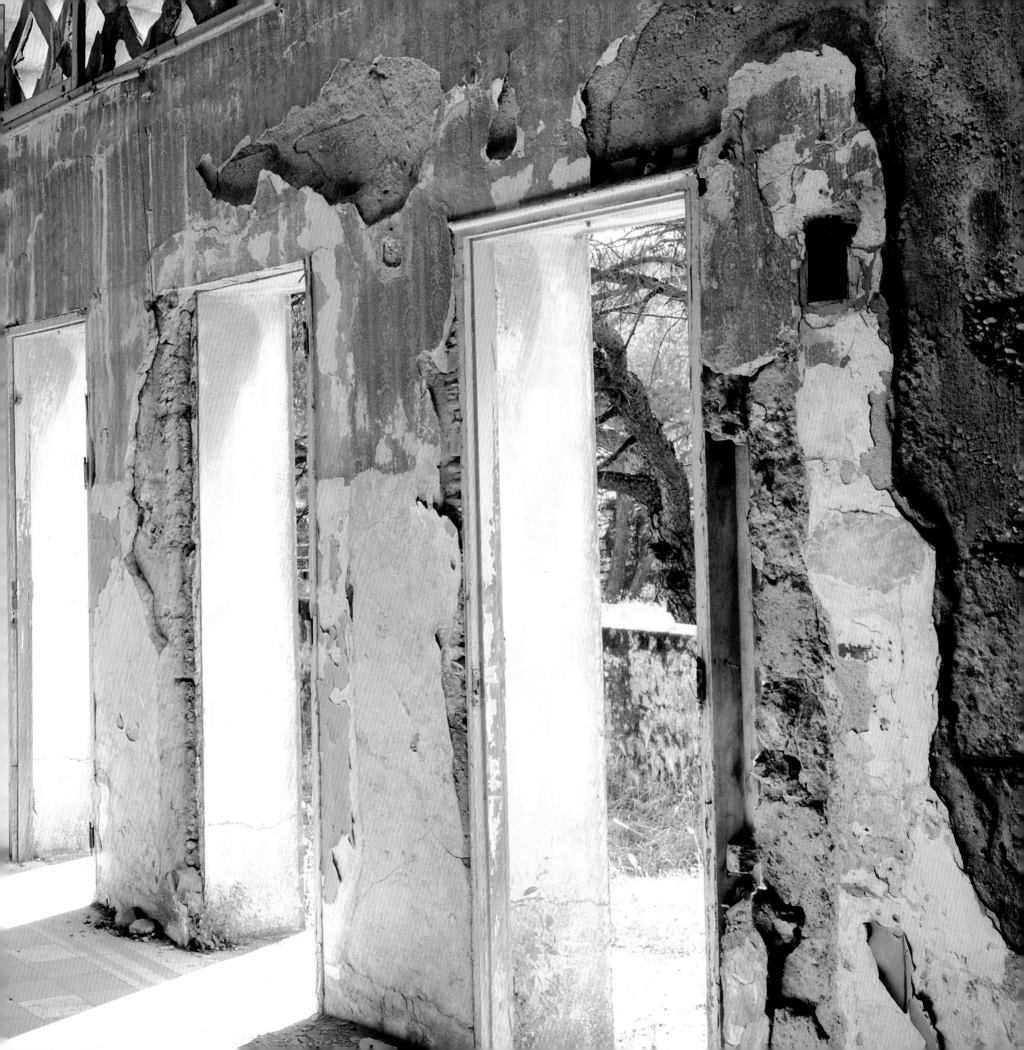

Duties of Care

Like a white suit that shows the slightest dirt, so a hospital or health centre, with its antiseptic ambience, is extremely quick to register the least neglect. A grubby window, a coating of dust upon a screen, can cast a pall of depression over what should be a light and airy ward.

Derelict Hospitals

The kind of grunge or grime we might barely notice in a disused factory – or even an abandoned house – are liable to make us shudder when we find them in an operating theatre. When a facility like this is left derelict – as one has been at Beelitz-Heilstätten, Brandenburg, Germany – it can soon seem genuinely horrific; a squalid hell hole.

This kind of contrast is strikingly represented in a radiology room in the abandoned St Joseph's Hospital, Peterborough, Ontario (*see* page 84): to a generation of patients, this was the last word in modern high-tech healthcare. (It would, of course, have helped that every streamlined surface then was sparkling clean.) In a disused hospital, a pair of yellow rubber gloves hanging on a coat hook might bear testimony to the trouble once taken to maintain cleanliness for patients' sake. Years later, though the ironwork's rusty and the wards and corridors in a state of turmoil, the white tiles of the wall behind still sparkle.

Empty Prisons

A community cares for its members in many different ways. It is arguable that a prison may be every bit as important to the people's protection as a hospital. It should even help its inmates, at least in

Right: A derelict sanatorium.

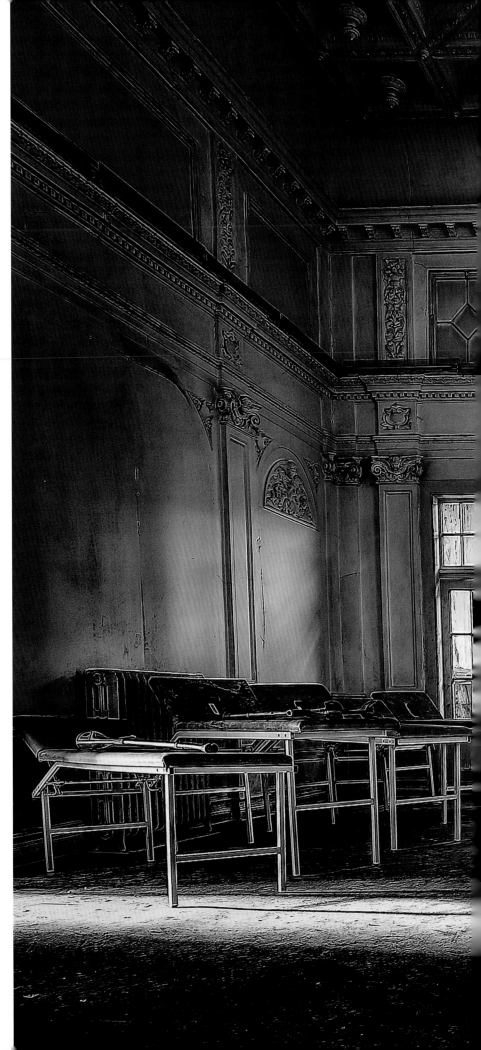

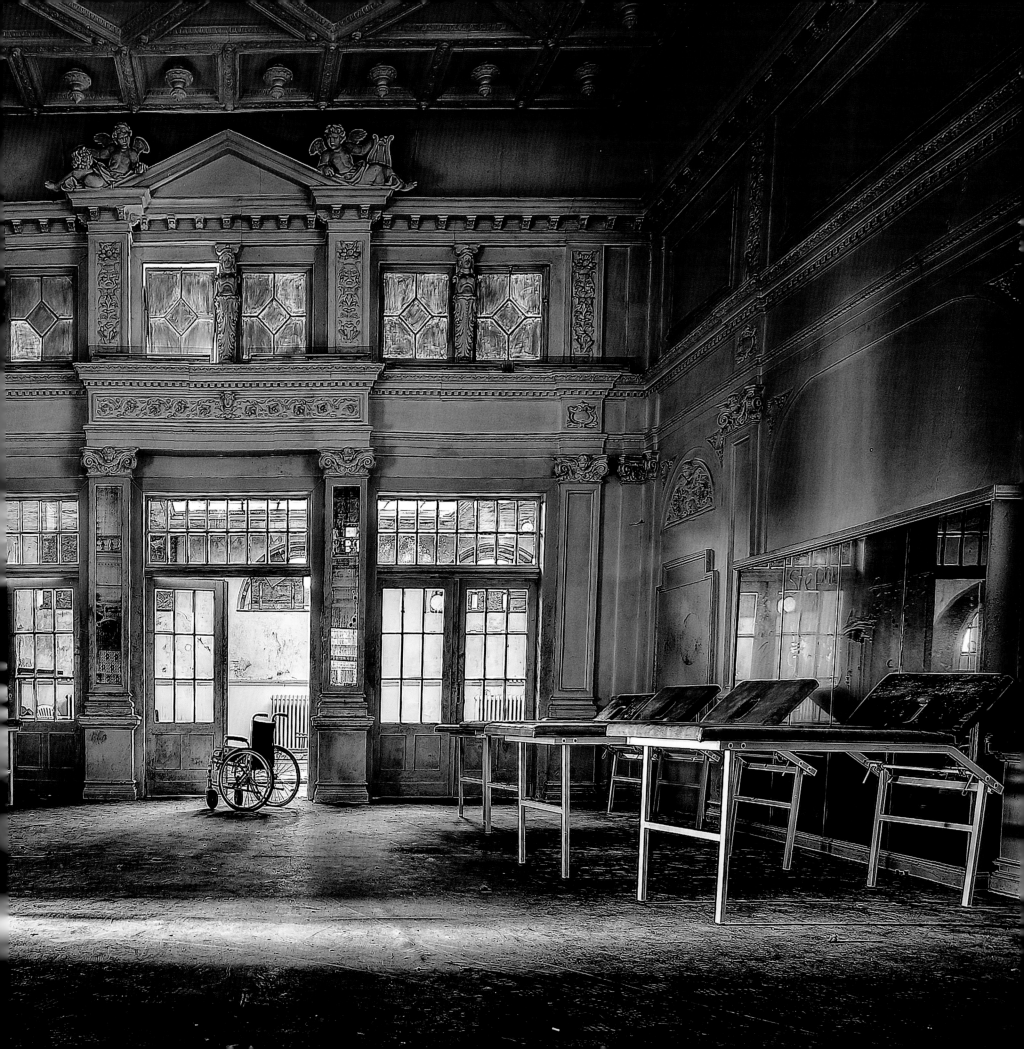

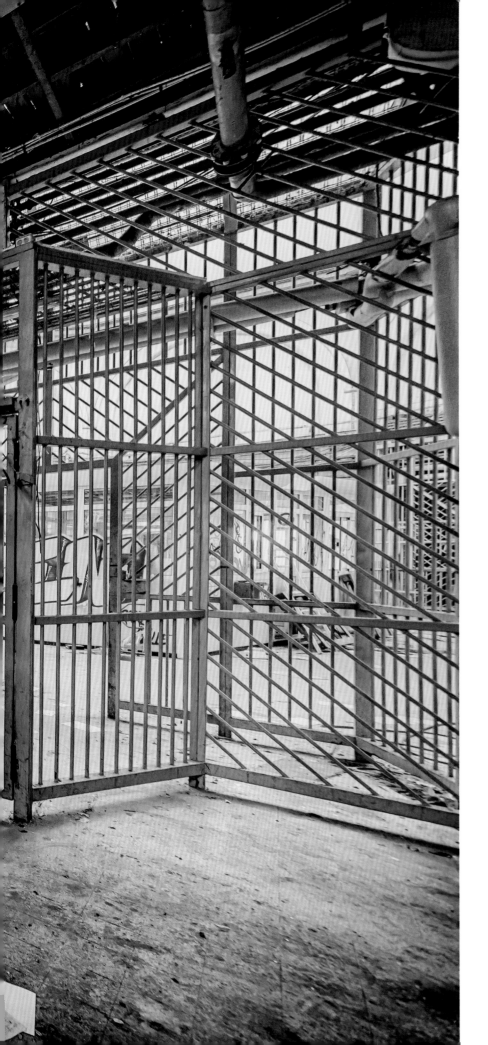

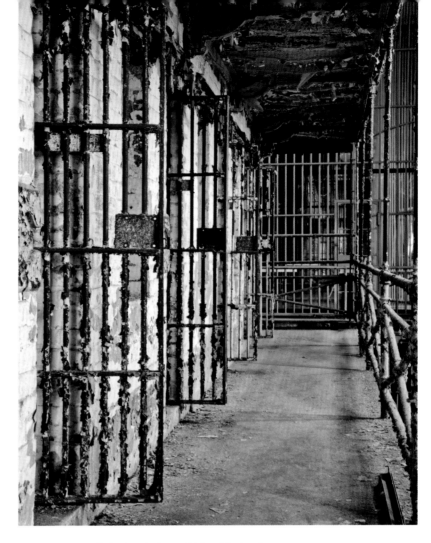

Above and Left: *The interiors of prisons which have fallen into disuse.*

wishful theory: their rehabilitation should benefit them as much as it does society. That said, few in the real world see the jail as a house of hope or set much store by the promises of the penal system. A derelict prison may not be the bedlam of echoing yells and banging that a functioning one is, but there it must be said the improvement ends. An institution that always felt inhuman – was to some extent designed with that in mind, indeed – isn't going to feel less so when its human inhabitants are removed.

On the other hand, a disused jail – especially an old one, designed to look like a medieval castle – may surprise us by looking better than we expect it to. Almost an ancient monument, it might be said. The sun and heat of the tropics can make poverty and suffering seem picturesque: this may be true even of places of incarceration in some

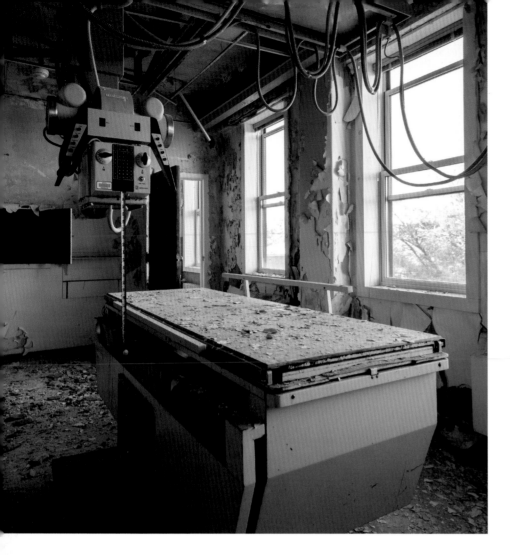

Above: Radiology room and an X-ray generator in the abandoned St Joseph's hospital, Ontario, Canada.

parts of the world. The impression might not survive a visit to – still less a term of detention in – a currently functioning prison, but it can make all the difference when the place has long since been closed.

Communist Care

In some systems, the state has taken upon itself the full range of duties taken elsewhere by a host of different public servants: the priest, the educator, the carer – and of course (and perhaps especially) the jailer. In the Soviet Union, and the Iron Curtain countries over which it had dominion, socialism had the status of quasi-religion; public services some of the aura of sacraments.

Right: Old Prison, Île Sáint-Joseph, Îles du Salut, French Guiana: Its wonderfully coloured terracotta walls showing through its post-impressionist peeling paint, this jail looks like the work of Paul Cézanne.

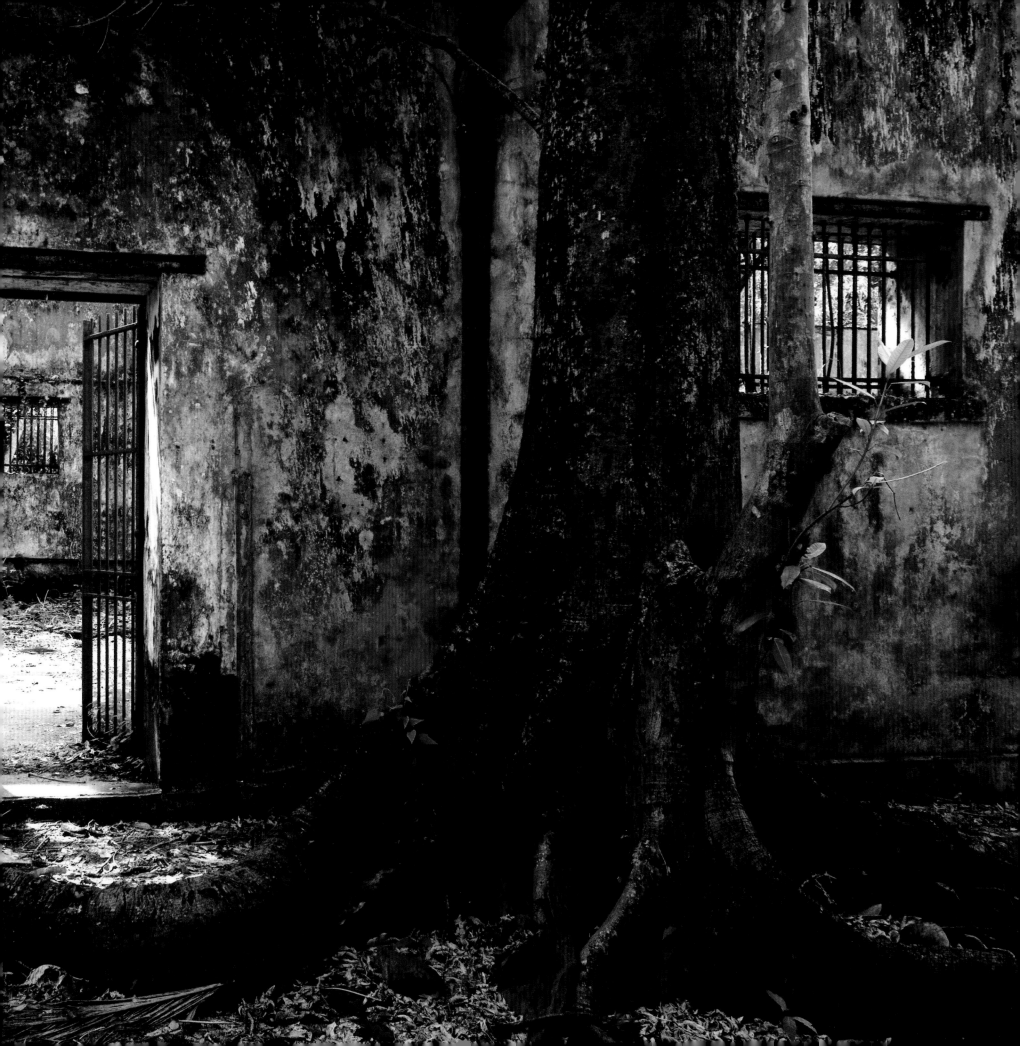

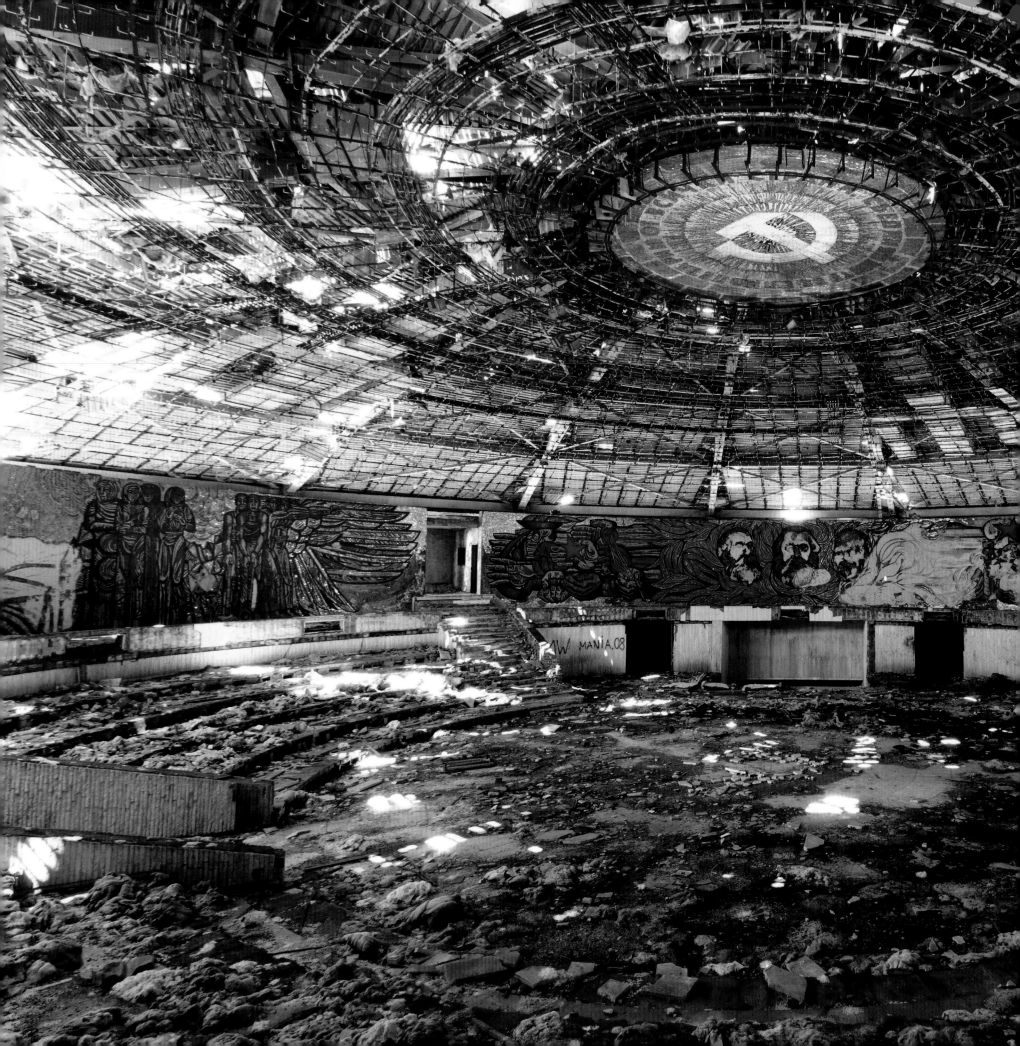

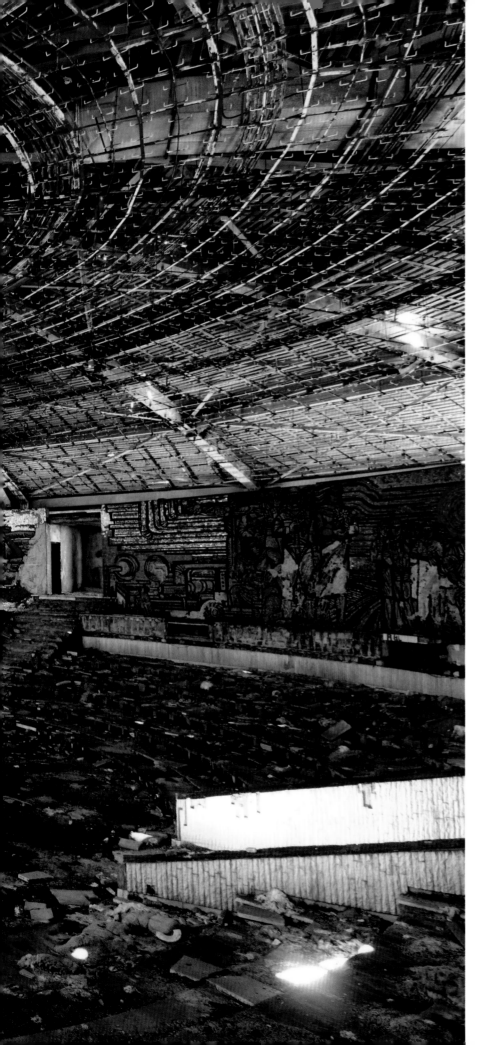

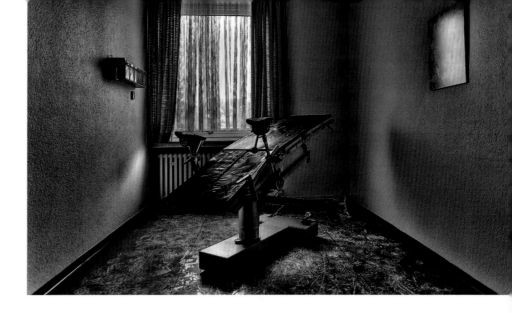

Public art was placed at the service of this cult. Monuments and memorials went up everywhere, designed and appreciated according to an official aesthetic, which gave pride of place to such qualities as 'patriotic feeling' and 'civic pathos'. Heroic soldiers fighting off fascism; strong women bringing in the harvest; mighty-biceped factory workers raising their production norms …All marched on united behind the banner of the socialist state, under the leadership of Lenin and his heirs.

Westerners like to laugh at the ubiquity of this imagery – that it was attacked with such ferocity at the time of the collapse of Communism has encouraged the sense that they were only ever tolerated through gritted teeth. And so it may have been, but other aspects of state monumentalism appear to have been more genuinely accepted: newlyweds willingly went straight to their city's war memorial after their marriage ceremony so the bride could lay her bouquet by the eternal flame.

The Soviet system was looking pretty derelict even before its collapse in 1991. A quarter of a century on, the God of Communism seems dead as well. Antiquities before their time, their Marxist–Leninist iconography almost impossibly exotic now, such memorials that still survive seem to belong to another world.

Left: Monument House, Buzludzha, Bulgaria: This flying-saucer-shaped monument sits atop a peak in the Central Balkan Mountains: it was looted and left derelict when Communist rule collapsed.

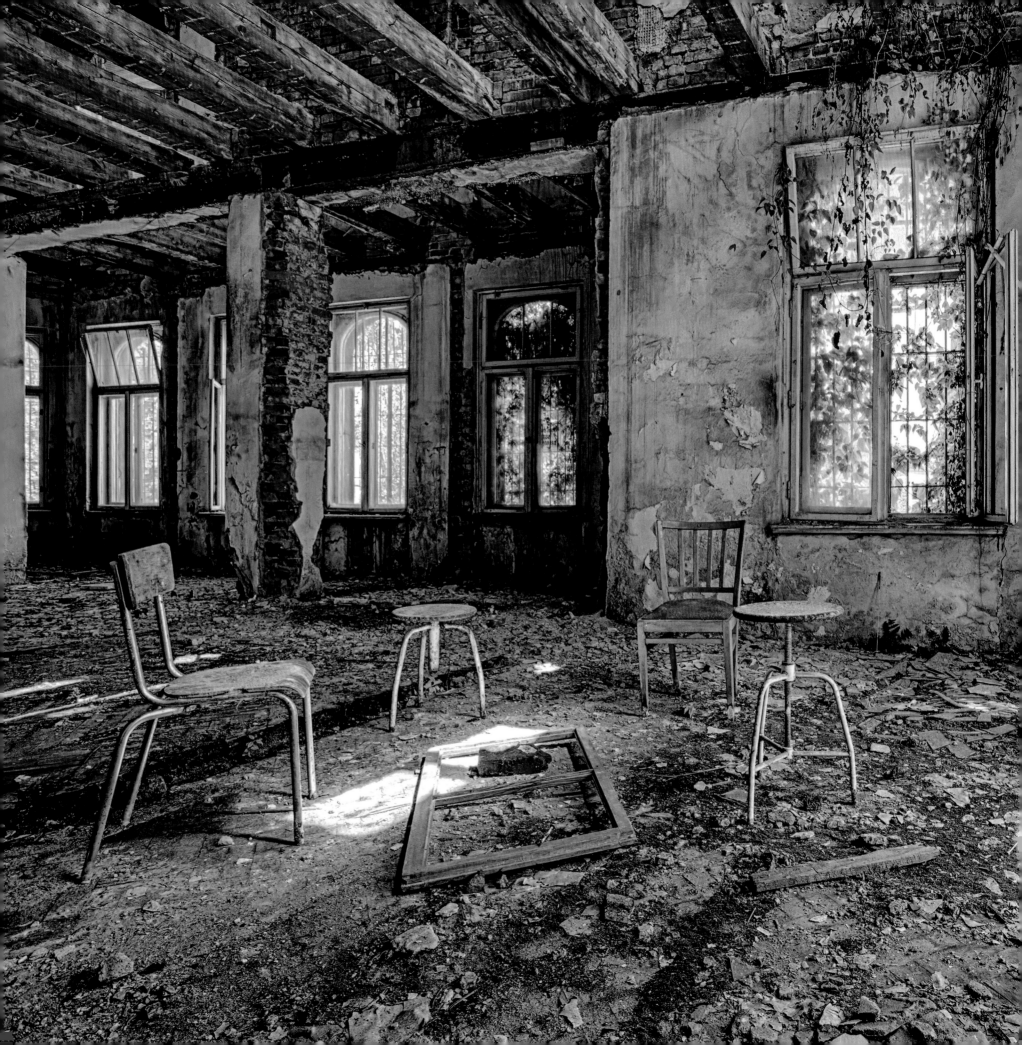

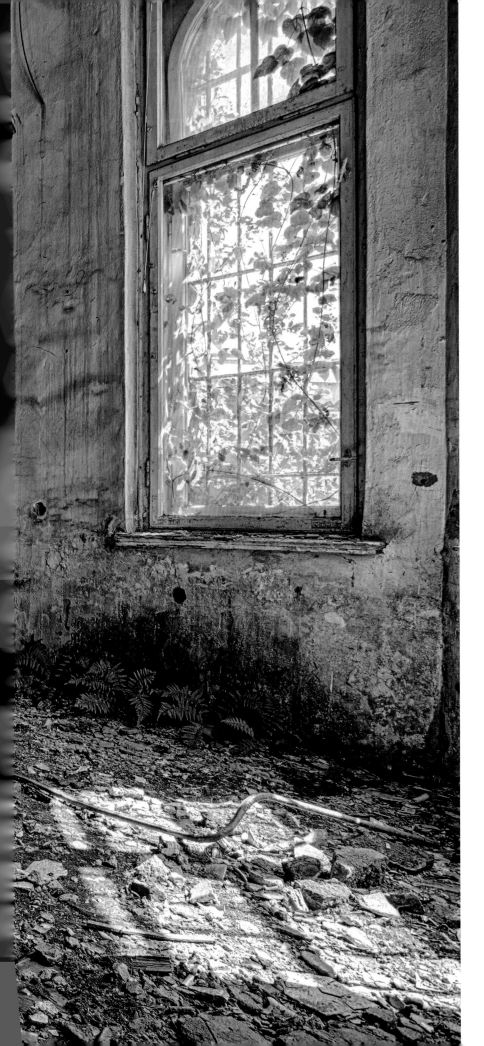

Tragedies & Disasters

When a terrible tragedy strikes, we tend to focus on the drama of the event itself: the murder–suicide that extinguishes a family; the air-raid that smashes up a city district; the mudslide that sweeps a shanty town away.

Understandably so …and yet, the moment that the dust begins clearing afterwards, more mundane – but in many ways more interesting – concerns emerge. The adorable yet anxious children; their mousy mother; the respectable father who kept himself to himself – the violence that killed them opens up a window on their lives. The bomb that knocks out an apartment building wall affords a new and unexpected view of the private existences of those who dwelt inside. Likewise, the *favela*–dwellers' abrupt transition from having very little to having absolutely nothing is, for the rest of us, an education in the inequitable workings of the modern world.

Chernobyl Forsaken

Nowhere though, is this effect more evident than it is in the aftermath of a nuclear accident like the one that occurred at the plant in Chernobyl, Ukraine in 1986. A 10-km evacuation zone, established in the hours after the reactor fire, had to be extended a few days later: soon over 130,000 people had been removed from an area of around 30 km around the Chernobyl plant. Forced to leave on the double, they left behind them an entire living environment – schools and hospitals, playgrounds, offices and factories.

Left: A few pieces of furniture and a wooden window frame are all that are left amongst the rubble of a deserted building.

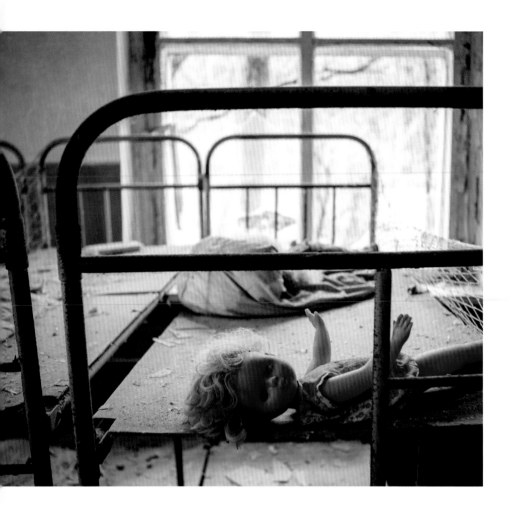

Above: Kindergarten dormitory in a village near Chernobyl, Ukraine.

All remained, poised, almost exactly as it had been on that day when the emergency sirens sounded as the reactor spewed radiation, like Mount Vesuvius had rained ash upon Pompeii. Here, just as in that ancient city, life came to an abrupt and complete stop. Instead of being instantly entombed in white-hot ashes, they 'escaped', only – in too many cases – to be ossified more gradually and painfully by the effects of cancer gnawing away at them from within. There are no Pompeii-style, twisted white corpses here, but we have a grotesque reminder in the form of a pink plastic doll left lying splayed, hands piteously raised, on a bedstead in a kindergarten dormitory (*see* above).

Right: The prospects and possibilities of a generation were snatched away at Pripyat after the Chernobyl accident, as the rows of empty cribs in this abandoned day-care centre remind us.

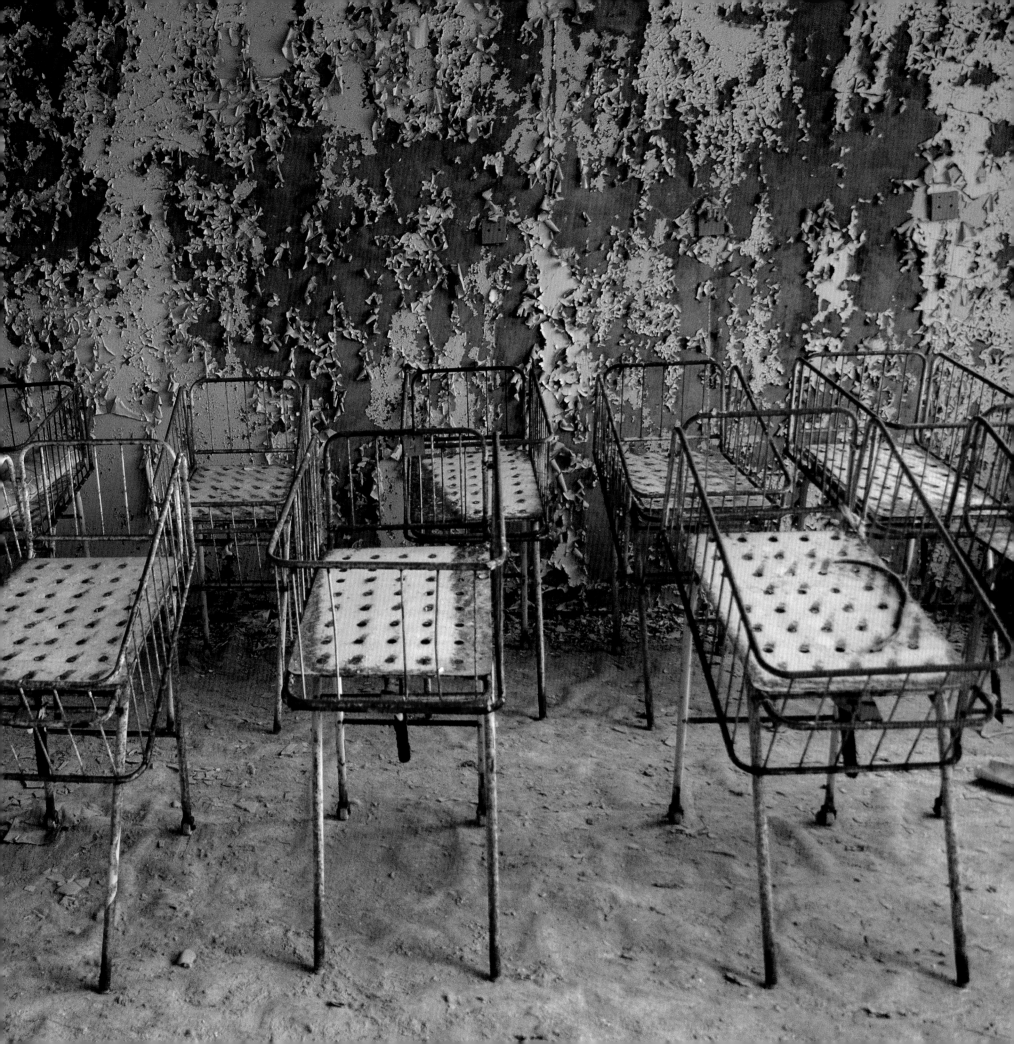

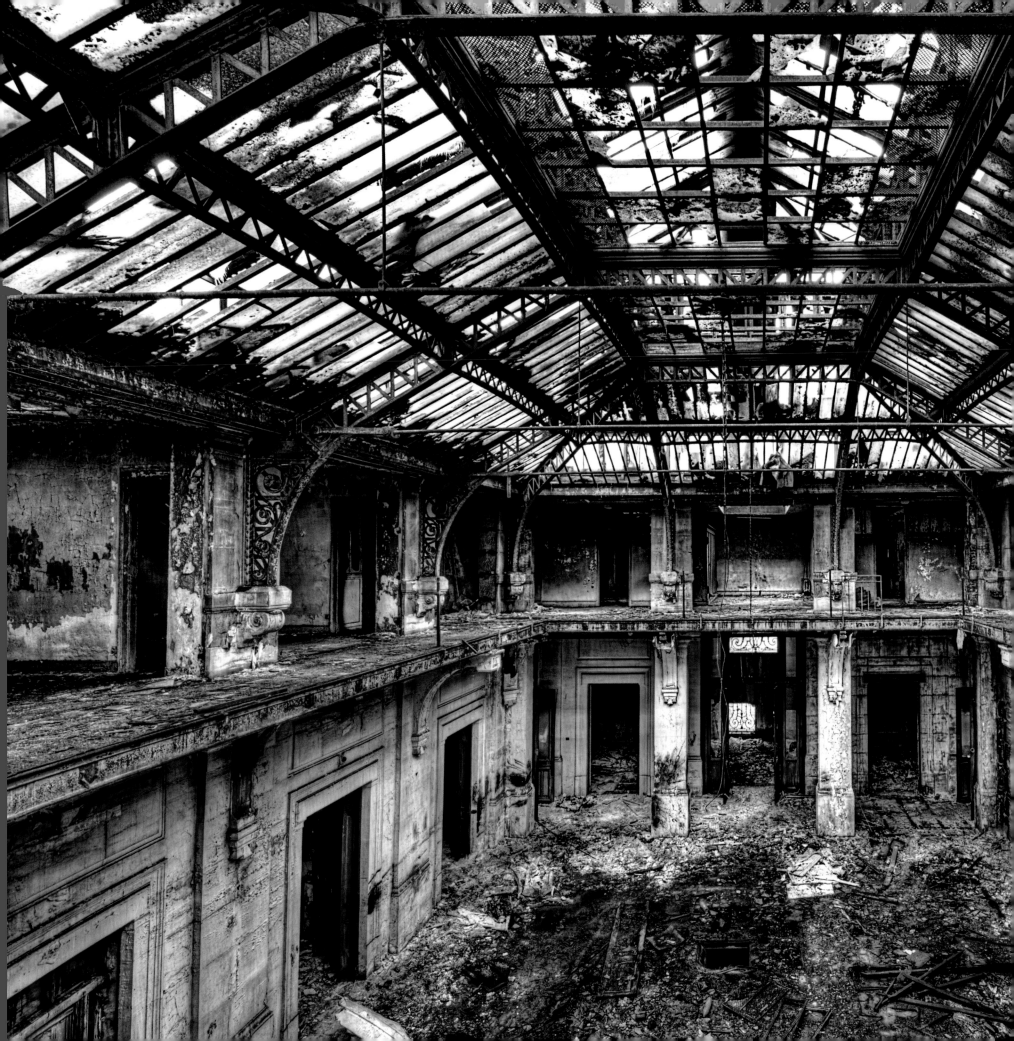

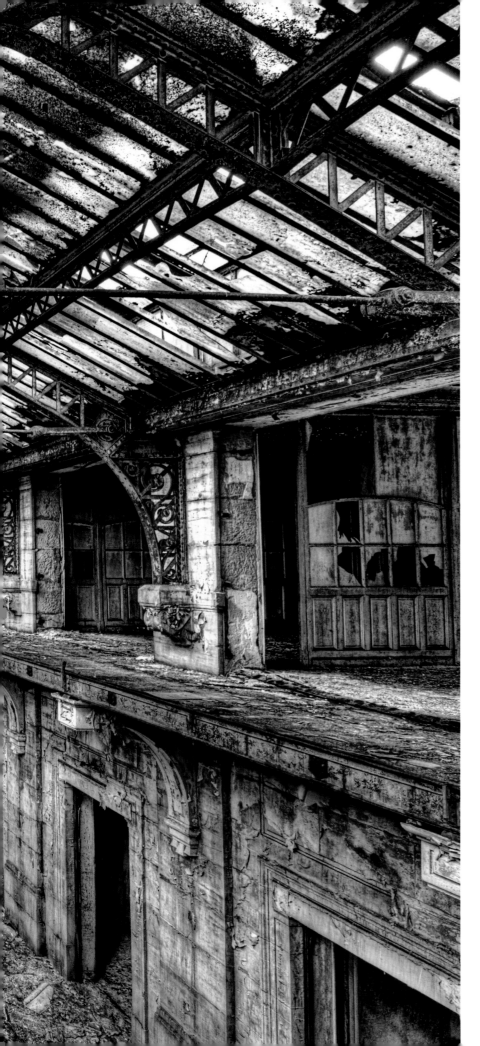

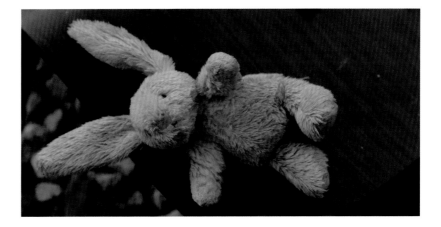

Above: *A stuffed rabbit left behind during the demolition of the Jungle at Calais, France.*

Fukushima Freeze-Frame

At Fukushima, Japan, in 2011, the meltdown of a pair of nuclear reactors compounded the crisis caused by the natural disaster which had triggered it: a devastating tsunami on 11 March 2011. The damage caused by the great wave in coastal communities had been spectacular: at the flooded plant, by contrast, there wasn't much to see. Nor, insidiously, was there anything visually to show for the calamitous failure of the reactors' cooling system and the leak of radiation that ensued. Across a 20-km exclusion zone, entire communities had to be evacuated at a moment's notice, leaving their houses, shops, offices, classrooms, exactly as they were. These places have remained, their workaday routines captured in vivid (if unpeopled) snapshot; an ordinary day suspended as if preserved in amber.

Sometimes though, the tragedy leaves a mark that's only too clearly visible. The village of Goussainville-Vieux Pays, in the flight path for Paris's Charles de Gaulle Airport, was left traumatized by a terrible plane crash in 1973. The destruction of several houses and a school – and the loss of a number of lives – proved impossible to negotiate for the community. Within a year or two, it had been entirely abandoned.

Left: *The magnificent glass roof inside the hall of this abandoned central office helps to makes this an image of desolate beauty.*

Work Spaces

Few, let's face it, have ever found the idea of public administration exciting or inspiring. Yet we couldn't do without it, and it – surely – has its dignity. Isn't there a certain austere beauty about an abandoned office like that to be found in a Los Angeles building – but generic enough to be absolutely anywhere? The fake-wood desk, the monitor, the window with its blind, the filing cabinet: modern, but timeless too. The harassed executive who had this office could have clocked off no more than a minute ago; we could imagine his successor walking in at any time. Even the historical Governor's Palace on Rhodes (*see* page 78), although built during the time of Italain occupation, has a certain beauty in its decaying state.

Filed Away

Bureaucrats are by conventional definition 'faceless', so it hardly seems so strange to see an office unoccupied. The environment is bleak at the best of times. In dereliction though, there's a trade-off between cold institutionalism and cheerful clutter – the former intimidatingly impersonal; the latter – at least ultimately – oppressively untidy.

As boring as they no doubt are inside, the documents piled up on the shelves of an abandoned corner of the Municipal Archives, in Puy de Dôme, in France's Auvergne (*see* page 98), have a look of distinct promise – a damp and mildewed treasure trove. When an office is left as messy as this, over many years its perishable contents compost down to a sort of mulch. An office in Chemnitz, Germany (*see* page 95), with its ceiling collapsing,

Right: Decayed office room in Chemnitz, Germany.
Next page: An abandoned hospital.

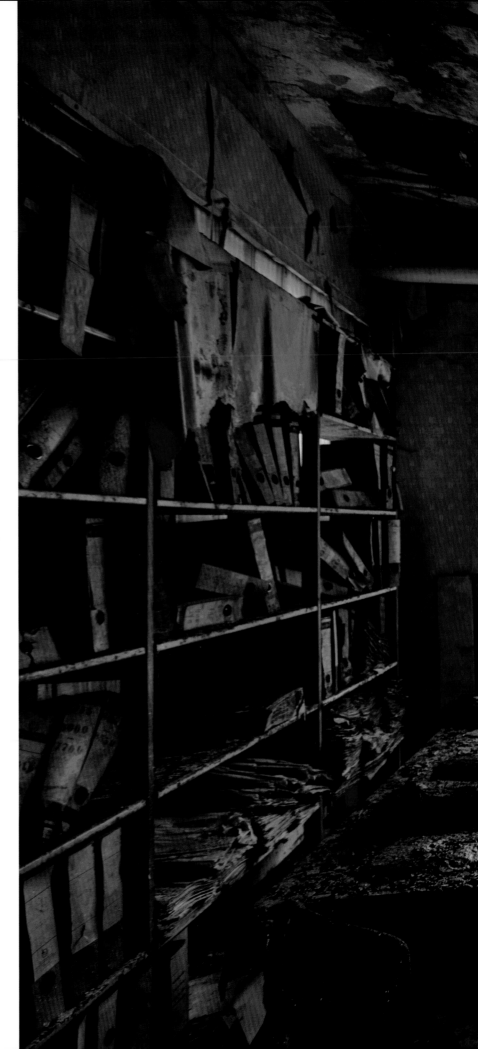

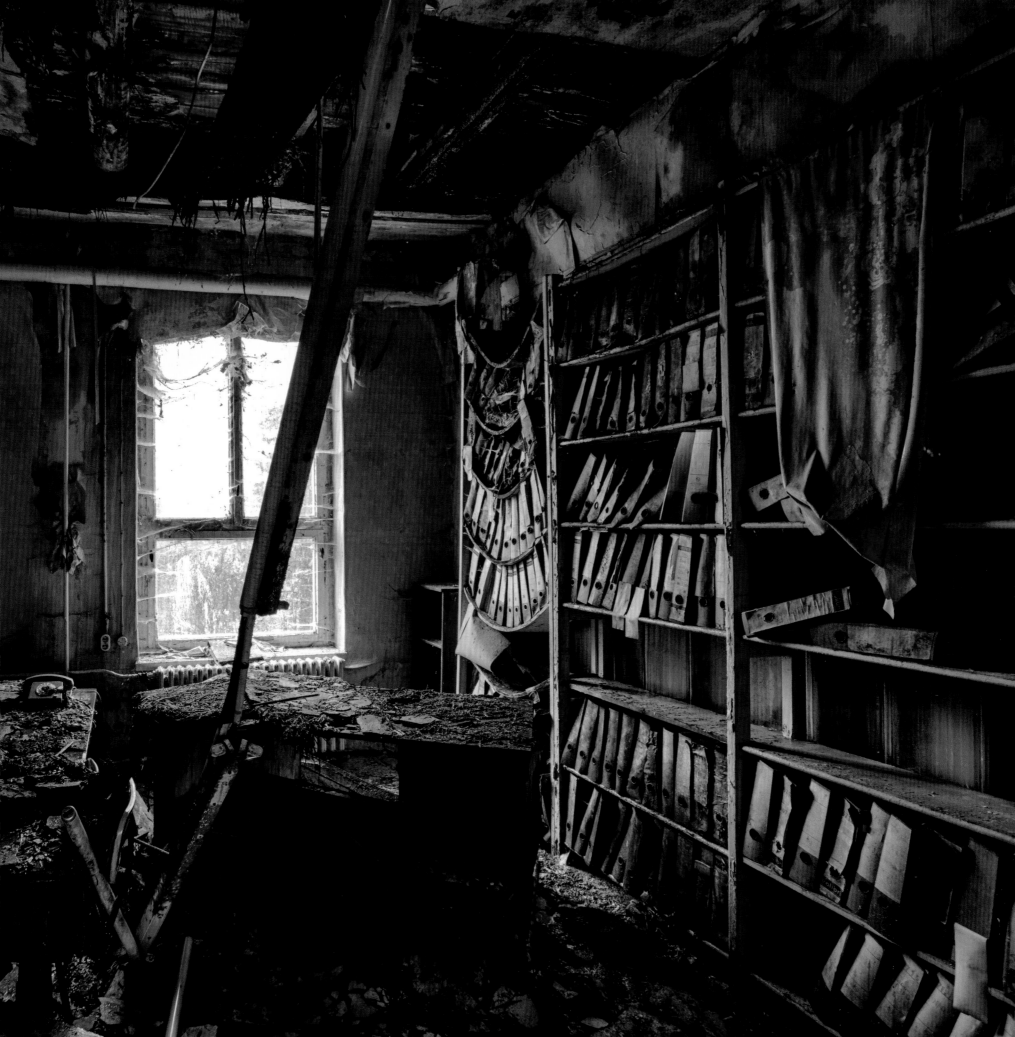

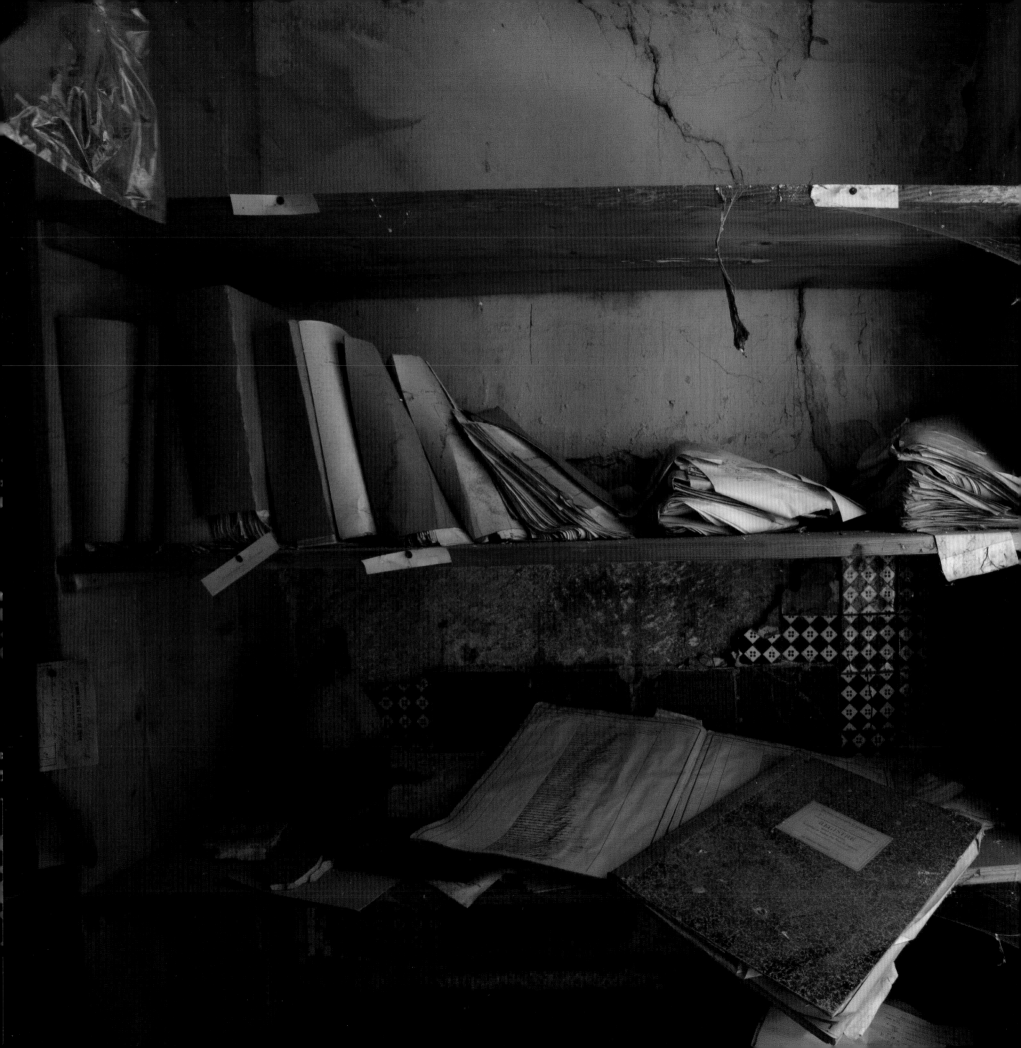

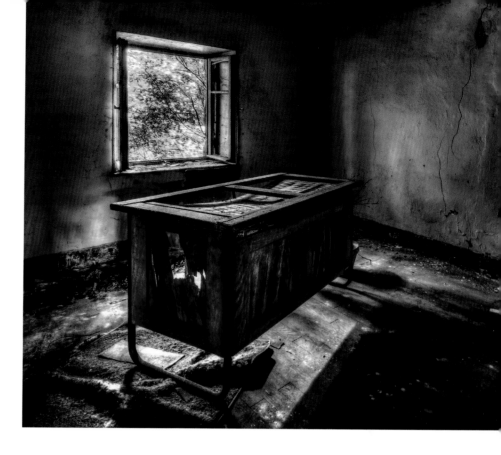

Above: A desk is starting to decay in this office, which has fallen into a state of disrepair.

its floors and its worktops thick with debris, forgotten files buckling together on its sagging shelves, disintegrates before our eyes, a working world dissolving into a symphony in dust.

Dereliction of Duty

The sense of melancholy we experience in a derelict building is to some measure our mourning for our mortality: as this place is now, so we shall be some day. It's never really that simple though: we surely feel regret for the present too, for those social ties that are supposed to bind us all but plainly don't. And that, we have to acknowledge, is a failure on our part. Ideology scarcely enters into it: the conservative feels as strong a sense of the communitarian connection as the leftist does of capitalist society. For none of us do things feel quite the way they should.

Left: Municipal Archives in Puy de Dôme, Auvergne, France.

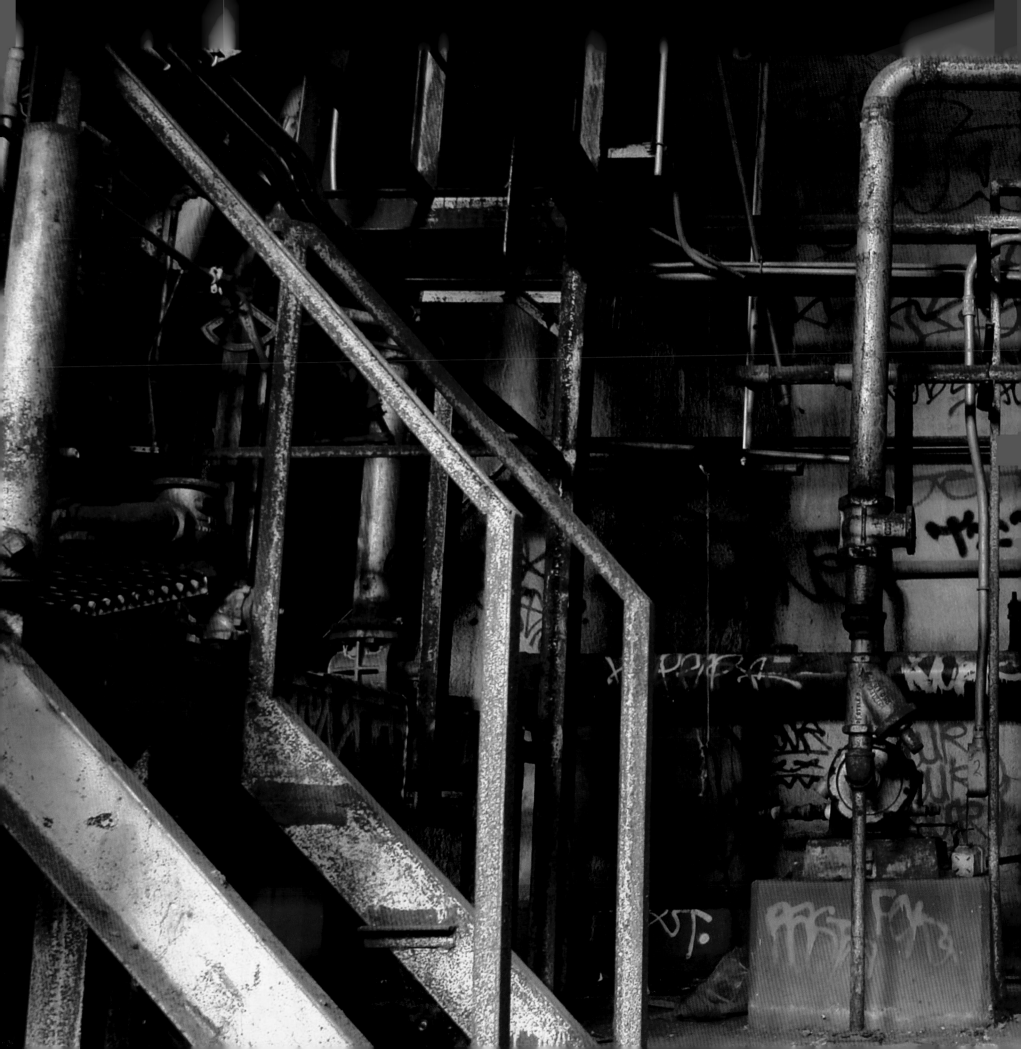

Industrial
Places

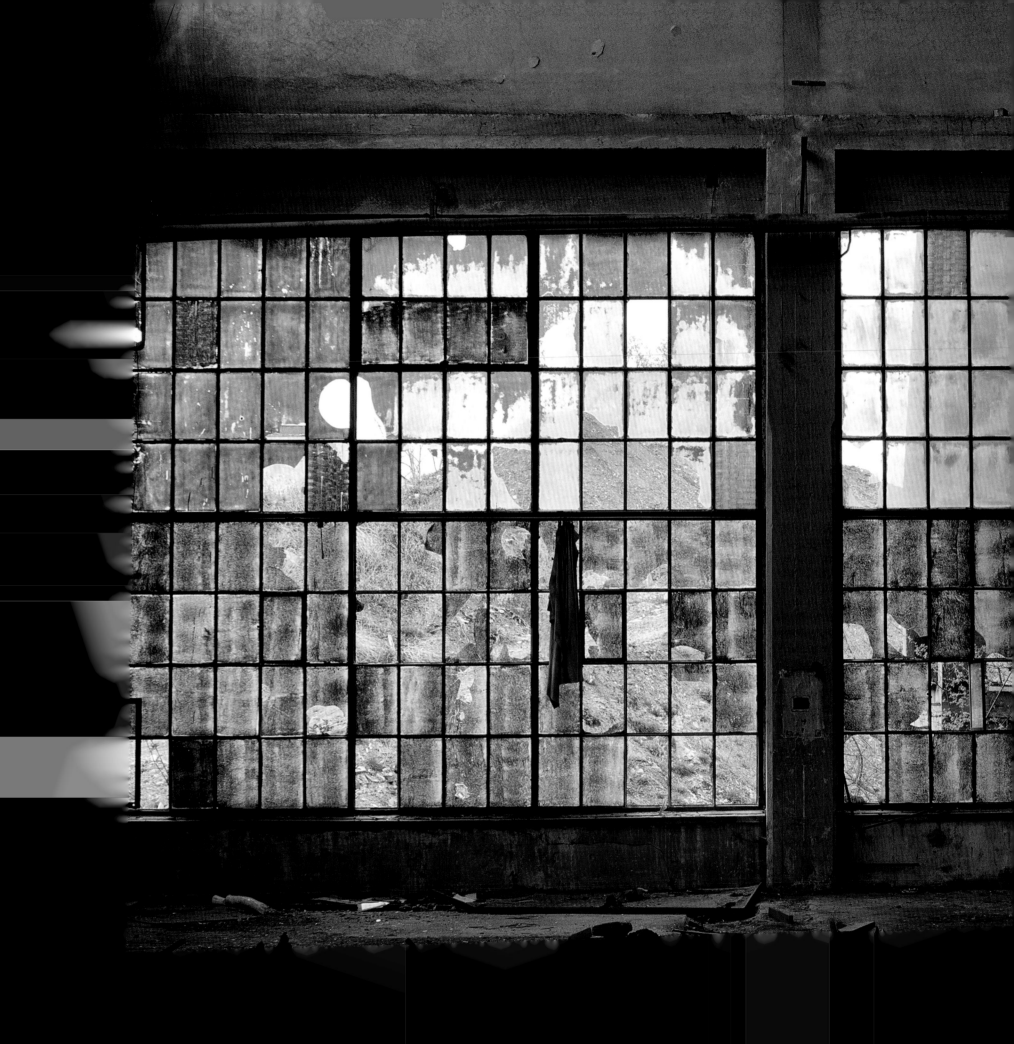

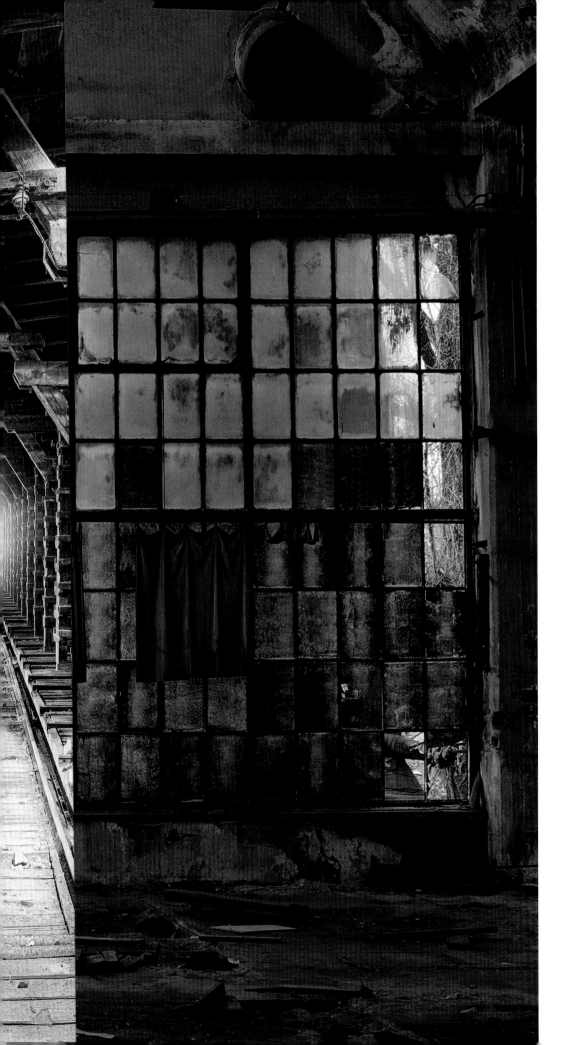

Picturesque Abandon

The **broken windows** in an abandoned East St Louis factory are an accidental artwork (*see* page 119); peeling yellow paint gives a post-impressionist glow to an old Atlanta warehouse wall (*see* page 142). Tools lie around no longer used: in their now-eternal inertia they seem to belong to some still life by Zurbarán. Elsewhere, oil drums lie clustered – a blaze of rusty orange set off by the corpse-like grey of a corrugated-iron wall with blackened broken windows (*see* page 120). Brightly-coloured pipes snake off into the distance in a corroding deserted factory (*see* page 138). Who would ever have thought that such unpromising places, such mundane things, could ultimately acquire such beauty? 'Left to itself,' mused the Irish poet Derek Mahon, in a disused garage in County Cork, 'the functional will cast/ A death-bed glow of picturesque abandon.'

Industrial Detritus

Any industrial project, from a factory to an oil refinery, from a power plant to a parking garage, is – as some would have it, an 'enterprise'. It is, in other words, an undertaking: a creative act; a 'work' in artistic as well as economic terms. A writer might call it an 'essay': at once a declaration of intent and an attempt to deliver on it. We can't help responding to the act of faith and courage such a venture represents. Only over time though, do we generally see the aesthetic appeal in it. And, ironically, by and large only after its primary economic purpose is obsolete. One day, all of a sudden, when it's already deep into its decay, we realize that it's become an integral part of its scene – and ours. 'The landscape is riddled with failed promises,' writes Ted Hughes

Previous page: *Abandoned tuna canning factory, San Francisco, USA.*
Left: *Broken windows in a factory hallway.*

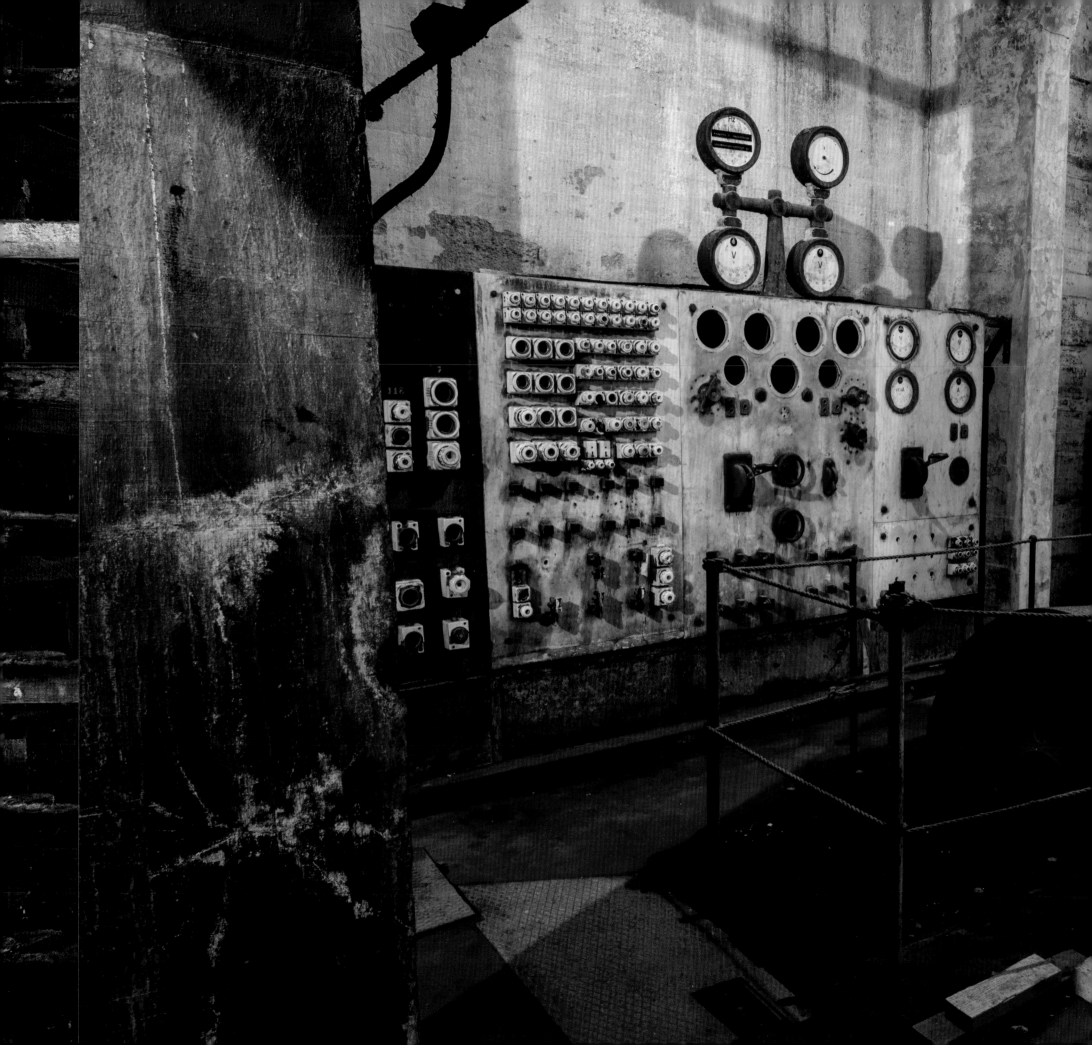

of the abandoned mines and mills littered about his native Yorkshire – but is it really failure, or the fulfilment of a different kind of promise?

Bricks heaped up in random piles in a vast and otherwise empty shed: did anything ever look so arbitrary before? A glass-fronted supply cupboard in an abandoned mill, a vision of redundant order: we see the regularity, but where's the reason? The subdividing panes of a vast workshop window (*see* page 102) reflect a mosaic of different coloured light: it's unusual, it's intriguing, but is it art?

The greenery growing among the old locomotives and rolling stock in a disused rail depot gives the place a pastoral touch: but what's the story? Once, we can only assume, the trains came and went, with work to do and routes to ply; now they just sit here, apparently no use even for scrap metal. Its vaulted roof arching over railed walkways, tracks for trolleys and a floor of ashen grey, an abandoned old ore silo is a vision of ancient Hades. An empty tuna canning factory in San Francisco (*see* page 100) presents a puzzle of piping, hoppers, vats and gantries; the purpose of a herring plant in Iceland is still more obscure (*see* left).

Left: Herring factory in Djupvik, Iceland.
Next page: A former silo for ore.

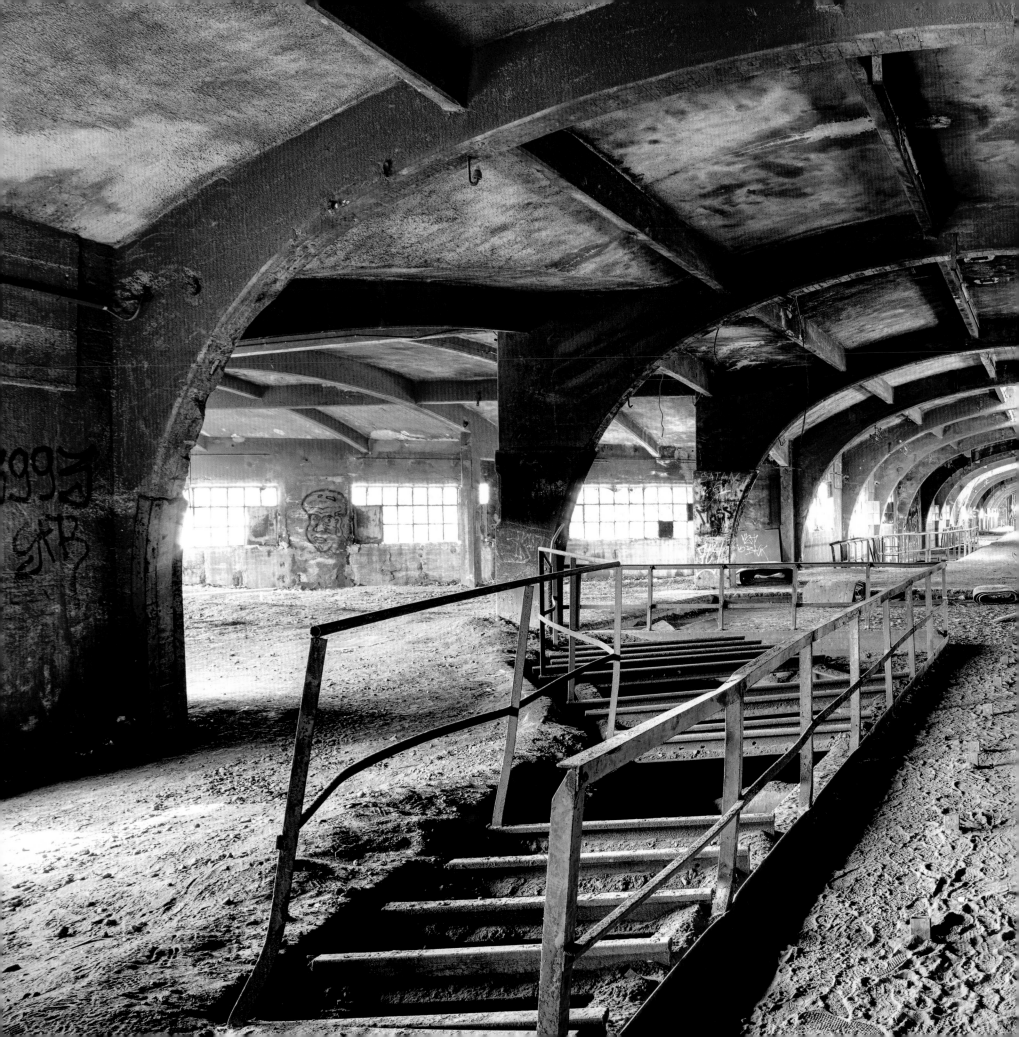

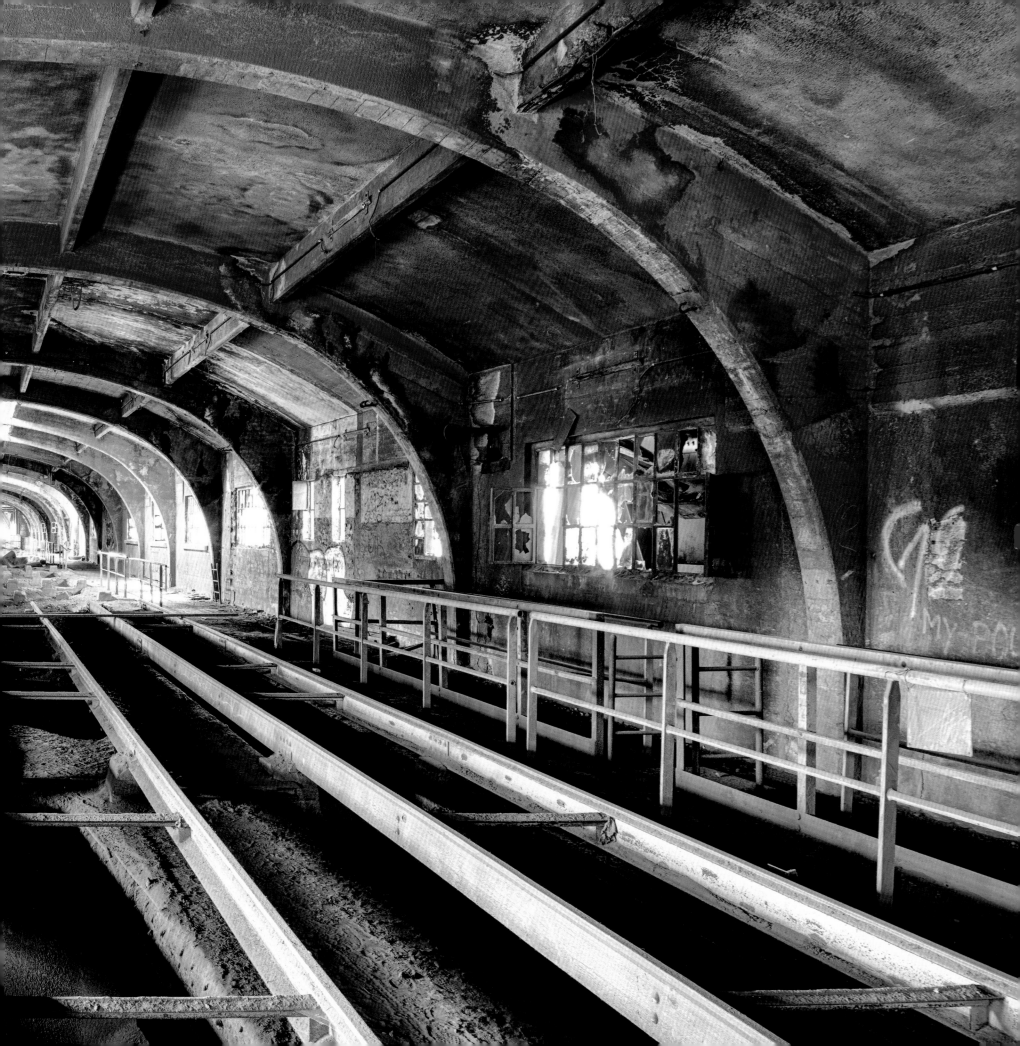

Factories & Warehouses

A poem,' said **Paul Valéry,** 'is never finished …only abandoned.' Much the same might be said of an industrial site. Its functioning life, effectively a continuation of the industrial work that went into building it; its long, slow deterioration thereafter may be seen as a further stage in that same long process. What once was a construction project, and after that a place of work, now has a new function, a new task of gradual disintegration. And, for us who see it now, a new life as an antiquity, a feature of the landscape, a man-made mystery to be explored.

And in exploring it we see it fresh and, with a little imagination, recreate it. Look around an abandoned factory; pace its echoing passages and empty halls. The internal walls are mostly gone, but in what was once the washroom, a splash of lurid colour beneath the basins is a bright spot in an infinity of grey. In a former factory, staircases soar mesmerizingly away above us in Escherian elegance (*see* page 140); meanwhile elsewhere a more modern, brutal flight carves up our view of a ruined boiler house in Berlin (*see* page 144).

Work in Regress

An abandoned Soviet electronics factory in Novovoronezh, Russia (*see* page 112) can be seen to be slowly being reclaimed by nature, green shoots of life fighting through. Elsewhere rails run at right angles through lines of racks in the storage section of an old lime kiln (*see* page 104). The control room of Djupvik's herring factory in Iceland (*see* page 106), by contrast,

Right: Street art in an abandoned pharmaceutical factory in Rome, Italy.

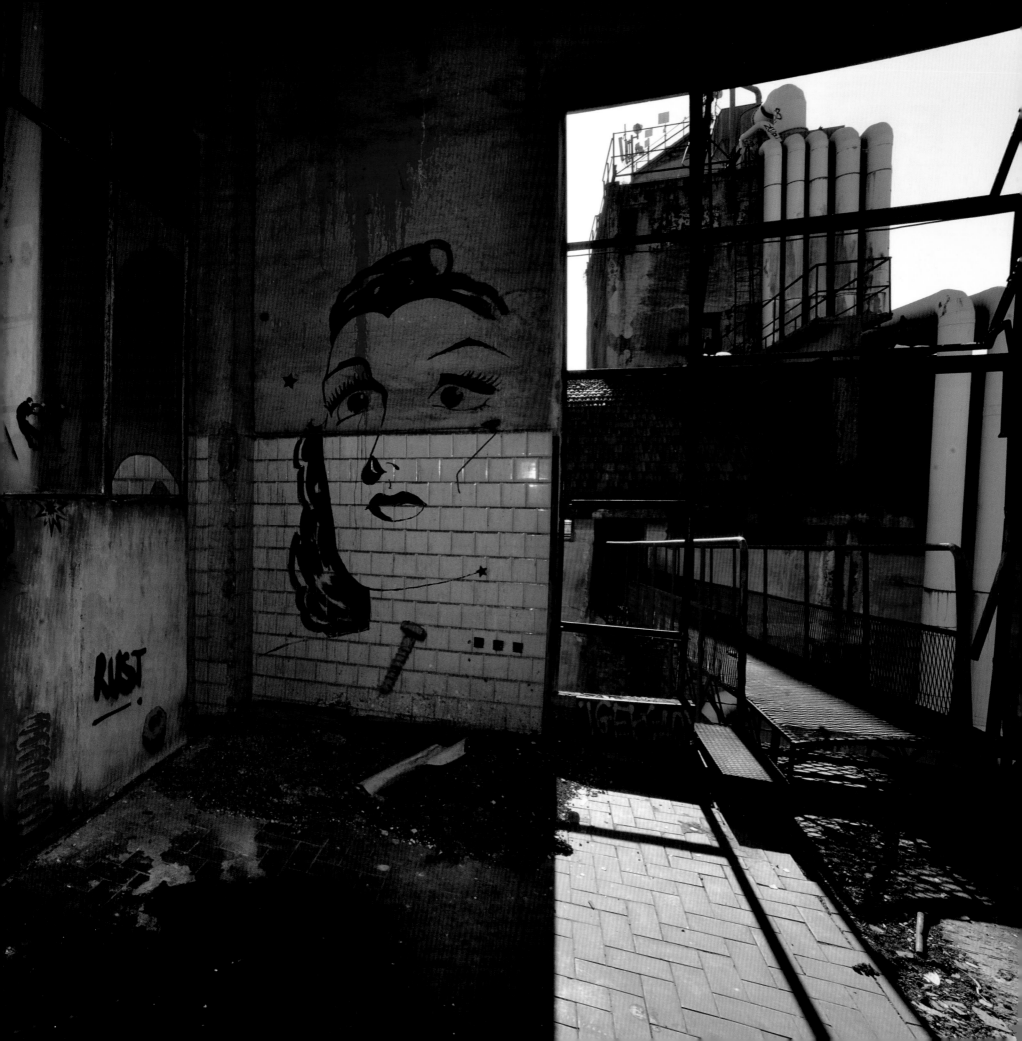

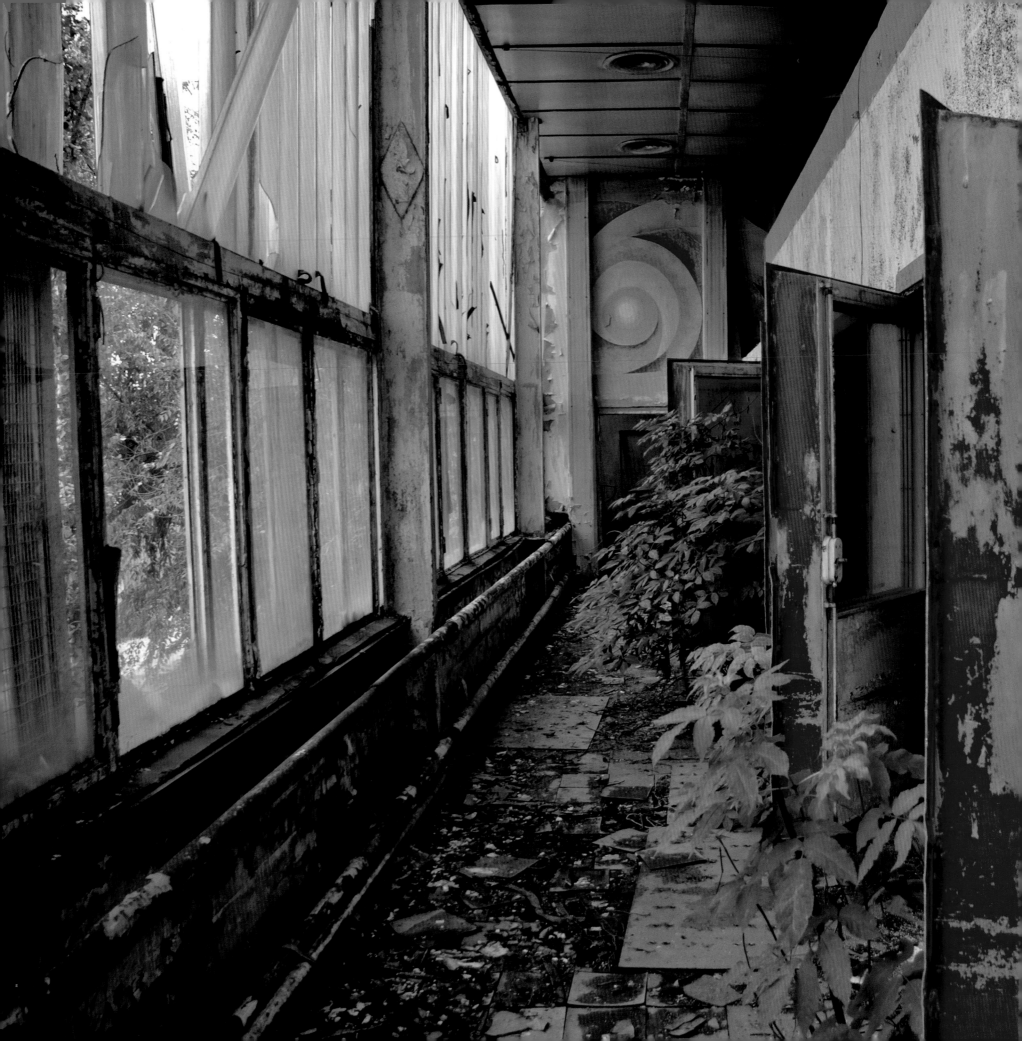

Above: *An old boiler.*

offers nothing really to arrest the exploring eye: blank and grey, apart from the ranks of little-windowed dials, the high-tech gear that lines the walls might as well be the washing machines in a laundromat, so little do they seem to have to say.

Such interiors have inevitably attracted visitors: curious kids or earnest 'urban explorers' – or, of course, graffiti artists in search of 'canvases' on which to work. An anxious-looking woman's face in a Rome pharmaceutical factory (*see* page 110) spills indiscriminately across polished tile and rough-plaster surfaces, while it's framed by open views over the plant.

Left: *Electronics factory in Novovoronezh, Russia.*
Next page: *Sand encroaches on an abandoned factory.*

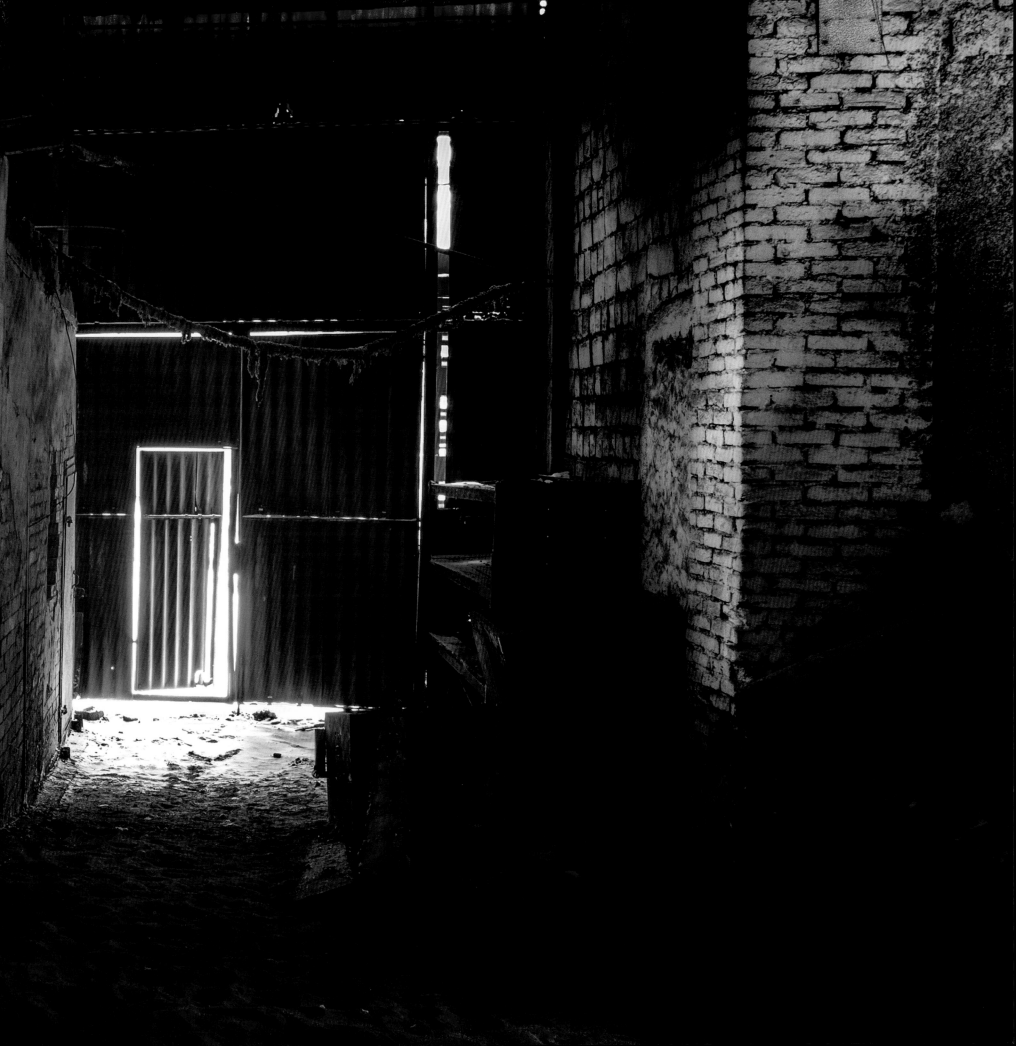

Transport Hubs

The most unsettling scenes aren't necessarily those of greatest destruction, as we saw with Pripyat, near pristine but abandoned, after the Chernobyl disaster (for example, *see* page 52), and with the offices and schools in the exclusion zone around the Fukushima nuclear plant. The sense that someone's suddenly hit the pause button on life and that we're now poised, suspended in time, can be every bit as startling – if not more so.

But what about when we feel frozen, transfixed not just in time but in space as well? Abandoned airports and bus and railway stations hold out the tantalizing possibility of progress, of escape, which they then dash. The wait for a train at a rural railway station can often seem an eternity: at Fontioso, Burgos, Spain, where the service was axed a few years ago, you could literally wait for ever (*see* page 122). In the shimmering heat of the central Spanish summer, we often have the sense that time is standing still. But that feeling is only underlined by the mocking presence of station buildings, the signs for passengers still holding out the illusion of mobility.

At a Standstill

The inability of the Spanish and French authorities to agree on a standard gauge for their respective railways gave rise to the extensive border station and depot complex at Canfranc in the Pyrenean foothills of Aragón. Here, for many decades, trains from the north and south would halt and decant their passengers and freight – all of which then had to be painstakingly checked and loaded on to the trains of the other country.

Right: The growth of plants inside this disused train depot bring new life to the scene.

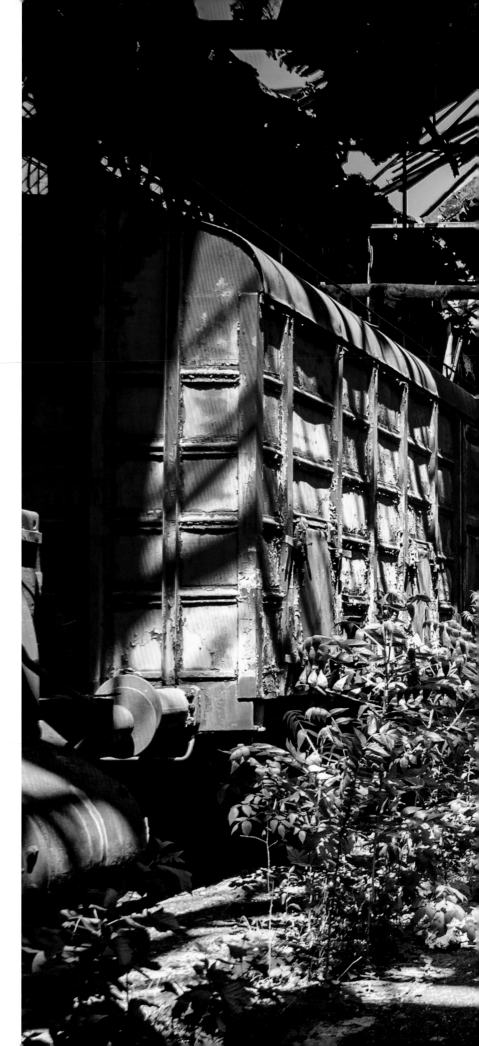

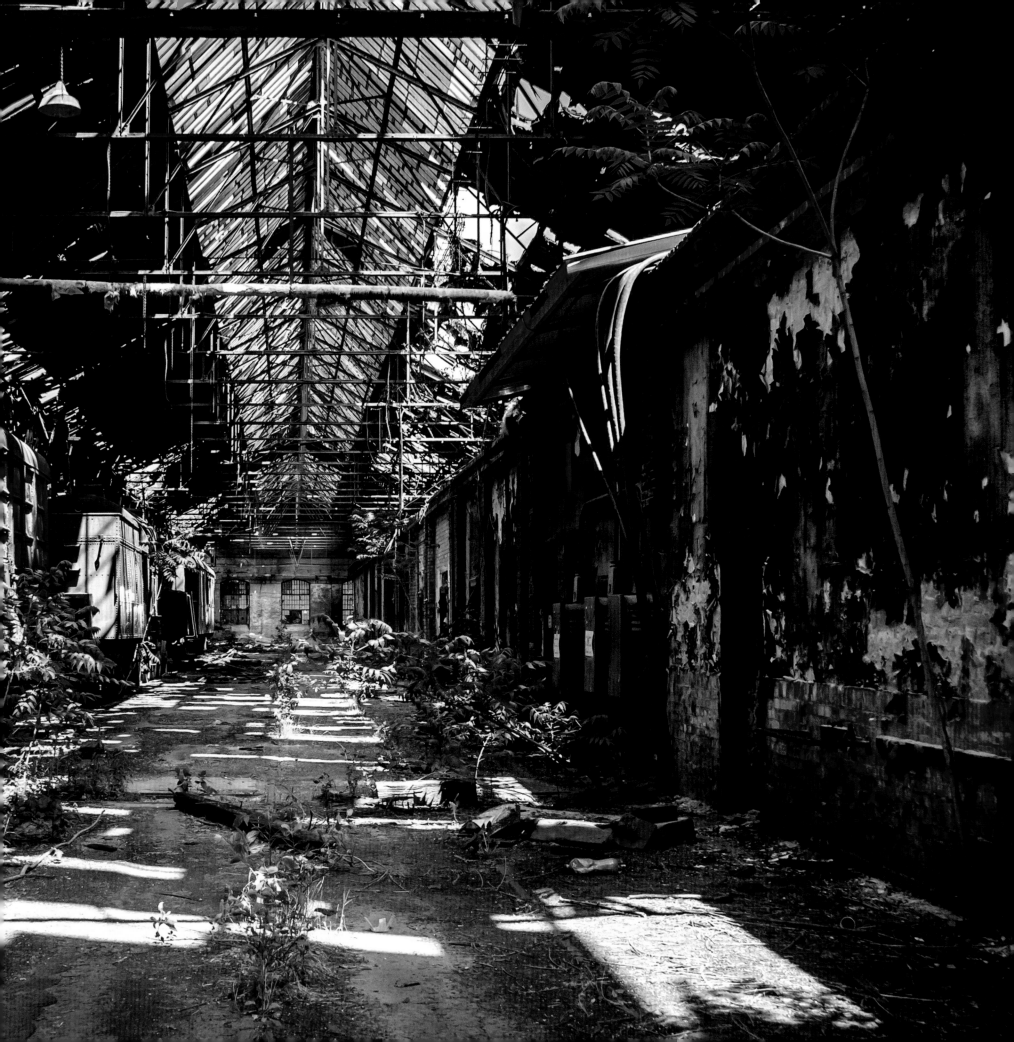

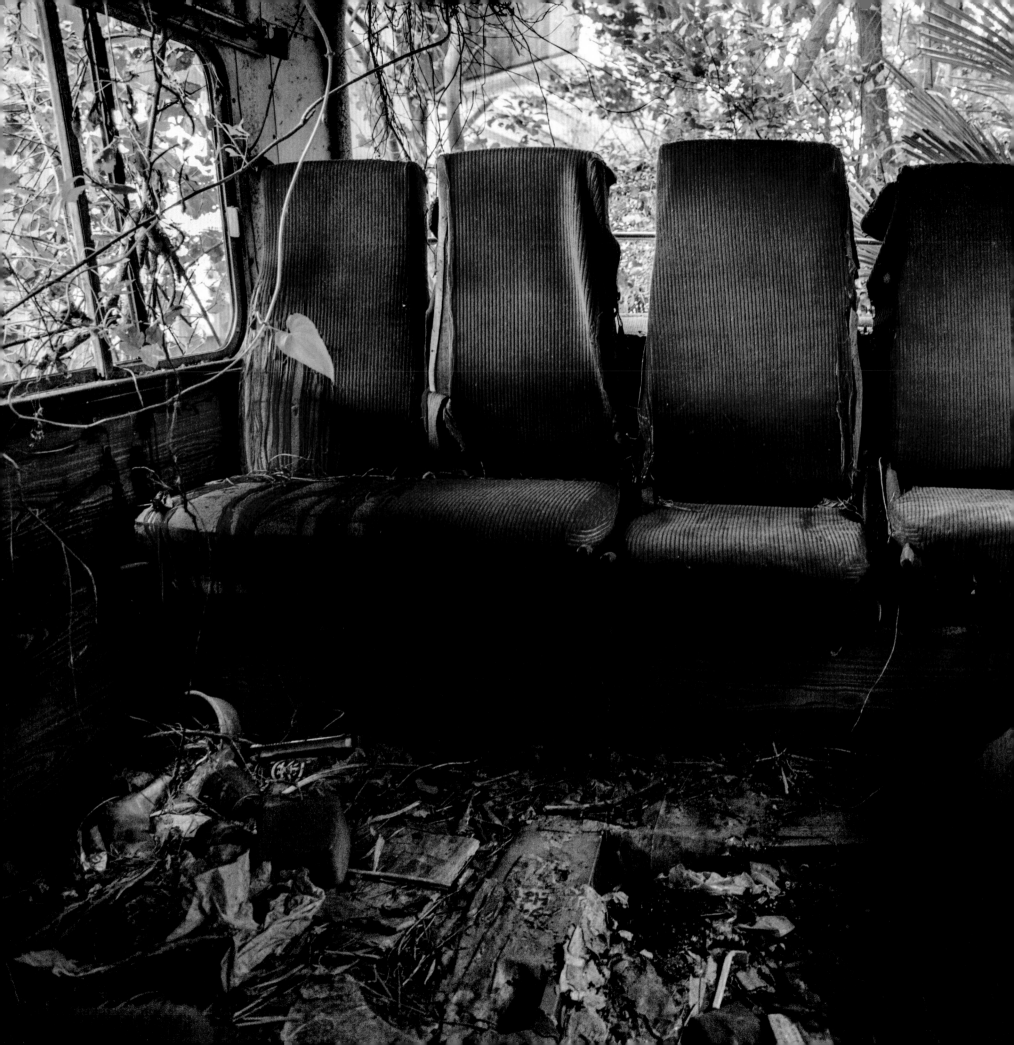

Above: Broken windows in an abandoned factory, East St Louis, Illinois, USA.

Between the 1920s and the 1960s, the cross-border traffic here continued to be brisk, but in 1970 it came to a sudden standstill. An accidental derailment damaged a bridge, closing the line on the French side, and it was decided that it would not be renewed. The result was a spectacular 'ghost station', with sidings, sheds and repair shops, as well as all the usual passenger facilities – still largely intact and accessible to members of the public.

All Aboard

The torn and ravaged chairs are all that remain aboard a bus going absolutely nowhere (*see* left). Nature is slowly reclaiming its ground as plants infiltrate through the broken windows and poke up through the floor. In a more urban setting is America's Twin Arrows trading post – on Route 66, east of Flagstaff, Arizona. What had some claims to be a tiny town is now a spent oasis, far out in the desert. A modern diner,

Left: Chairs in an abandoned bus.

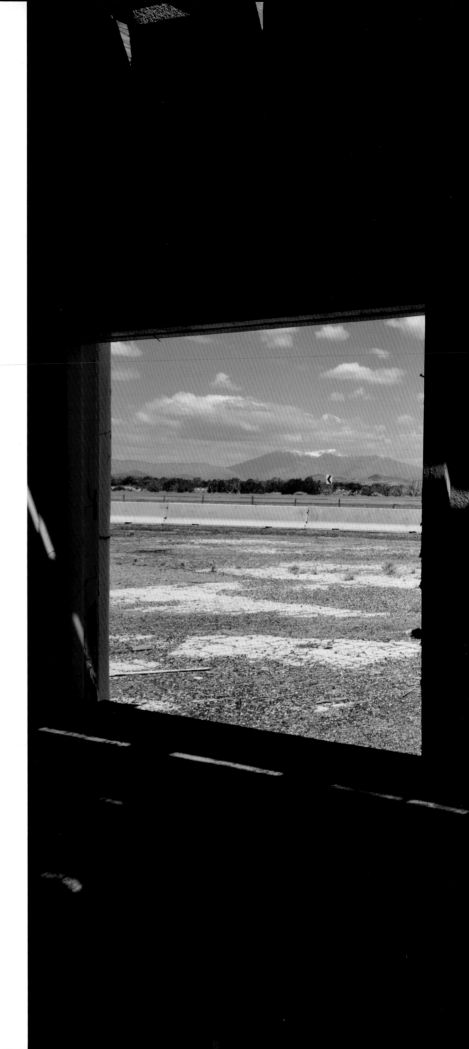

gas-station (*see* right) and curio-shop are now as much an archaeological monument in their way as the rock art left behind by the ancestors of the Navajo in the nearby hills.

Airs and Graces

If we were to peer in across the carpet of forgotten mail on the floor of an abandoned office in Athens' International Airport – as much a ruin as the Parthenon now – the maps we might see on the walls would appear to taunt us. No one will be going to any of these places from an airport that closed down in 2001 – years before the country was engulfed in economic crisis.

Right: The gas station at Twin Arrows in Arizona, USA, now stands derelict in the desert, miles from anywhere, though this was once a somewhere in its own right.

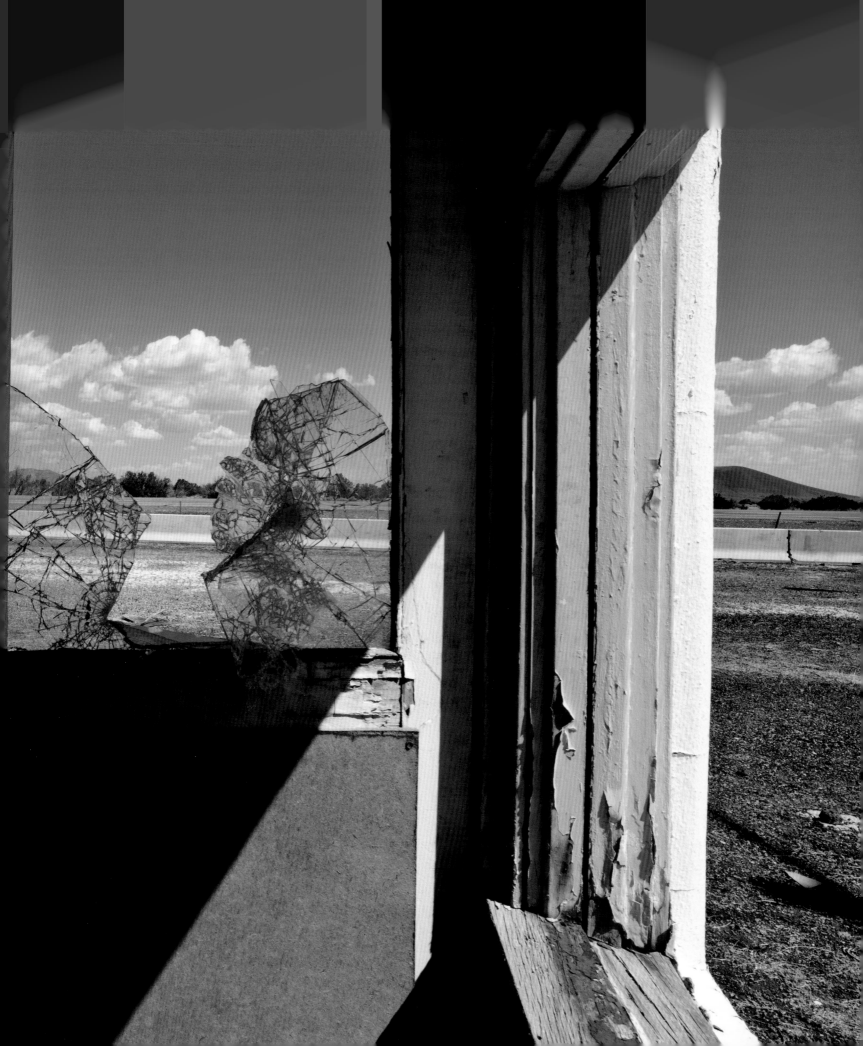

Airports have had a special status and prestige in recent times, prized as an index of economic advancement and cultural sophistication. The price of admission to the life of the wider world, any country or city worth its salt had to have one for its busy, well-travelled people. The ambition hasn't always ended well. The agony of contemporary Spain in particular – post-property bubble – has pretty much been measured out in abandoned airports.

'Don Quijote Airport' was appropriately named, for Ciudad Real Central was as quixotic a project as they come. In La Mancha, south of Madrid (too far south for its own good, indeed), this stunning state-of-the-art airport was built at a cost of over €1bn, but had been forced to close for lack of traffic within a few months of its opening in 2009. Almost as spectacular a flop was Castellón–Costa Azahar, near Valencia, barely used since it was opened in 2011.

Lowered Expectations

Once a hopelessly unrealizable dream was described in English as a 'castle in Spain' – nowadays it might as easily be an airport. Or perhaps we might talk instead of a parking garage in Dubai – like the one built as part of the Nakheel Harbour & Tower development, completed in 2012 but never used. In keeping with the style and scale of a project whose centrepiece was to be a skyscraper over 1 km high, with a new inner-city harbour at its base, this is genuinely impressive – as big and beautiful as a parking garage could reasonably be.

Even so, it doesn't seem much to show for so staggeringly ambitious a building project – brought to a halt when the world financial crisis hit the UAE in 2009. It quickly became clear that there would be no takers for the 200-odd floors' worth of luxury apartments the Tower was to have, so the project's only concrete legacy was this parking garage.

Left: *The old station buildings at Fontioso, Burgos, Spain, seem like castaways from another world.*
Next page: *An old staircase and tracks in an abandoned factory.*

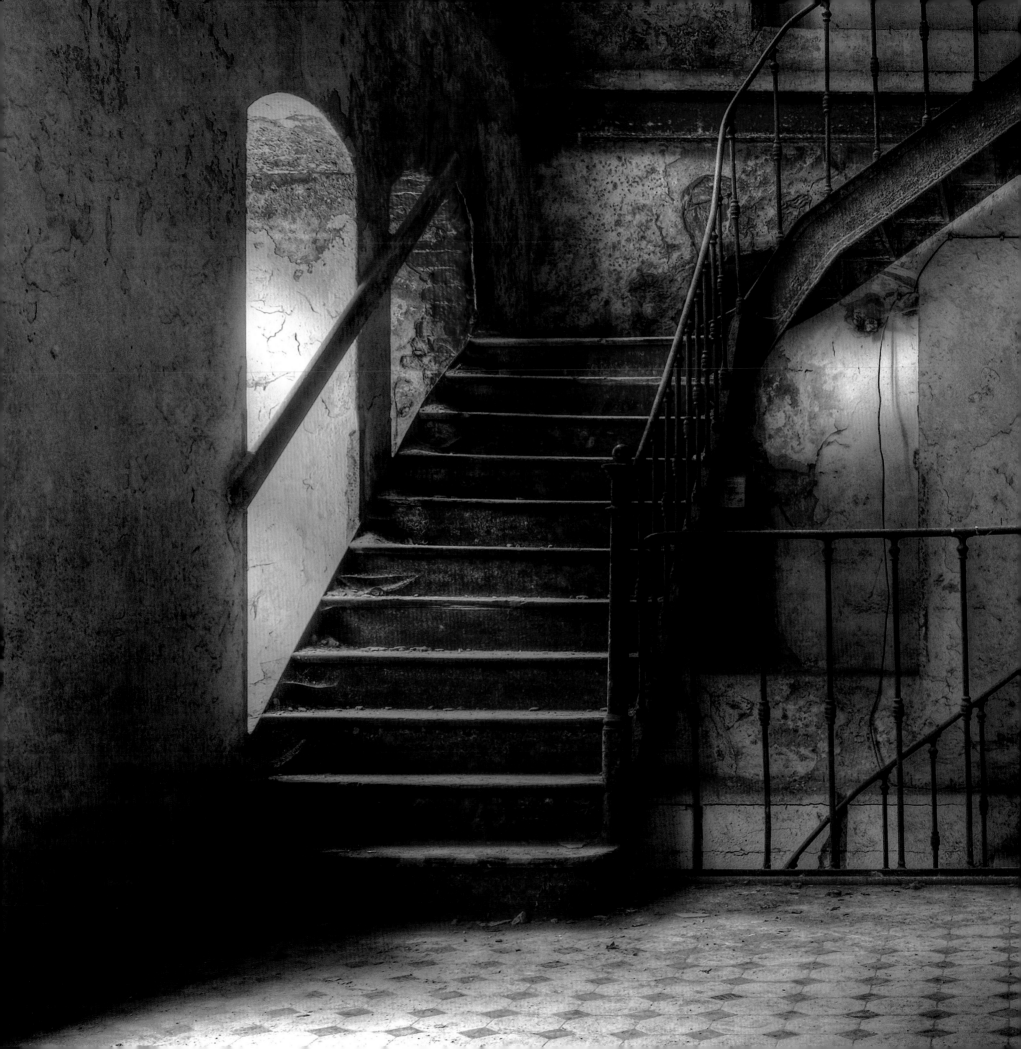

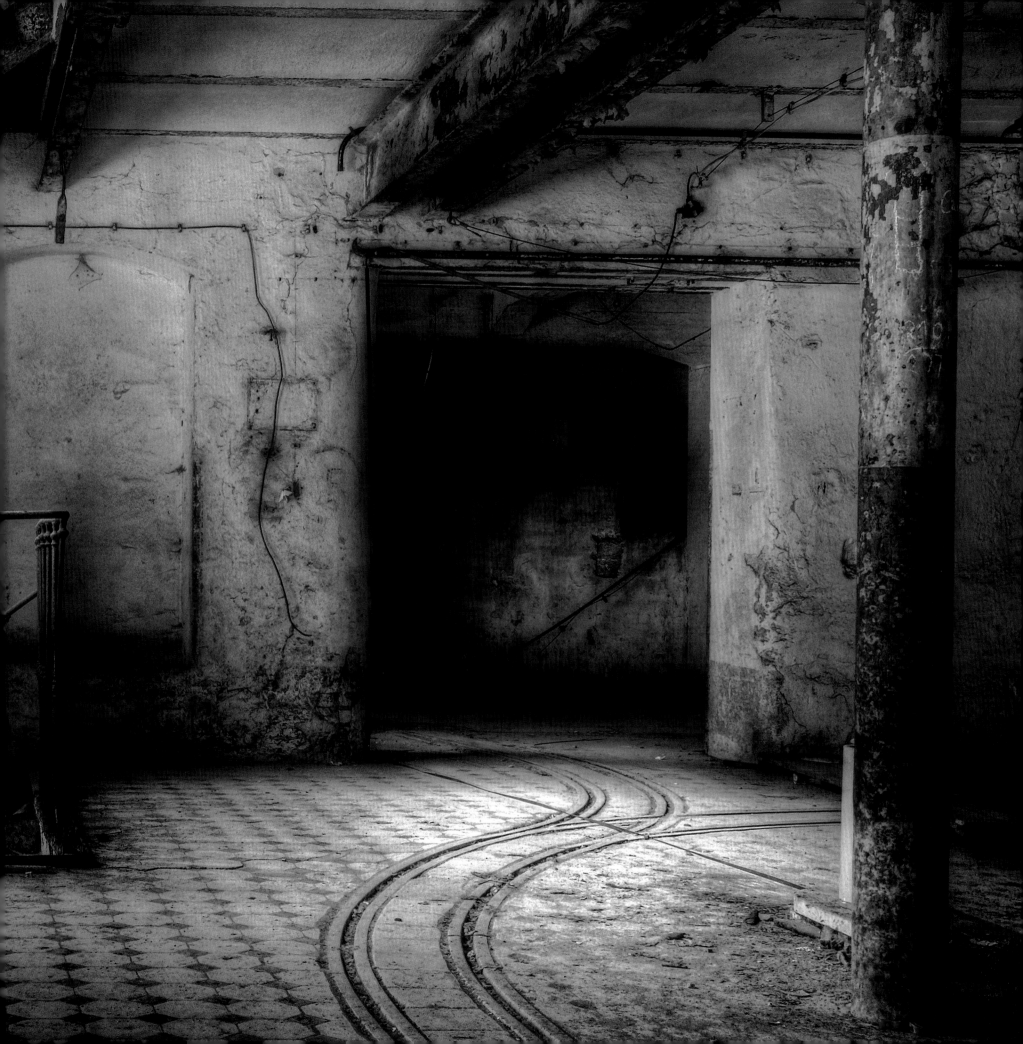

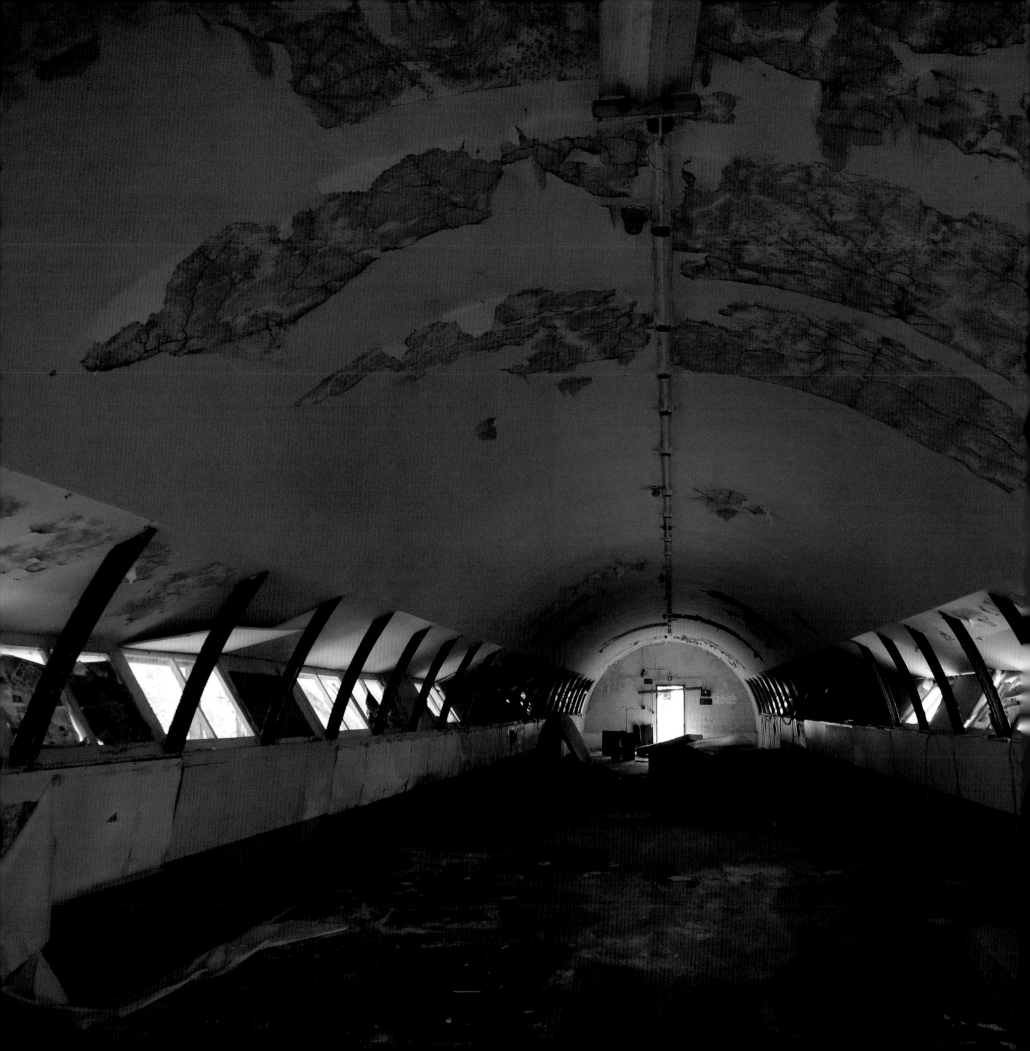

Military Ruins

Military ruins – like military real estate in general – can of course come in all sorts of shapes and sizes. From the tiny concrete 'pill boxes' to be found by roadsides and beaches up and down Britain to California's vast Fort Ord; from the German U-boat pens still to be seen at Brittany's Saint-Nazaire to the Soviet submarine base at Balaklava.

US Naval Base Subic Bay (*see* left) once covered an area of over 650 square km (250 square miles) on the coast of Luzon, in the Philippines. There were facilities for ship repair, refuelling, re-arming and general supply, as well as accommodation for thousands of personnel. The Americans left in 1992, and while the Philippines government has maintained the site as a commercial freeport, much of the old military infrastructure has since crumbled into ruins.

Unoccupied

Nagyvázsony, near Budapest, Hungary, is known as the site of Kinizsi Castle, an impressive medieval ruin, partly restored to house the town museum. The fifteenth-century warlord, Pál Kinizsi, had his headquarters here. But more recent conflicts have left their legacy as well. Outside the town is the base – abandoned in 1990, after the fall of Communism – where Soviet troops were stationed for several decades.

Hungary's experiences under Soviet domination had of course been far from happy, ever since the country fell to Stalin's share in the great geopolitical carve-up that came after the Second World War. Even so, a Hungarian government

Left: The inside of a concrete 'Quonset Hut' in the abandoned US naval base at Subic Bay, in the Philippines, appears to disintegrate before our eyes.

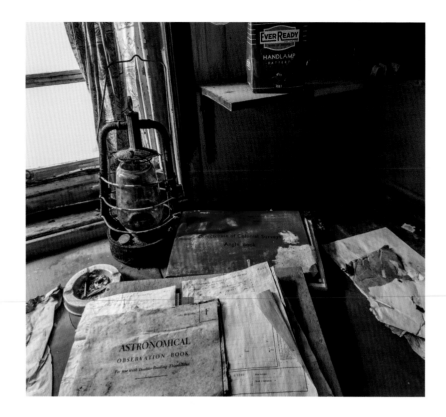

Above: This picture was taken in 2013, over half a century after British Research Base W on Detaille Island, Crystal Sound, Antarctica, was abandoned by its occupants in 1959.

at least nominally held power. When, in 1956, the people rose up to confront their Communist compatriots and demand democratic reforms, the Soviet Army was sent in to restore Moscow's idea of 'order' by brute force. During the decades that followed, the Soviet Union itself was slowly to crumble and collapse. Its base here has stood empty ever since.

Camping Out

At Rumangabo, in the eastern Congo, pictures of the country's biggest army base, taken by M23 rebels after its abandonment, showed just how little government forces had had to fight for. Built by the Belgian colonists, the barracks here were almost completely bare, a doorway informally stopped up with cubes of earth.

Right: Sinter Plant, the Ruhr, Germany: Dark, deeply forbidding, and yet compelling in its mystery, this German sinter plant seems a scene of almost mythic promise.

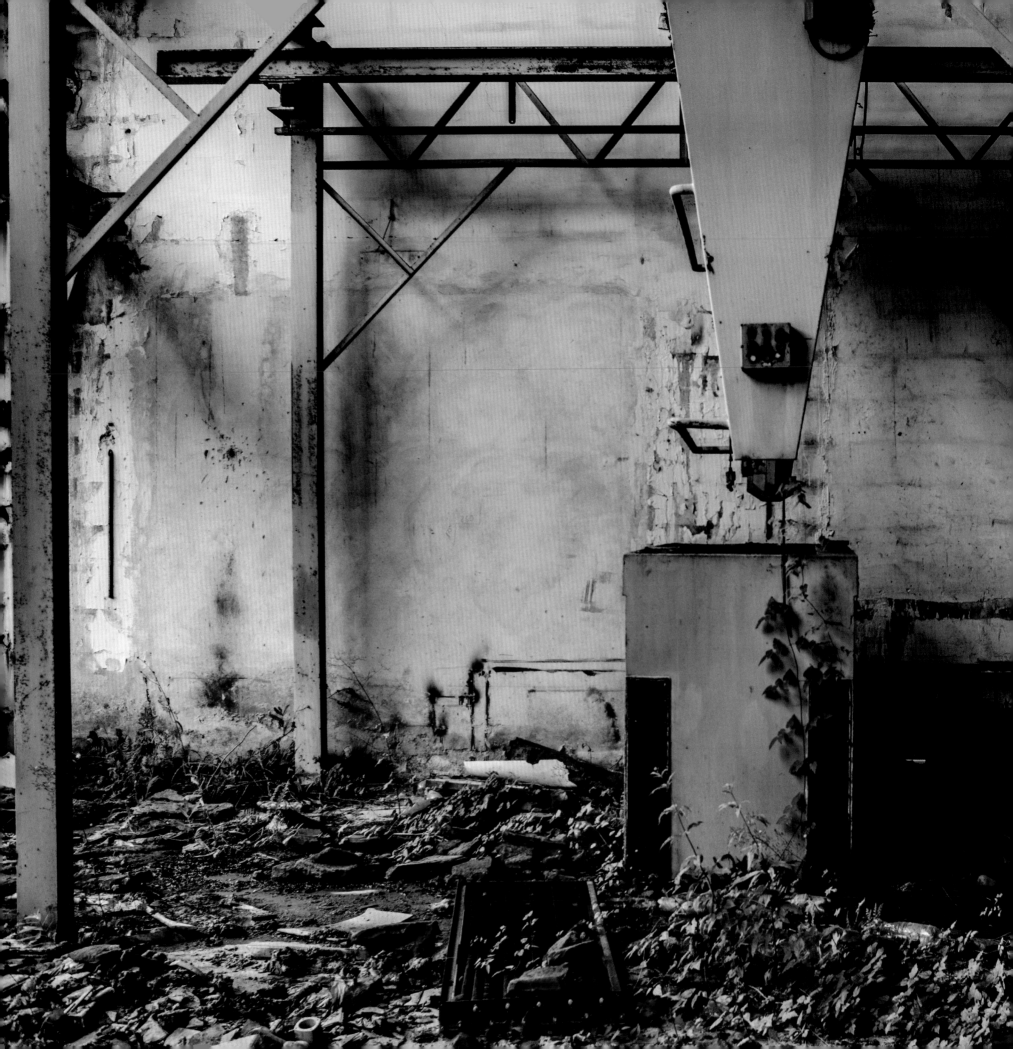

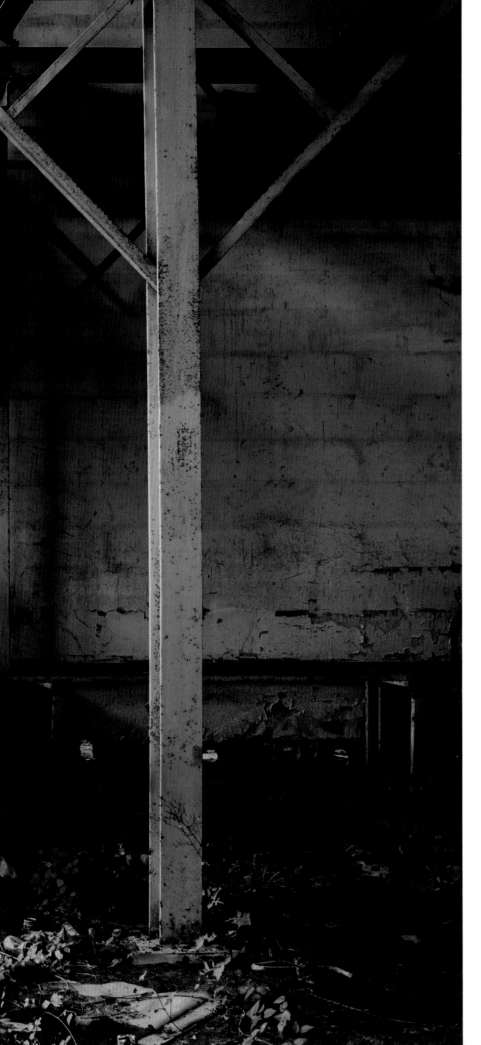

Not that guests of the US government at Camp X-Ray, Guantánamo, Cuba, could have fared much better. Designated as captured 'foreign combatants' from the so-called 'War on Terror', they were detained here under who-really-knew-what conditions. Though some were to be held for years, they were fairly quickly to leave Camp X-Ray, its inmates being transferred to nearby Camp Delta in April 2002.

In some cases, troops may actually be billeted in a disused building. When they move on, it arguably falls derelict anew. The Dutch peacekeepers, who in 1995 set up home in the old battery factory in Potocari, Bosnia and Herzegovina (*see* left), were themselves subsequently to be convicted of dereliction of duty. A court in their own country's The Hague decided that, in handing 300 Bosnian Muslims who'd sought sanctuary with them over to the Bosnian Serb forces of General Ratko Mladic, UNPROFOR Dutchbat (United Nations Protection Force, Dutch Battalion) had effectively – and heedlessly – sent them to their deaths. The refugees were among the 8,000 civilians killed in what was to become known as the Srebrenica Massacre.

Left Cold

Antarctica is littered with abandoned bases – well, there are quite a few, though it's a vast continent of course, and much of the interior remains unexplored. Between the crisp, dry, cold conditions down there and the shortage of traffic, they tend to remain just as they were left for years on end. Sweden's hut on Snow Hill Island dates back to 1903; in 1958, Soviet explorers set up a tiny base (with a bust of Lenin) at the so-called 'Pole of Inaccessibility' – the farthest point in the continent's interior from the sea. The scramble for Antarctica in the mid-twentieth century saw a host of countries establishing themselves here, including Australia, Argentina, Poland, Britain (*see* page 128) and the USA.

Left: Nature begins to take hold over the inside of the Potocari battery factory in which Dutch peacekeepers stayed at the time of the Srebrenica Massacre.

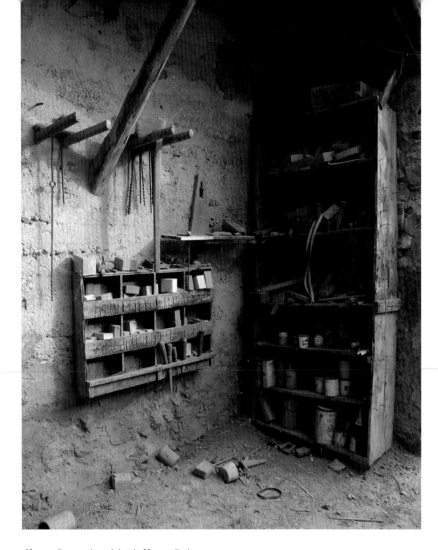

Above: Carpenter's workshop in Huesca, Spain.
Right: The ruins of a heavily polluted European factory.

Subterranean Slavery

Deep in the earth, south of Saint Omer, near France's channel coast, a big
and complex bunker system was dug by the Nazis during the Second World
War. It was called *La Coupole* (the 'dome' or 'cupola') for the convex concrete
cap that covered its central section – and, it was believed, bomb-proofed it.
Here it was that Hitler's scientists started developing the secret weapons they
hoped would win the War: the V1 (*Vergeltungswaffe* ['Retribution Weapon'] 1)
and the V2 Intercontinental Missile.

The former, a propeller-driven cruise missile, remotely directed, made a loud
buzzing noise as it plunged towards its target – hence its English nickname,
the 'Doodlebug'. (Though by the time the weapon was deployed the war

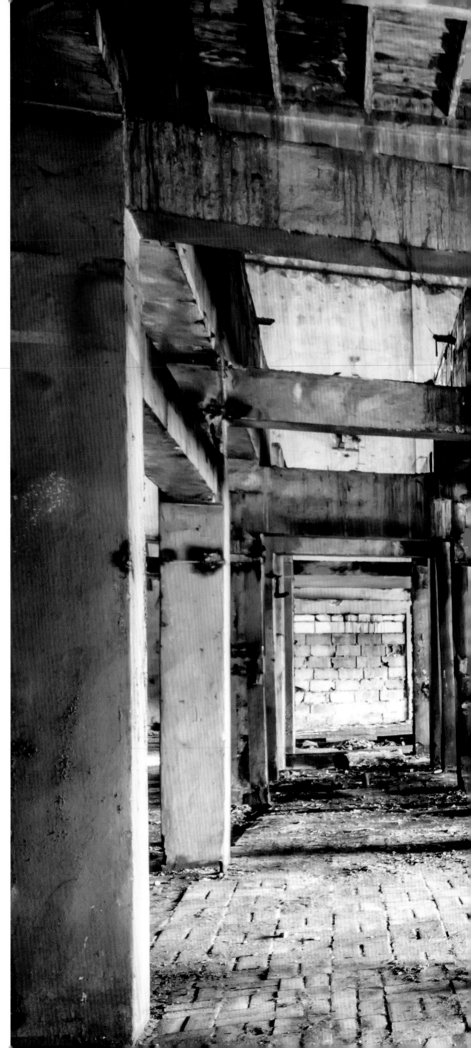

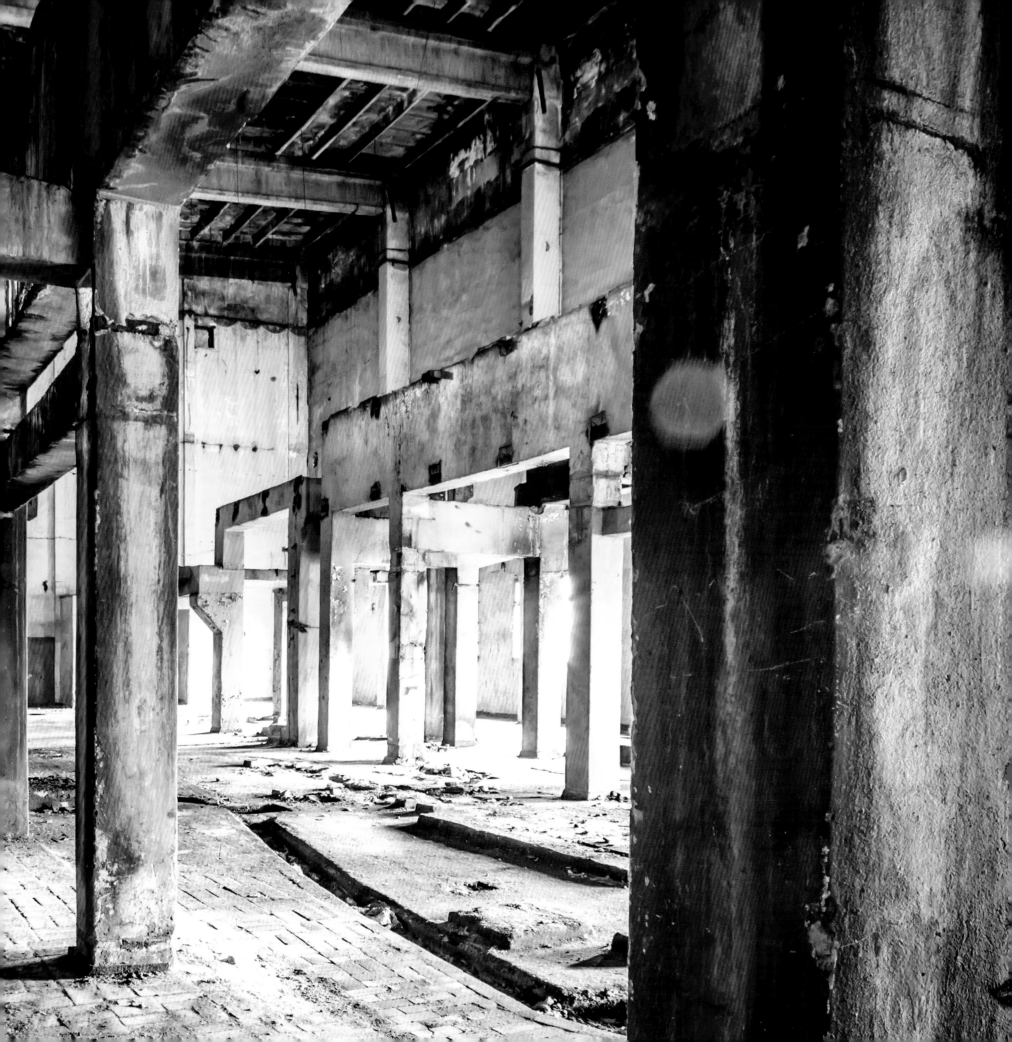

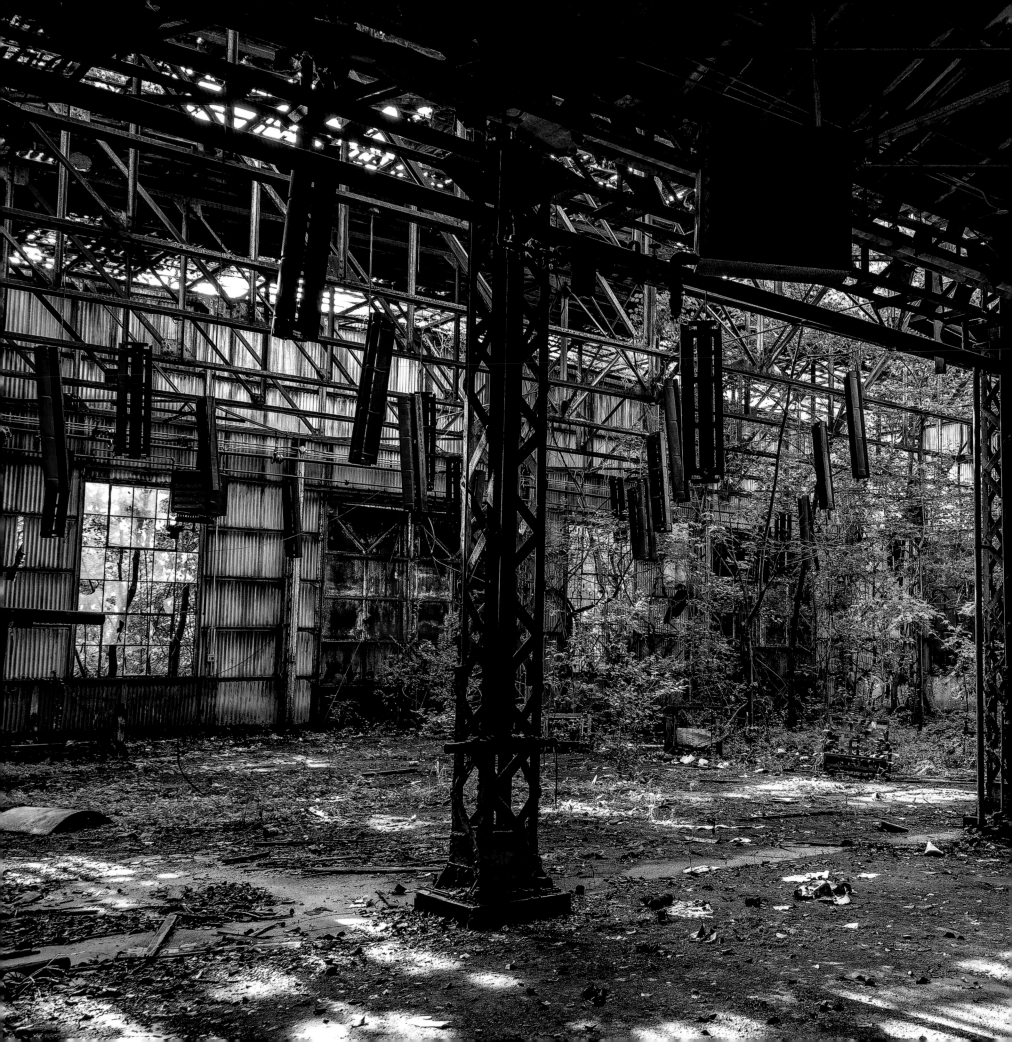

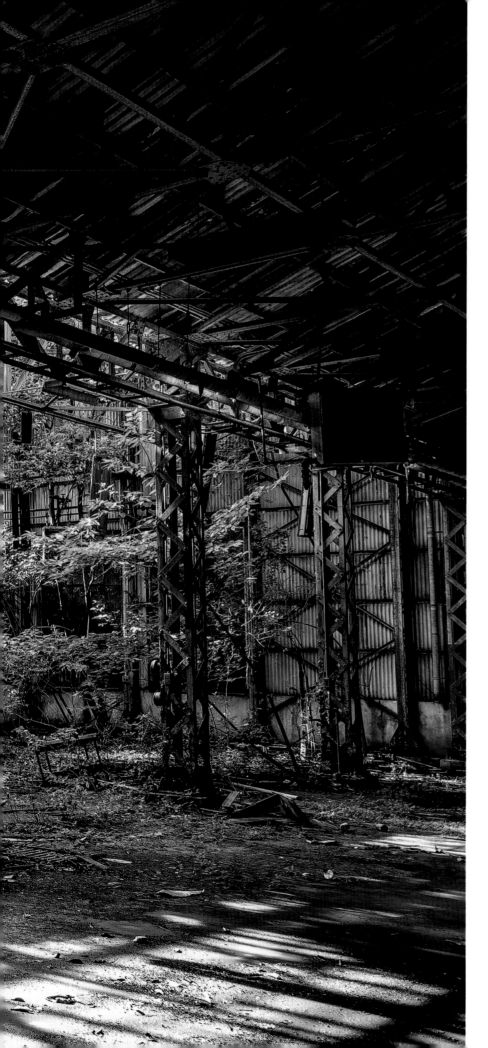

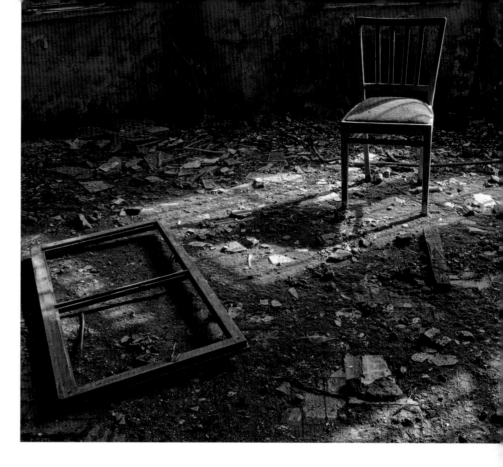

Above: The remains of a former SS headquarters in Gdansk, Poland.

seemed all but over, it made the final few months of the conflict much more anxious than they might have been.) The latter, essentially a rocket, which soared into space before falling at supersonic speed – so completely unheard – upon its target, might easily have brought the Germans victory had it been ready sooner.

These frightening capacities were arguably among the less alarming aspects of the programme though. Most of the workers who helped on both these projects were slaves, brought from the concentration camps. They lived here in atrocious conditions. Over 25,000 are believed to have been killed on the V2 project alone. While La Coupole's concrete reinforcement did, for the most part, prove a match for the repeated Allied bombings of Operation Crossbow, the blocking of tunnel entrances and of off-site launching ramps

Left: An abandoned military base in Fuchū, Japan.
Next Page: The return of peace to Georgia may not quite have hammered swords into ploughshares, but it's made of this derelict power station in Tvarcheli, Abkhazia an oasis of fertility and life.

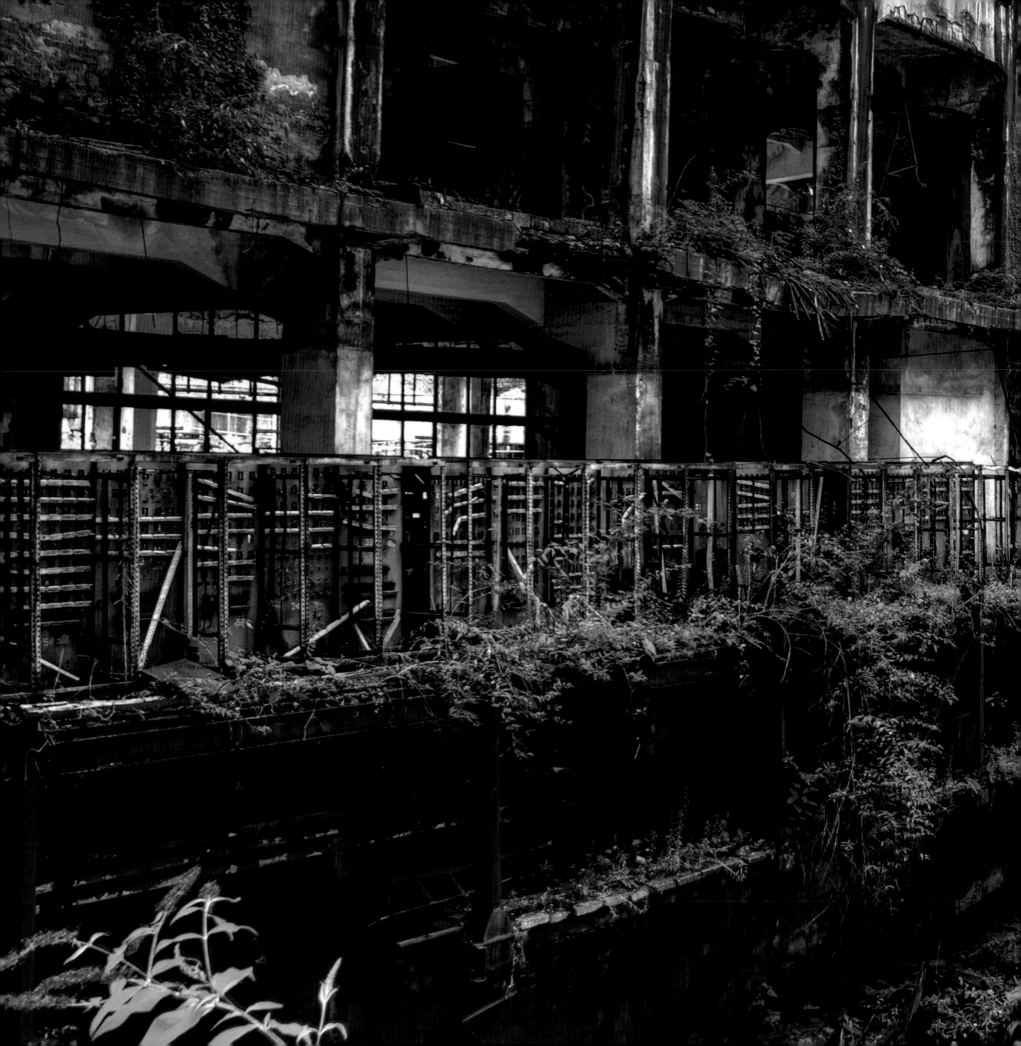

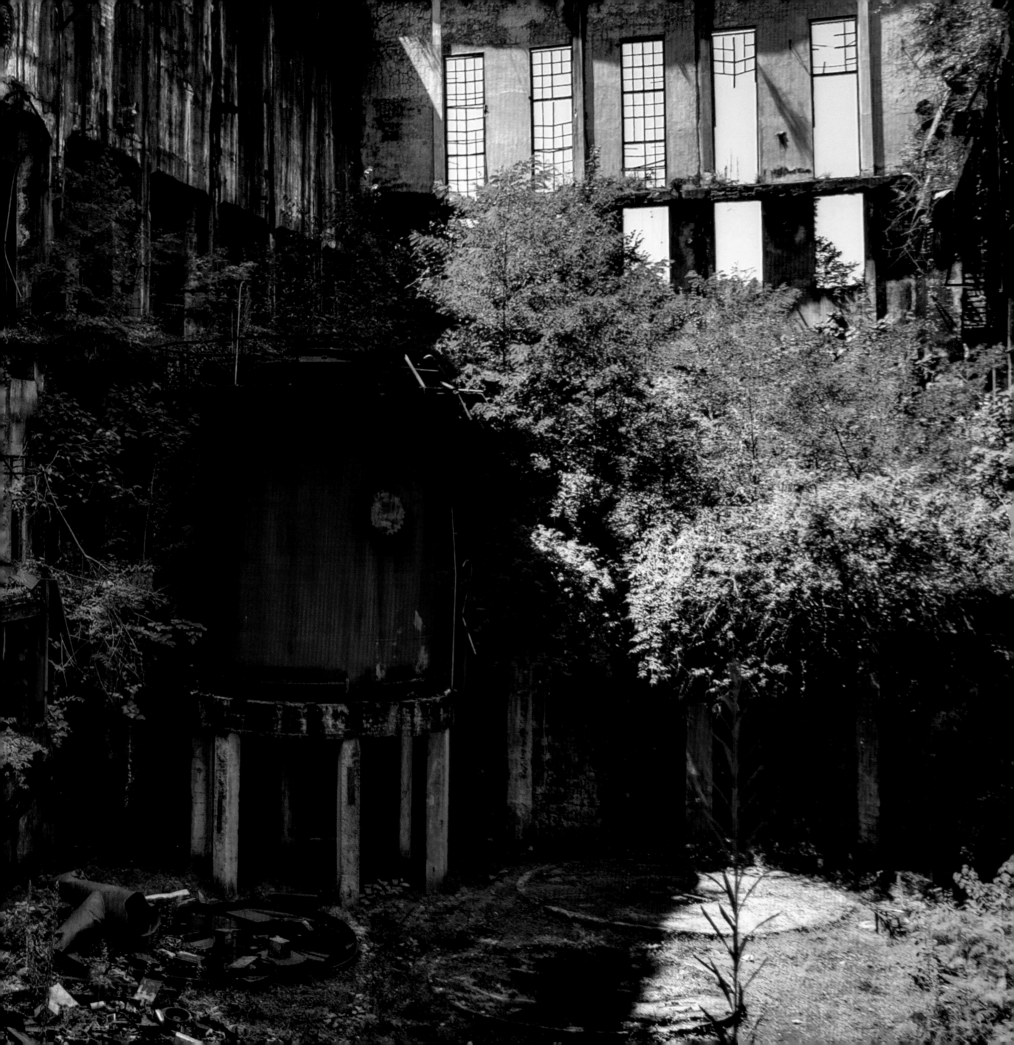

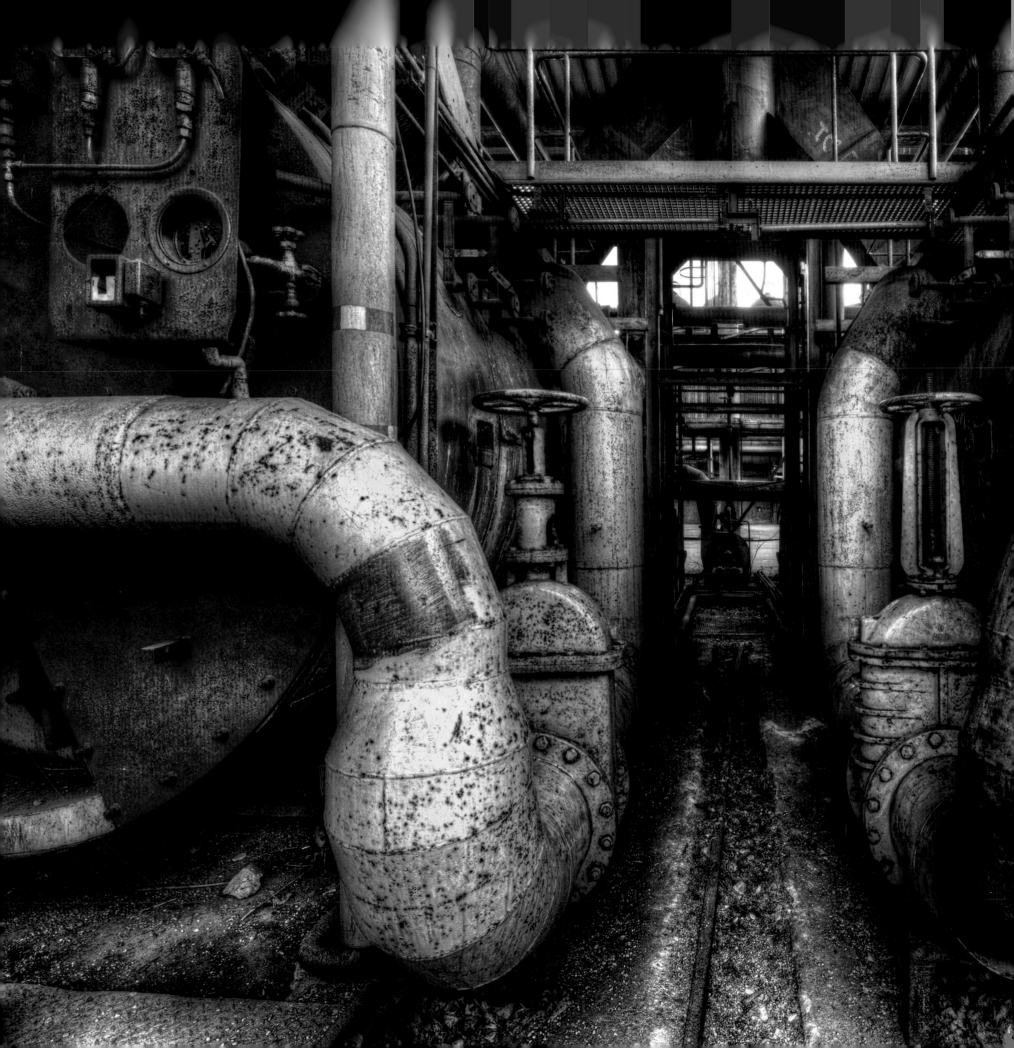

helped frustrate the Germans' long-range weapons programme until it was too late to take effect.

Sites of Feeling

The Nazis were able to do a great deal of damage with more conventional weapons. Much of central Liverpool was razed in the bombing of the Blitz (1941). Most of the wreckage was cleared away in the post-war period. But the roofless hulk of St Luke's Church, left standing (just about) where Leece Street met Berry Street in the city centre, was preserved in its derelict state as a monument to what Liverpudlians had endured.

A derelict building can be paradoxically expensive to maintain, and by the new century the authorities were mooting the idea of demolishing the damaged church properly. It was saved after public outcry: while of little obvious beauty and just about no discernible use, 'the Bombed-Out Church' (as most now knew it) was the focus for strong feelings.

A sort of 'pathetic fallacy' often governs our response to dereliction – as perhaps it does to the way we feel about our physical environment in general. The contradictions are especially striking here though: what gives one ruin poignancy, dignity or romance, while another simply looks decrepit and in need of knocking down?

Some sites are obviously and powerfully 'poetic'. An abandoned sinter plant (*see* page 129) in Germany's Ruhr evokes a vision of a Wagnerian *Nibelheim* – that dark, deep and mysterious underworld in which dwarfish smiths hammered away at their anvils to forge the purest gold. This combining together of minerals under extremes of pressure and temperature is arguably the nearest real-life modern industry has ever come to alchemy only heightens our sense of something mythical and mystical going on down here.

Left: Brightly-coloured pipes in a corroding deserted factory.

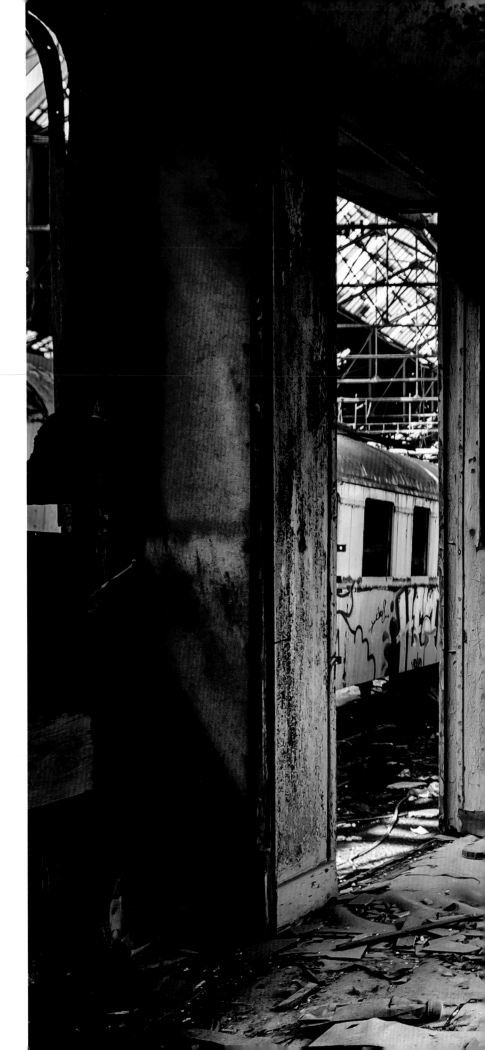

The Collapse of Industry

An empty warehouse in Atlanta, Georgia (*see* page 142), strikes us 'poetically'. This time, though, the poem is no romantic fantasy, but a spare and modern meditation on economic dispossession and the psychological alienation that comes with it. Literally, it's a disused warehouse; taken one figurative level further, it's an emblem of the collapse of industrial prosperity in its traditional US centres.

Empty Worlds

Abandoned warehouses seem like a little world of emptiness in their own right. We might see regularly spaced steel beams receding into the distance like the columns in some Renaissance study of perspective; those gantry-

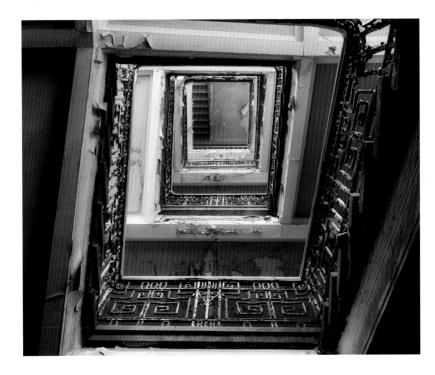

Above and Left: *Industrial interiors.*

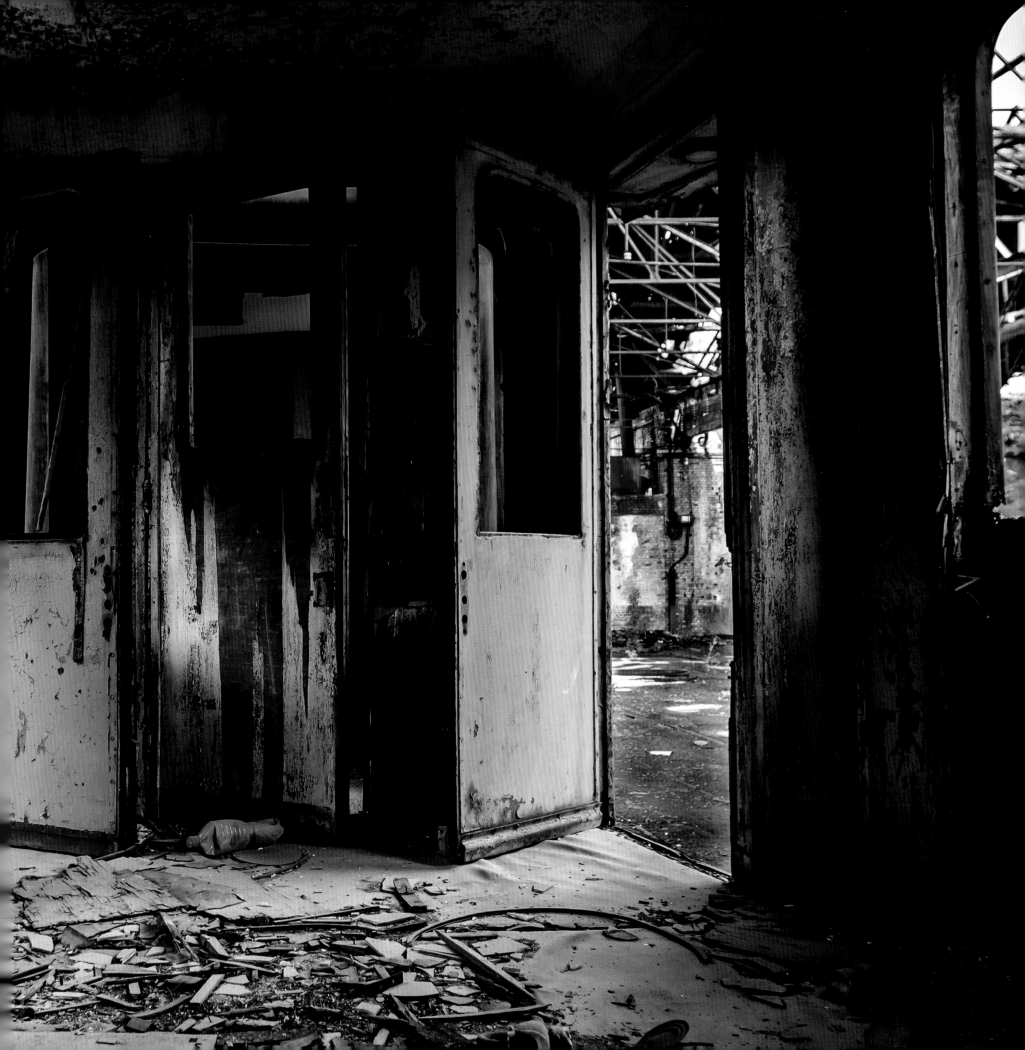

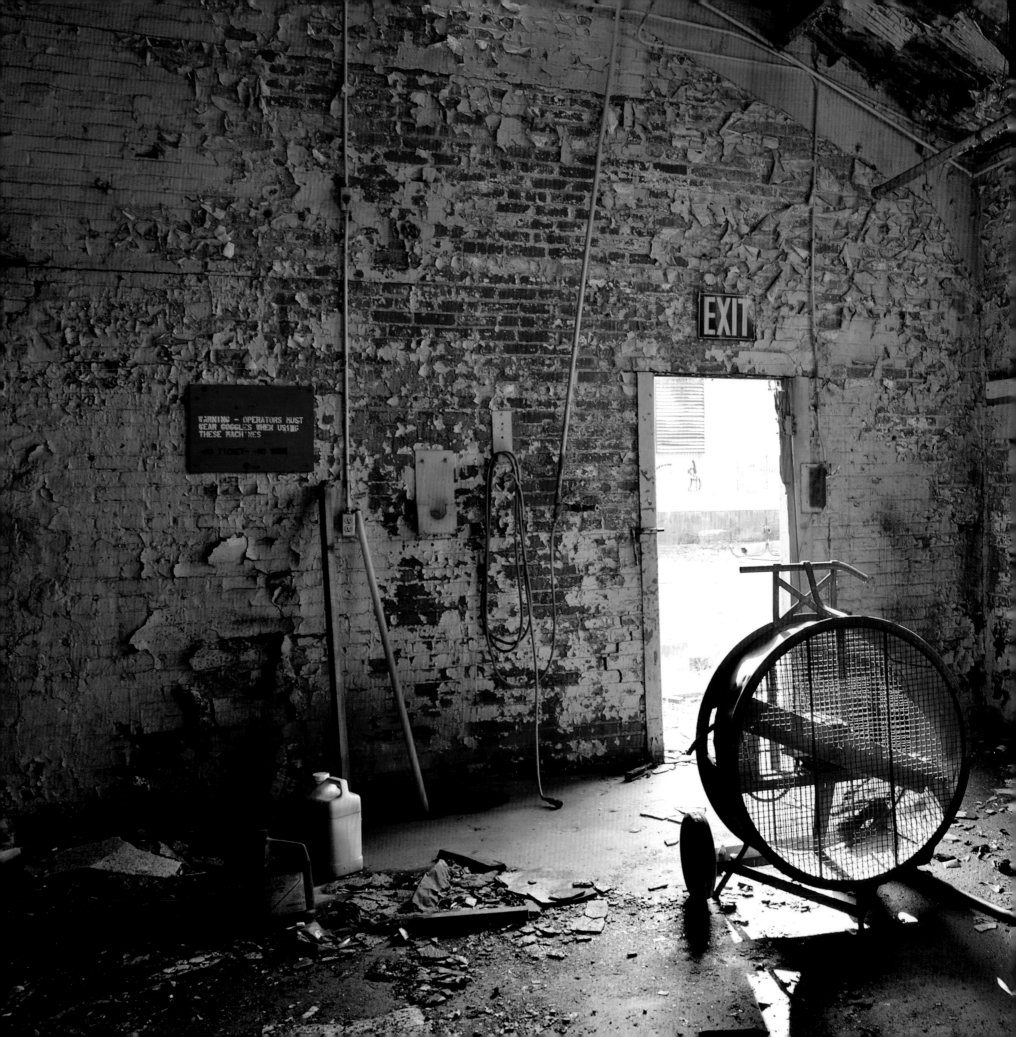

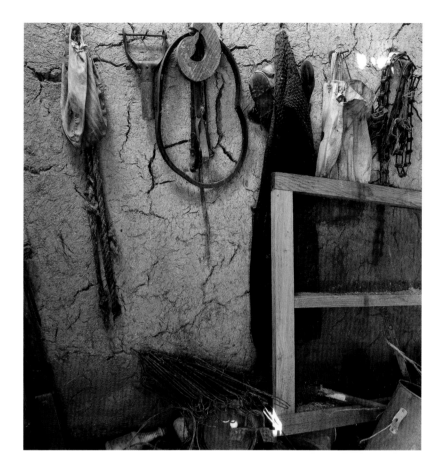

__Above:__ Old farm equipment in Alberta, Canada.

like girders holding up the huge roof overhead …This space-without-content appears to go on for ever. Never, we feel, was there ever so spectacular, so compelling an exhibition of an existence in which there's nothing doing…

In 2011, reversing the procession of North American and European writers to his home in Patagonia, the Chilean poet Cristian Aliaga set off to explore the wastes of post-industrial Europe. Seeing the unemployed drinking in a bricked-up pub in Leeds, he thought about the modern Westerner's withdrawal from the world. On to Birkenhead, and the hinterland of hopelessness and poverty around the once-great shipyards. 'We're workers sacked from everything,' he reflected.

__Left:__ Abandoned warehouse in Atlanta, Georgia, USA.

Old Buildings, New Worlds

'Even now there are places where a thought might grow…' We've seen poet Derek Mahon inspired by an old garage; this reflection was prompted by 'A Disused Shed in County Wexford' – itself in the grounds of a hotel, 'burned out' in Ireland's Civil War of the 1920s. For Mahon, these abandoned buildings are little lost corners, outside the historic mainstream – even though it was often as not history that drove them to dereliction. The mushrooms he finds growing in this Wexford shed have become the inhabitants of their own little cosmos – living, dying and, the poet imagines, hoping by its different rhythms.

And yet in some sense their stoic survival points to the world's capacity to replenish and renew itself, whatever travails and tumults it has endured. We find a stunning equivalent in the war-destroyed power plant in Tvarcheli, Abkhazia, Georgia (*see* page 136); among its ravaged, ruined masonry, a Big Bang of fresh fertility has brought forth a luxuriant green forest of plants and shrubs.

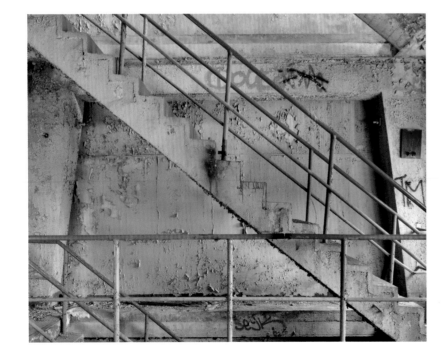

Above: *Stairwell in the ruins of a boiler house in Berlin, Germany.*
Right: *An abandoned tunnel in Kiev, Ukraine.*

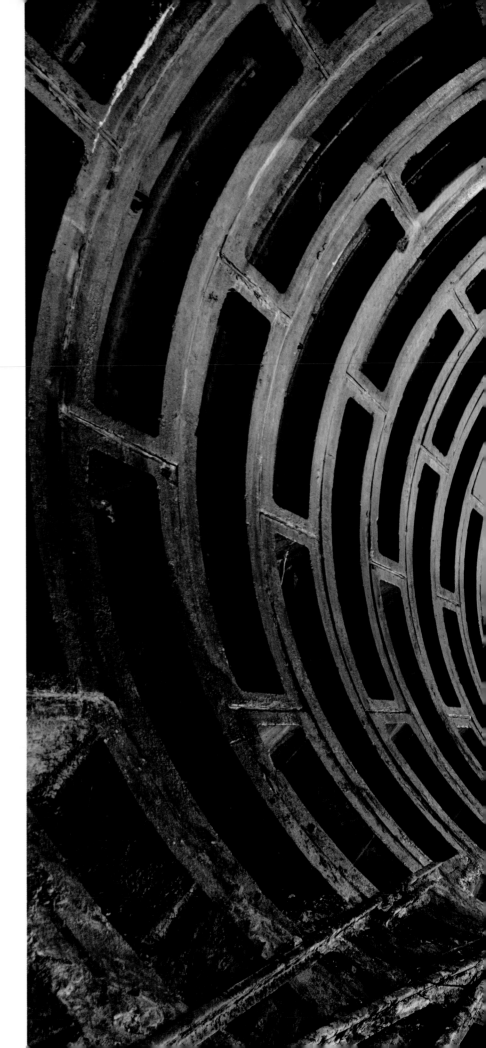

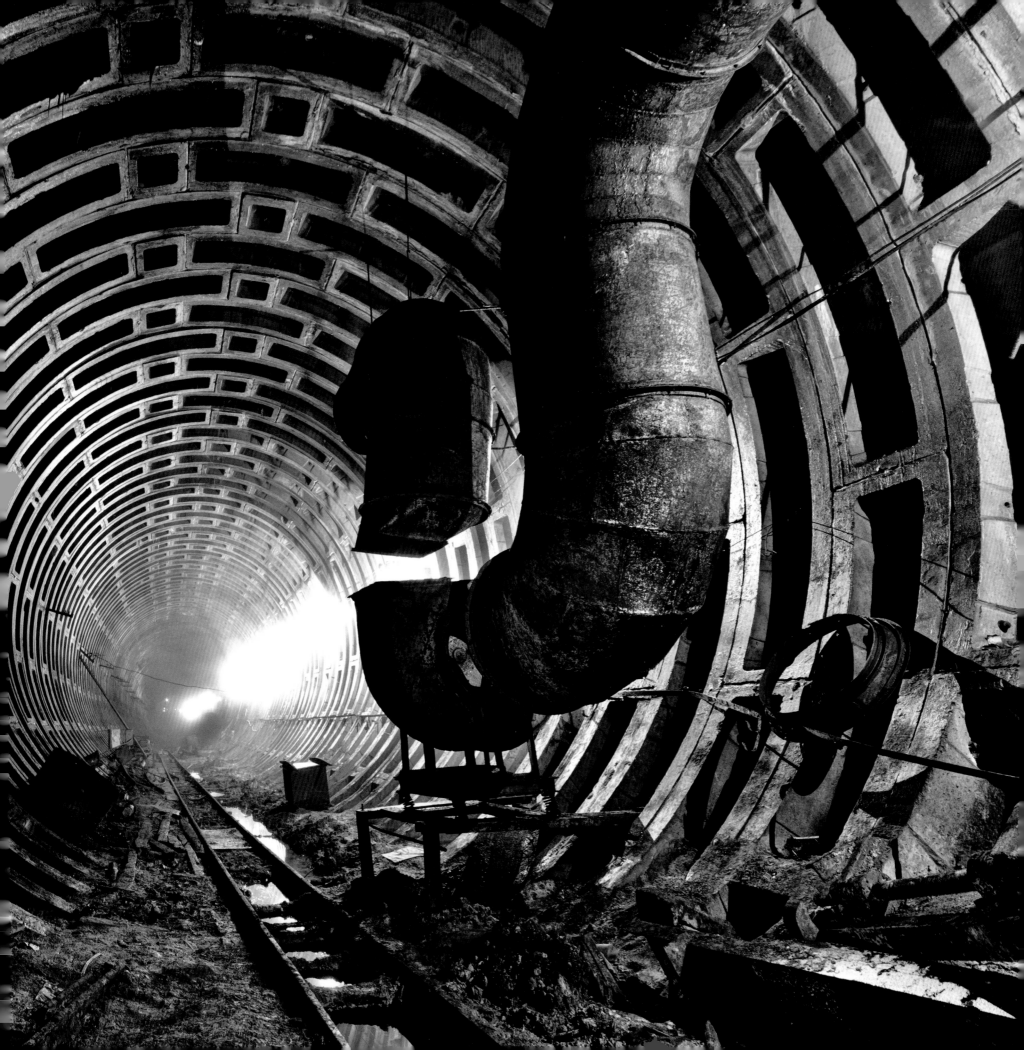

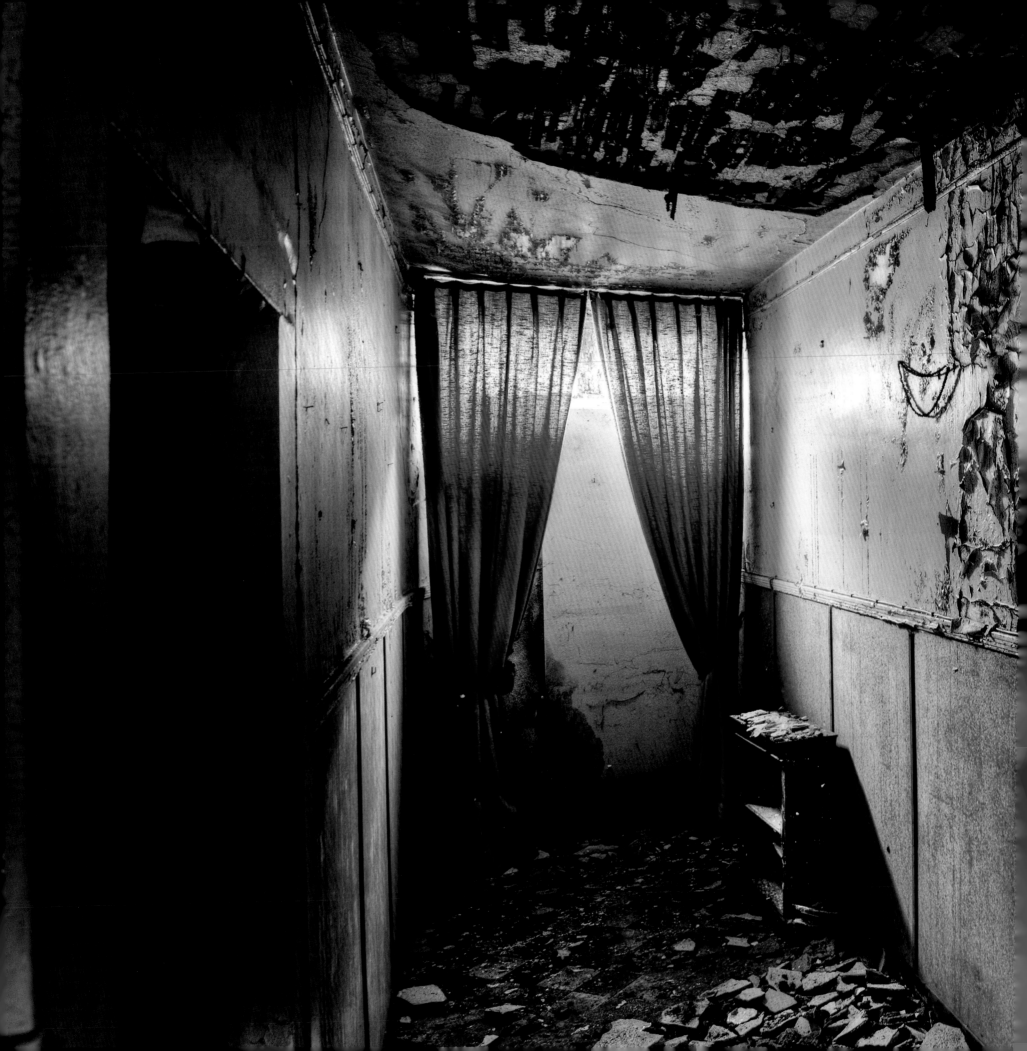

Residential Places

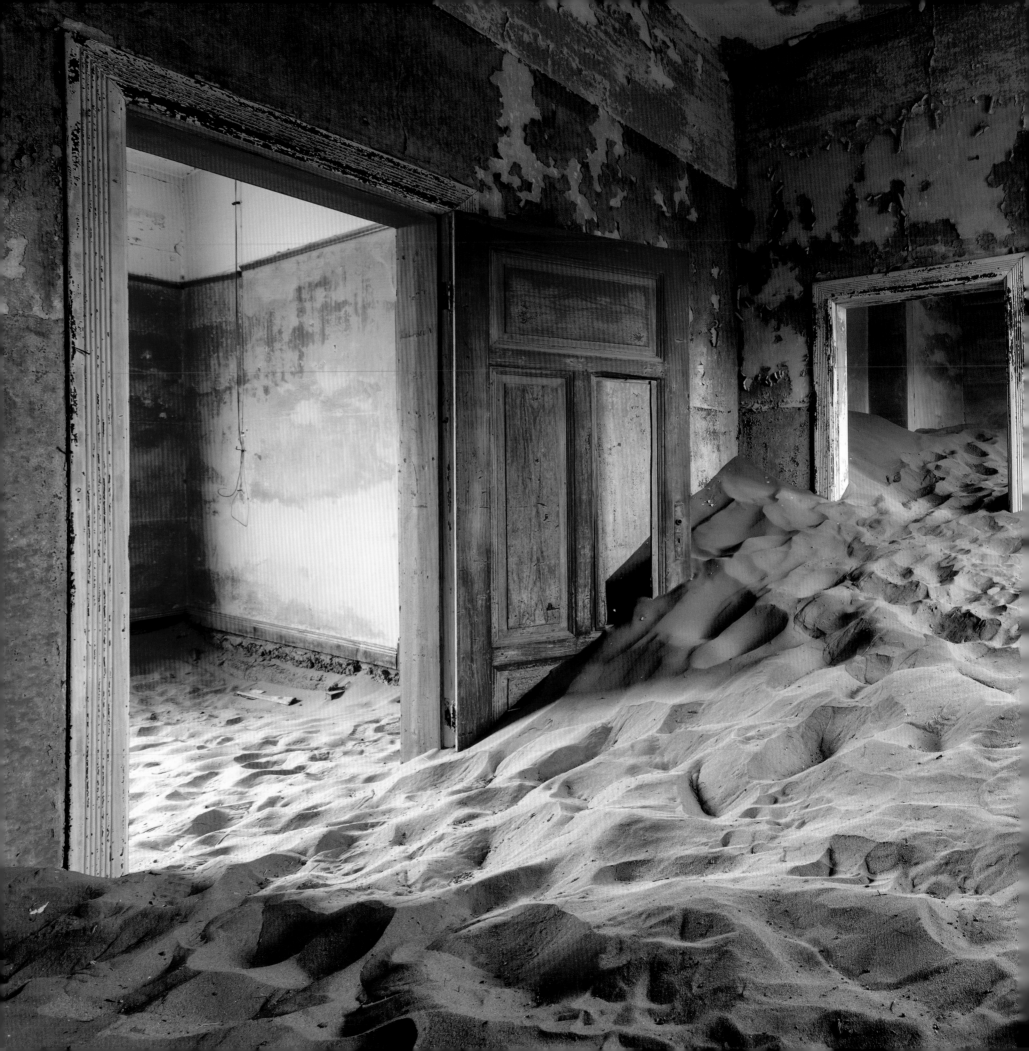

Living Ruins

Someone bustled about this kitchen once; lazed on that scabby sofa to watch TV; rummaged in that cupboard; went up those creaking stairs to bed. And we, looking eagerly, and yet still somehow furtively, about… We're intruders, drawing conclusions – perhaps passing judgement – where we've no business. But that's the paradox we're presented with the moment we set foot in an abandoned house: what was private is abruptly, brutally, made public. This home was once a castle, its door a frontier and its walls a rampart; a place protected from the perils of the world. (For worse as well as for better, of course: so formidable a fortress makes the perfect prison too, allowing all manner of abuse to flourish unobserved and unrestrained.) The boundaries between the public and the private spheres are in normal life as strong as they are intangible. Where, now, does intimacy begin and end?

Domesticity Decays

'All houses wherein men have lived and died/Are haunted houses,' wrote Henry Wadsworth Longfellow. We find the traces of past lives in every stick of furniture, on every surface, every wall. But to see this kaleidoscope of life and history is immediately to be reminded of what's missing: the clamour these things create in our imagination isn't matched in real life. Here, those lost souls have left us only that same old interminable silence; that realization that, once we're gone, we're gone for good.

'Is it my own death I sense here/among the cobwebs twitching at my arm?' asks the Australian poet Jan Owen of her feelings in a 'Derelict Cottage'. The answer, obviously, is yes – though not so much because death is so final as because it leaves behind so much unfinished business. This scene of existence

Previous page: Derelict room in a Luxembourg house.
Left: Abandoned building being taken over by encroaching sand in Kolmanskop, Namibia.

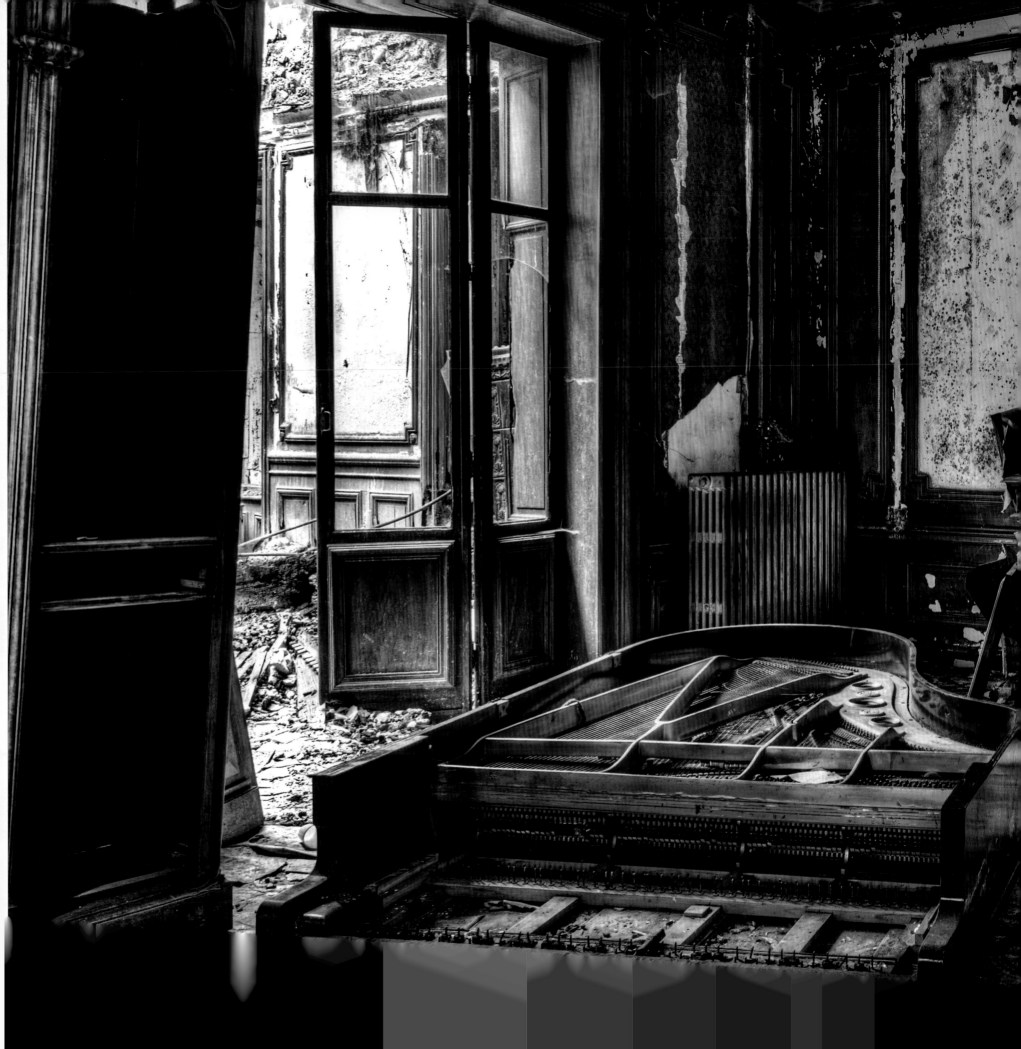

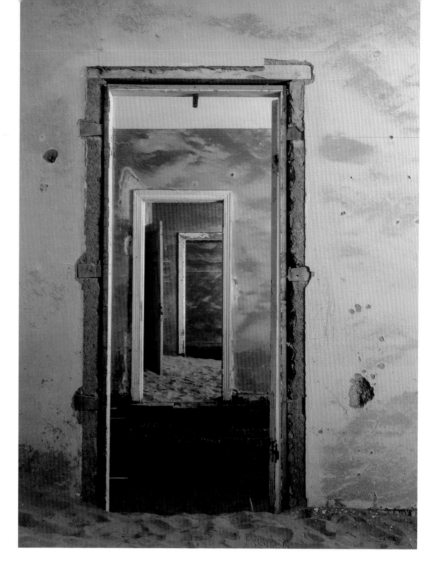

Previous page: A broken piano lies in an abandoned home.
Above: Doorway in the ghost town of Kolmanskop, Namibia.

A real-life mansion lies run-down and abandoned (*see* page 152), with its broken piano lying centre stage in the room and graffiti on the wall. What grand opulence once embodied this now empty home?

Missing Links

The great paradox of the abandoned house is that it makes absence palpable – a presence. Without its patriarch, this little world seems somehow all adrift. The lady of the house, its queen, kept her children on their toes and her servants on the run. Without her, some central gravitational force has gone.

Left: Moss covers the deserted furniture of a home near Chernobyl, Ukraine.

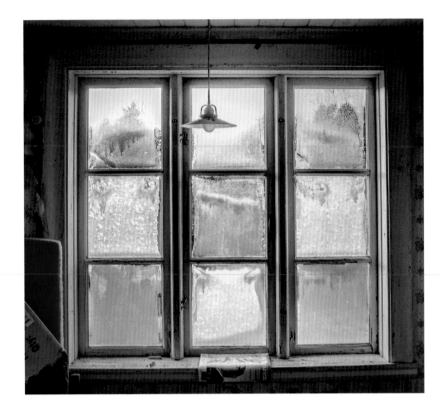

Above and Right: Homes lie derelict, with their floors covered in rubble and their windows broken.

It took the ebullient personality of the hostess-with-the-mostest to make that ill-advised wallpaper work with those over-fancy curtains; her husband's cheerful curmudgeonliness to make sense of that cluttered 'den'. Some special legacy, some secret longing, some connection lost and mourned, must explain that problematic picture on the wall. Those ornaments might reflect a quirky hobby or some far-flung relative; those abandoned roller-skates some tragic bereavement or just a childhood left behind. In their day, the younger generation seemed a force for anarchy themselves – their toys on the floor, their infant scribbles on the walls; above all, their shouting and their laughter. But this riotous assembly bonded everyone together.

Keeping Faith

Are we wrong to feel a sense of wistfulness here – not in ourselves, but in these interiors, so faithful to the affections and the tastes of those who shaped them?

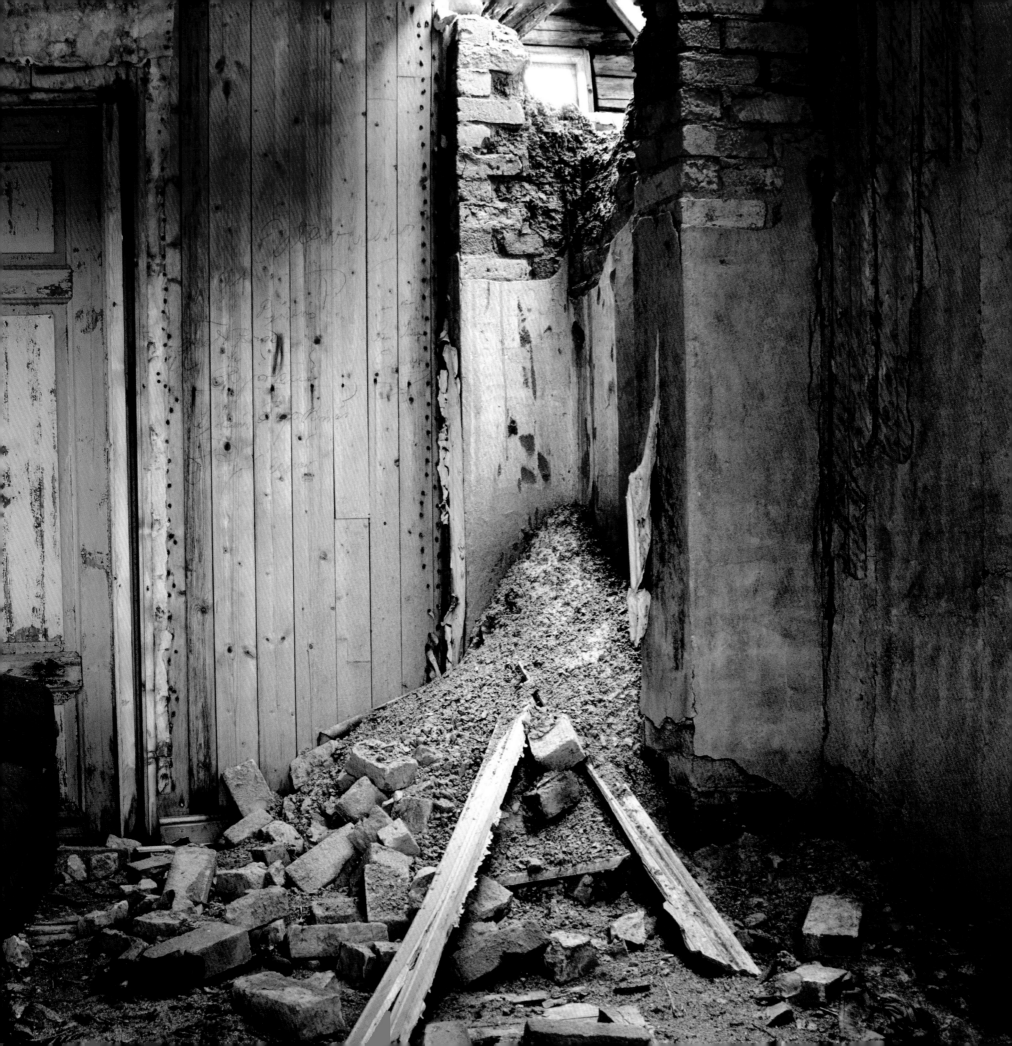

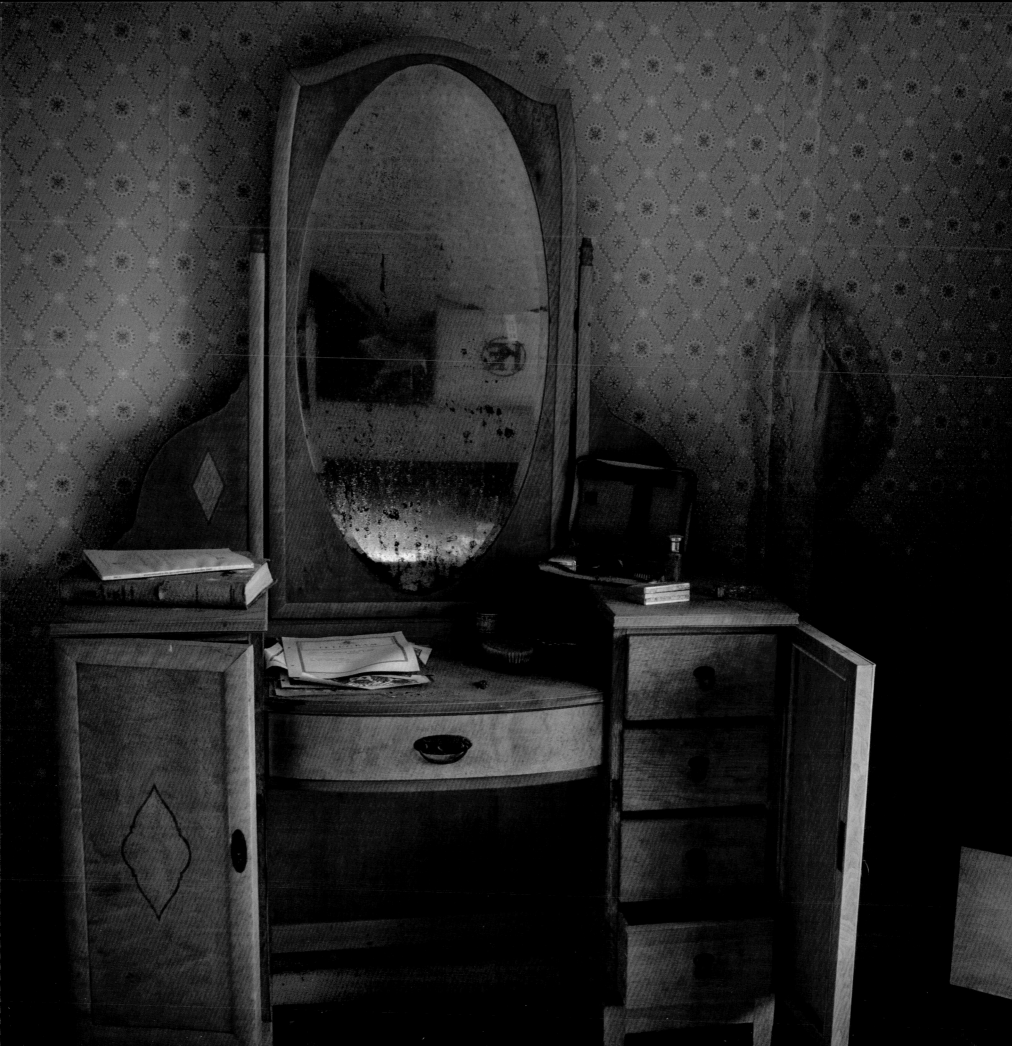

'Home is so sad,' said Philip Larkin. 'It stays as it was left/Shaped to the comfort of the last to go/As if to win them back.' Yet even to perceive this sense of loss is to feel an answering stirring in ourselves, missing in anticipation all those things we've yet to lose.

What's the story behind an evidently once-opulent blue and turquoise room in Luxembourg, much of its glittering features gone; its ornate ceiling now in pieces across its plushly carpeted floor (*see* page 146)? What does it have in common with a shabby-looking room with a chair by the window in Alberta, Canada (*see* page 160)? The bedroom of an abandoned croft near the village of Lacasaidh (*see* page 161), on the Isle of Lewis in Scotland's Outer Hebrides, transports us back instantly to another – and a very different – time.

Above: Abandoned farmhouse in Alberta, Canada.
Left: Abandoned house in Scandinavia.

Above: An old chair sits by the window in an abandoned house, Alberta, Canada.

Portraits and Places

Some people are 'living ruins' themselves, said the Spanish poet Rosalía de Castro. She described a nineteenth-century Galicia whose sense of ancestral pride was founded in its ancient Celtic remains; its modern angst by the tumbledown farmhouses left strewn about its countryside by departing emigrants. But despite such a superabundance of derelict property, Galicia's real ruins were to be seen among its elderly men and women, ravaged by time and experience, by the hardships of poverty

Right: The bedroom of an abandoned croft near the village of Lacasaidh, Isle of Lewis, Scotland.
Next page: A few items are left behind in a deserted house in the woods.

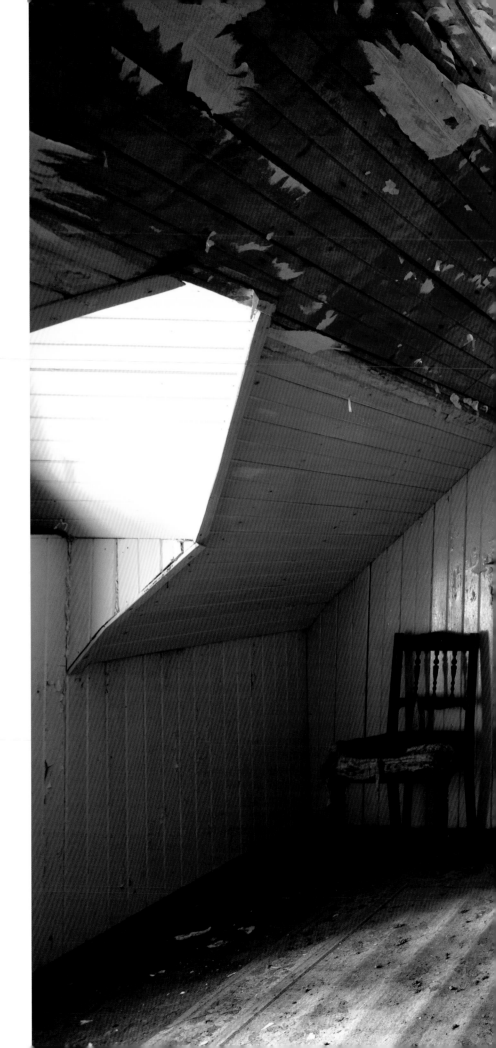

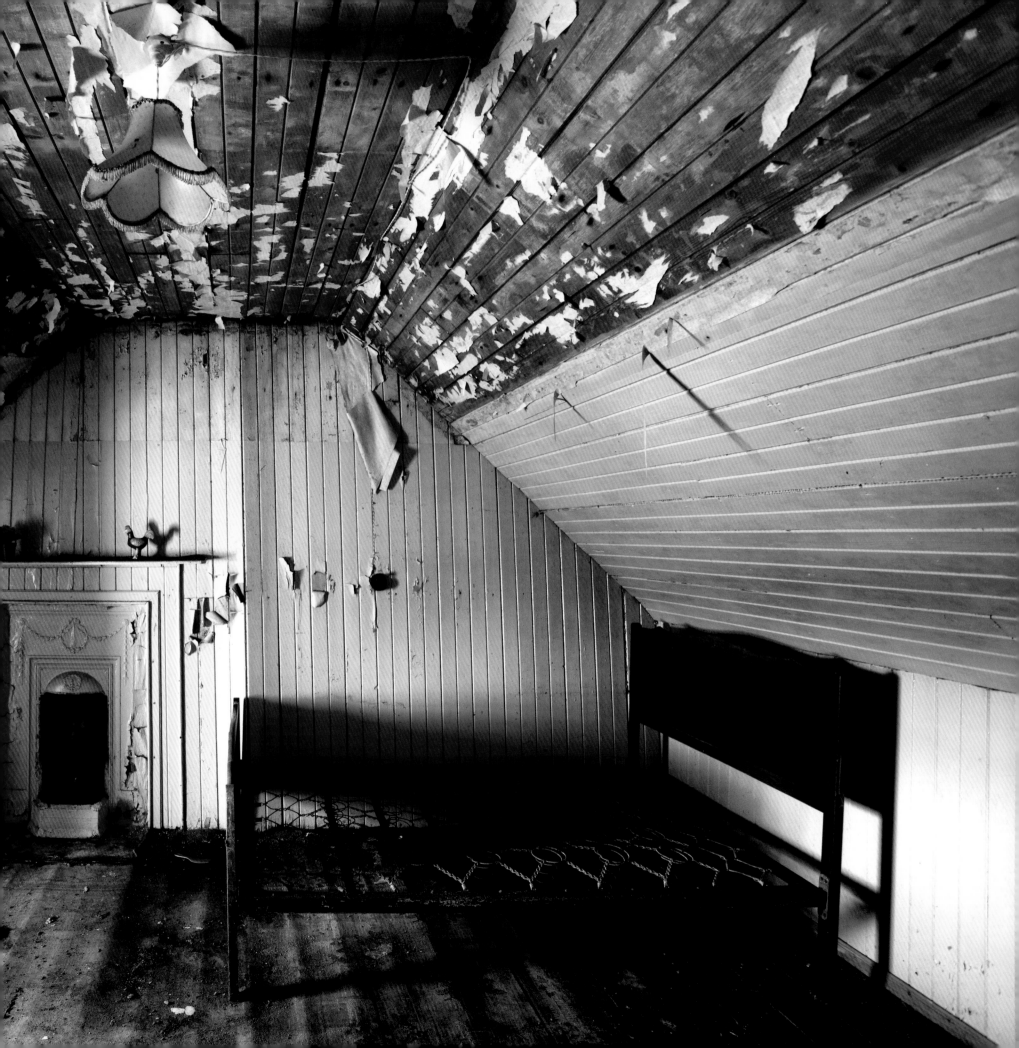

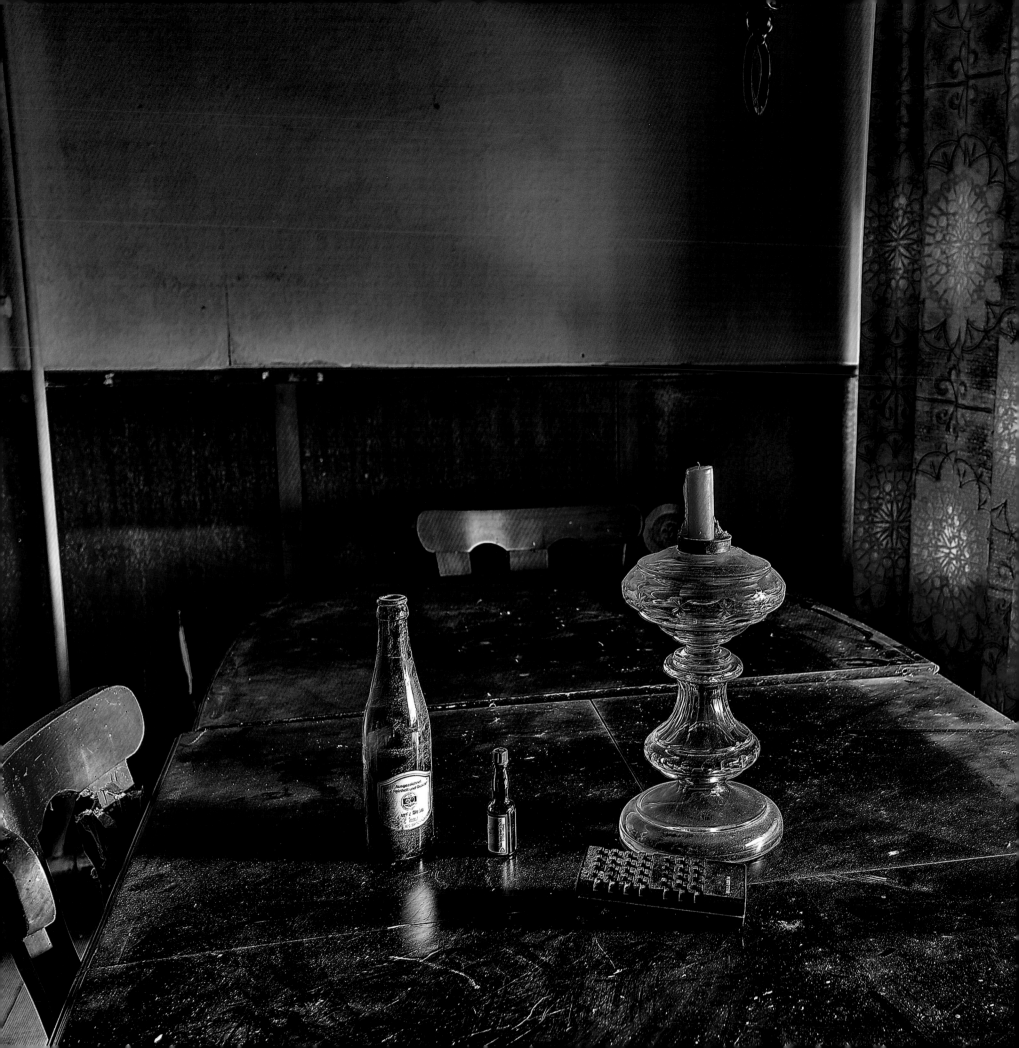

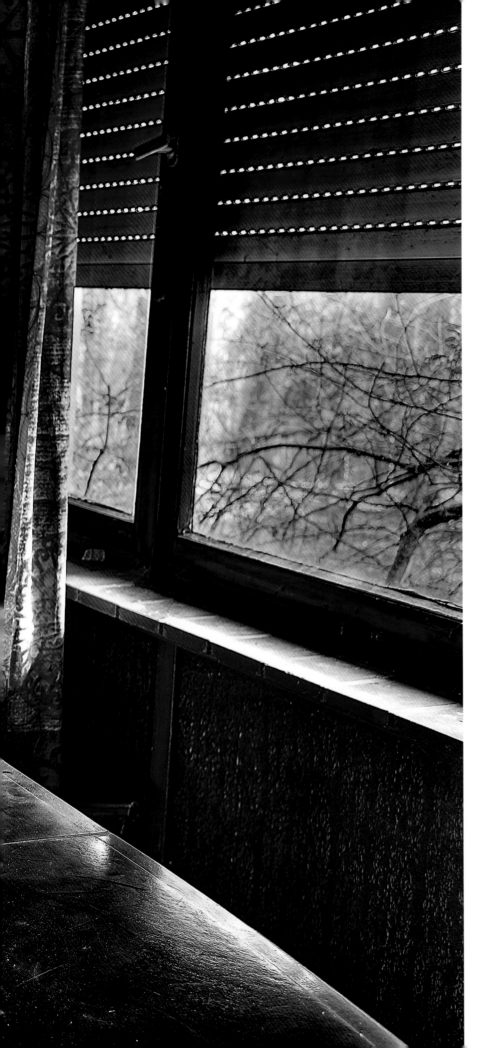

and the trauma of social change. Those experiences, etched on their faces, marked out their sufferings as plainly as the failing fabric of a ruined castle or cottage recorded their country's history. They'd lived into a time in which they seemed to have no place.

If our very presence inside an abandoned house challenges our sense of where the boundary ought to be between the public and the private realms, it goes further – questioning where 'we' leave off and our 'world' takes up. For photographer Britt M. (*see* pages 156, 157, 158 and 187), the two spheres are inseparable. She started out as a student of film and drama studies – the play was the thing; the story key to the human truth. Increasingly drawn to work with the camera, she found her true vocation in the field of portraiture; only as an adjunct to that did she get into the dereliction photography for which she is now known.

Life, Interrupted

However abruptly the life that built it ends, the house breaks down only gradually. Left to itself, it can take years – and even decades. Virginia Woolf described this in her memorable account of the decay of Mrs Ramsay's house after the character's death in the novel *To the Lighthouse* (1927):

'Nothing stirred in the drawing-room or in the dining-room or on the staircase. Only through the rusty hinges and swollen sea-moistened woodwork certain airs, detached from the body of the wind ... crept round corners and ventured indoors. Almost one might imagine them, as they entered the drawing-room questioning and wondering, toying with the flap of hanging wall-paper, asking, would it hang much longer, when would it fall?'

We see it in studies of an abandoned house in the woods: the bottles and candlestick clustered on a dusty but tidy table (*see* left) suggests peaceful domesticity, though the branches outside the window seem threatening.

Another image (*see* page 176) shows the struggle slowly being lost: while the pair of boots inside the door draws attention to a clear division between inside and outside, the latter's steady encroachment is suggested by a mess of wind-blown twigs and leaves. Not, however, as much as the indoor sand-dune inside a derelict house in Kolmanskop, Namibia (*see* page 149). This diamond-mining town was abandoned in the 1950s. Since then, it's been progressively reclaimed by the desert sand.

Yet, as infinitesimally slow as its encroachment is, nature doesn't rest till it's established an equilibrium of sorts between the worlds of the house and of what's outside. When Woolf's Mrs Ramsay dies, we're told:

'The house was left; the house was deserted. It was left like a shell on a sandhill to fill with dry salt grains now that life had left it. The long night seemed to have set in; the trifling airs, nibbling, the clammy breaths, fumbling, seemed to have triumphed …Toads had nosed their way in….A thistle thrust itself between the tiles in the larder. The swallows nested in the drawing-room; the floor was strewn with straw; the plaster fell in shovelfuls; rafters were laid bare; rats carried off this and that to gnaw behind the wainscots.'

A Window on the World

Writing in the context of his country's Civil War, the Irish poet W.B. Yeats saw a similar battle between the shelter of the house and the encroachments of nature as analogous to that between the individual and a besieging history. His Sligo home is falling into ruin even as he occupies it, but he finds hope in the thought that the abandoned starlings' nest above its window has created a cavity in which new arrivals may live. 'The bees build in the crevices/Of loosening masonry,' he writes in 'The Stare's Nest by my Window' (1923–24). As one dwelling disintegrates, another one is built.

Right and next page: *Little remains in these derelict bathrooms.*

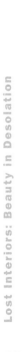

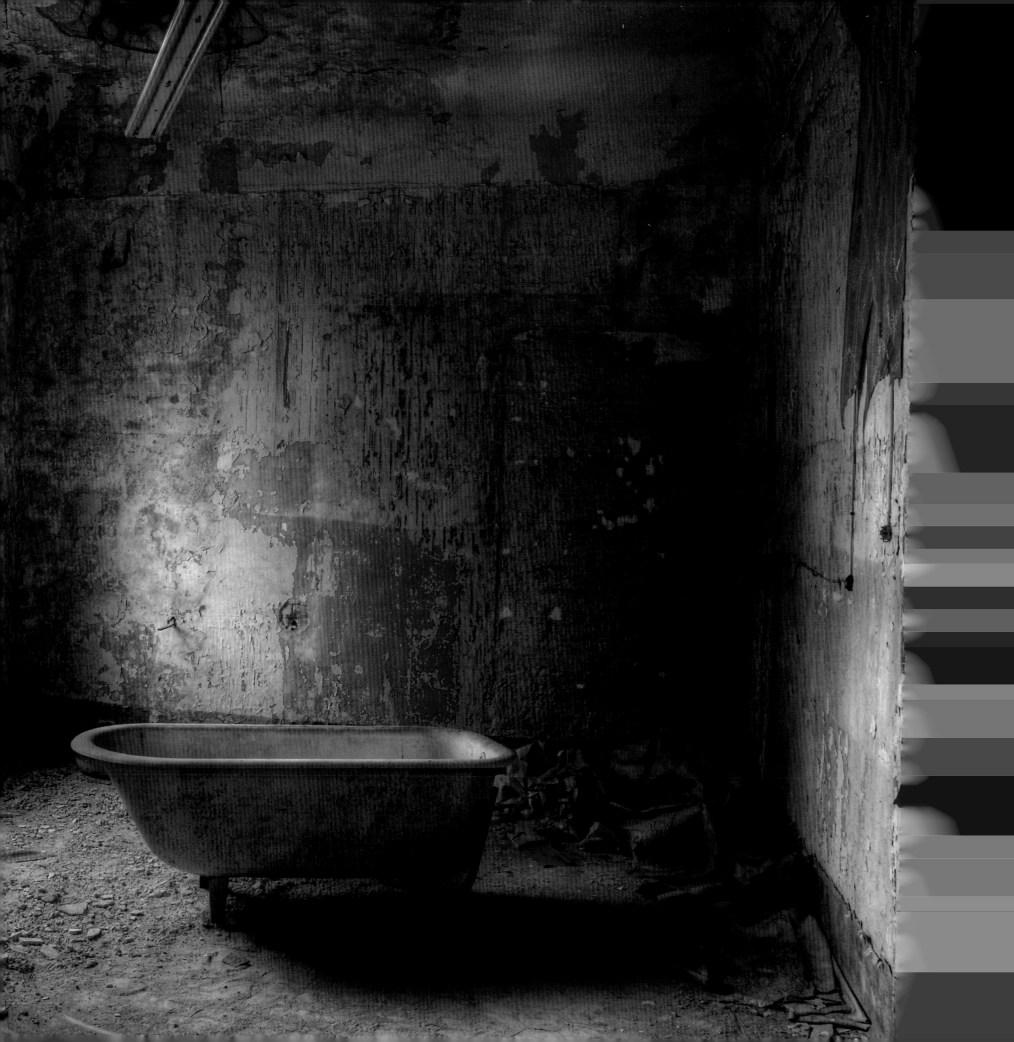

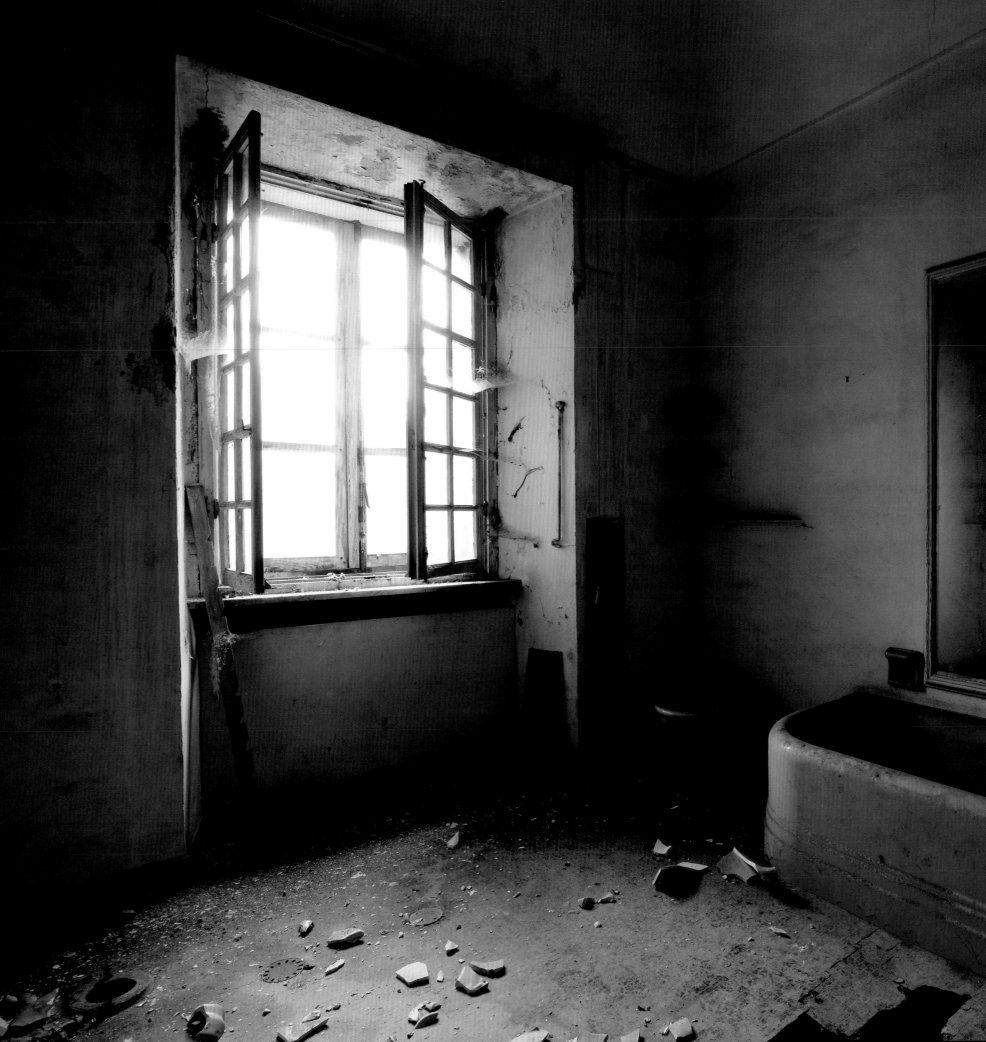

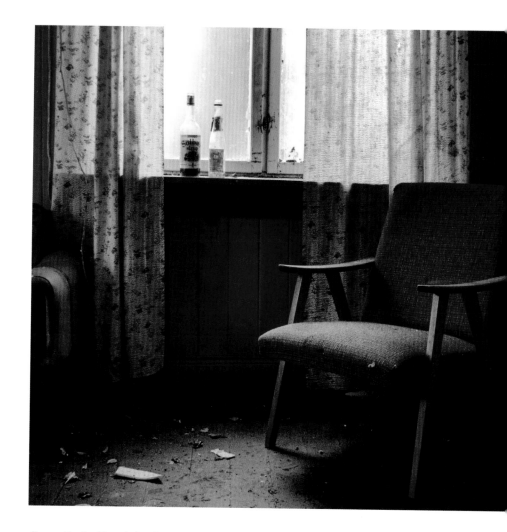

Above: *Abandoned house in Scandinavia.*
Next page: *The roof has caved in on what must once have been an elegant room.*

An unusually upbeat view of what we'd normally see negatively as 'ruin', Yeats's optimism was plainly influenced by his commitment to Ireland's national struggle. But it's also the kind of perspective one could only get from a vantage point at a window, looking outward, to see the house's difficulties within a wider context. As Tennyson saw, the house's 'eyes', its windows, were liminal – like a threshold. They simultaneously separated and linked the worlds of inside and outside. The interpenetration of these two spheres is strikingly symbolized in the section of window frame lying all askew in a room in an abandoned house in Saskatchewan, Canada (*see* page 182). Instead of the old windows, gaping spaces give out on to endless wheat fields: we're poised between a homely 'in here' and a big and menacing 'out there'.

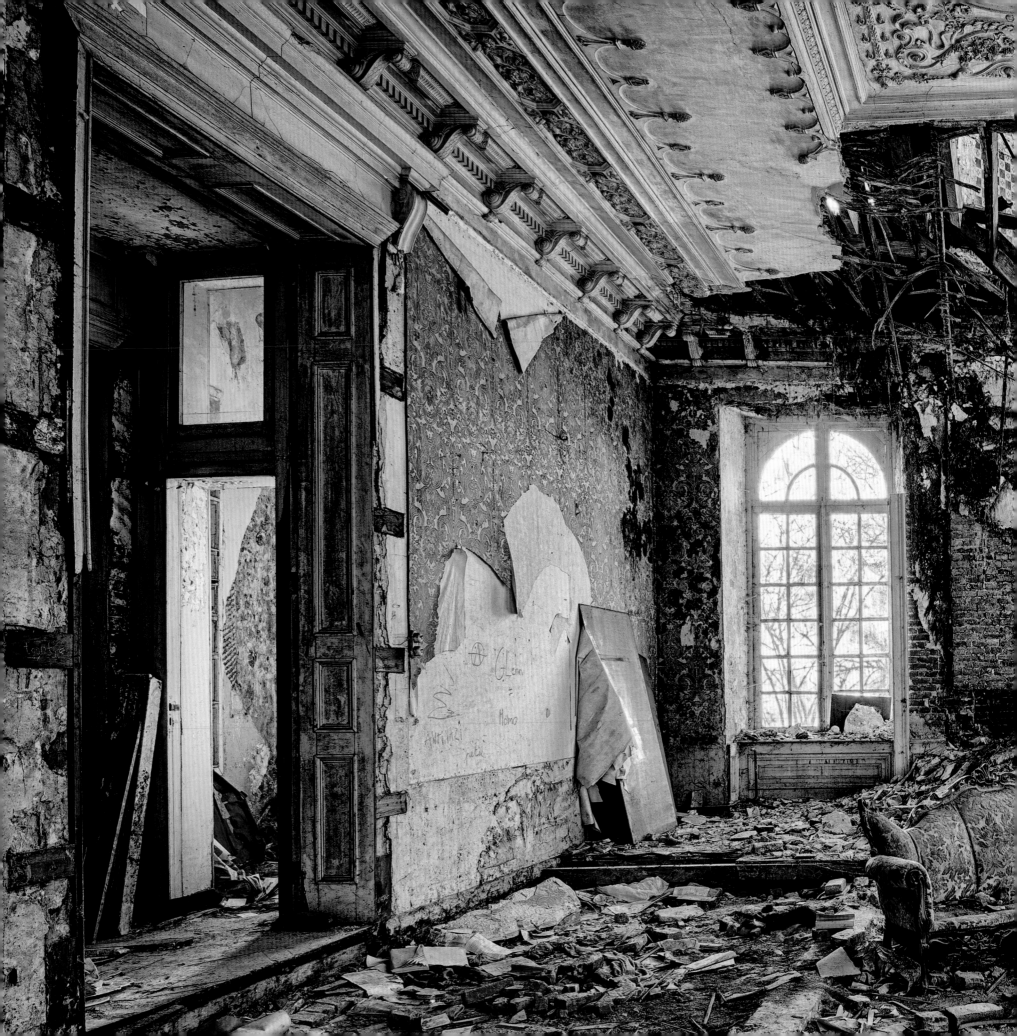

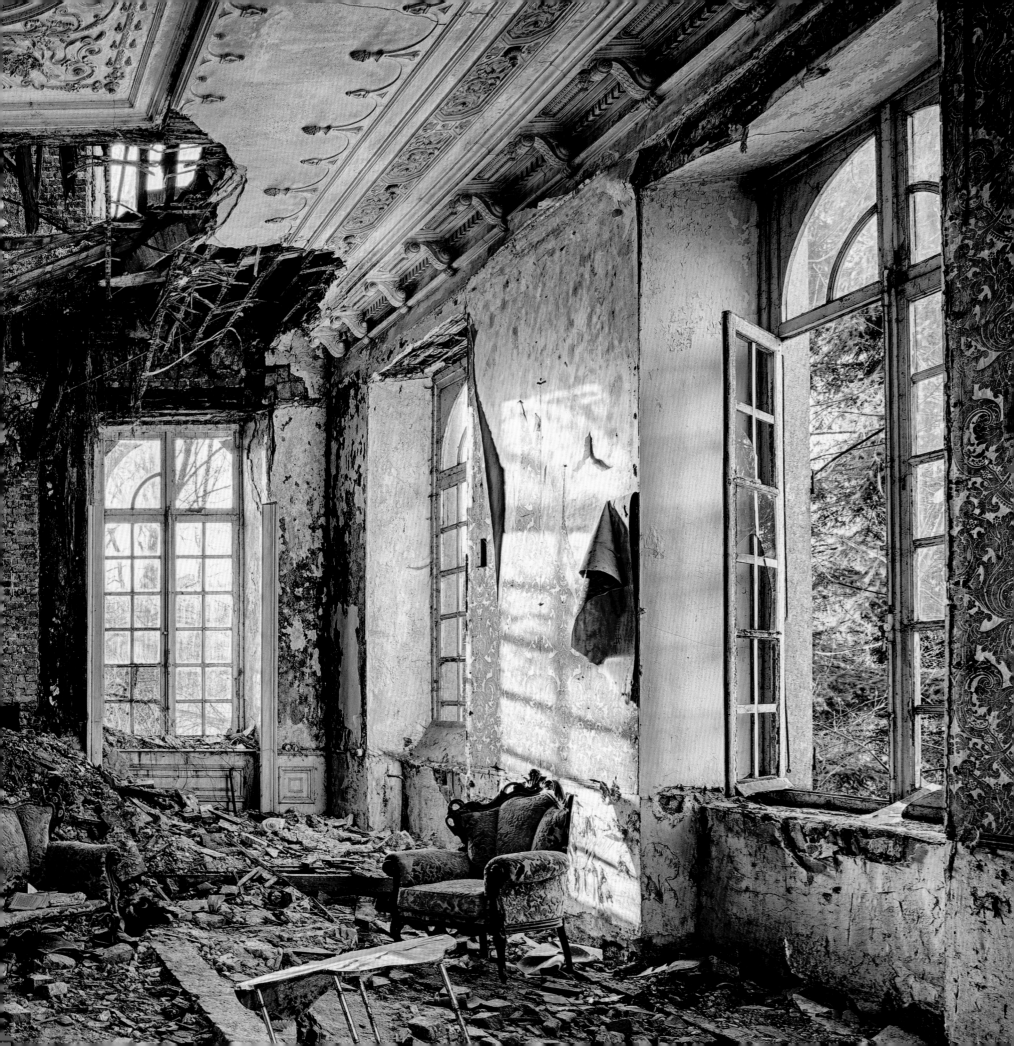

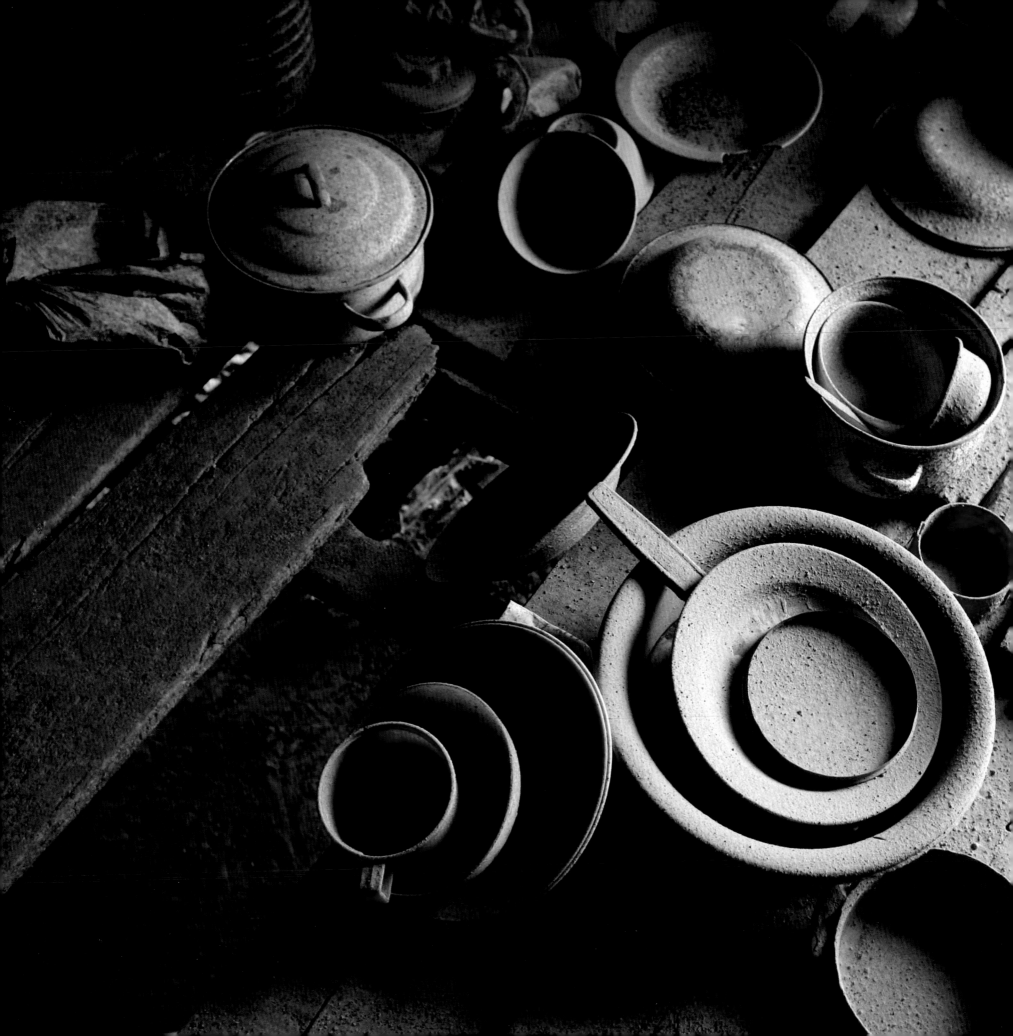

Fleeing from Disaster

Sometimes, a home simply has to be abandoned for safety's sake when a natural disaster of some sort strikes. Other times, humans are a much more direct cause.

Acts of God...

In 1995, whole communities had to be evacuated from villages across the southern side of the Caribbean island of Montserrat, after an eruption of the Soufrières Hills volcano. Those villages which weren't actually carried away by lava flows, have for the most part remained unsafe and empty to this day. It was a similar story in Indonesia where the long-dormant Mount Sinabung has been erupting on and off since 2010. Up to 10,000 people have been evacuated from the surrounding area.

Such powerful disasters have taken place throughout recorded history: these modern-day villagers have at least had the advantage of a warning. Who knows how many lives were lost when the Roman cities of Pompeii and Herculaneum (*see* page 172) were engulfed in ash after the eruption of Mount Vesuvius in AD 79?

... And Man

The idea of the 'natural disaster' is controversial in itself. Current thinking is that famines are generally man-made. Colonial mismanagement is believed to have turned the failure of the monsoon rains in Bengal in 1776 into

Left: A fine coating of ash adorns the kitchenware left out on a table after the Indonesian village of Mardingding was evacuated after the eruption of Mount Sinabung.

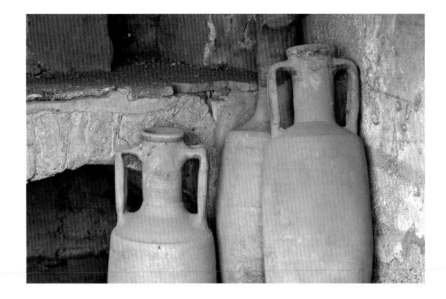

Above: Roman amphorae – large jars for wine and oil – stand in a corner in a house in Herculaneum, interred in ash during the Vesuvius eruption of AD 79.

a famine that claimed 10 million lives, while Ireland exported grain throughout its famine years.

Flooding too is at least exacerbated by human factors – deforestation, overgrazing, ill-considered dams and irrigation schemes. The 'ghost village' of Gairo Vecchi ('Old Gairo') in Sardinia was living on borrowed time from the beginning – though it survived for centuries despite having been built on fundamentally unstable ground. Not until 1951 did this original architectural sin catch up with the community though: flooding in the area caused the first of a succession of landslips which were ultimately to make the whole place uninhabitable.

Then there are the poor planning laws, cowboy builders, corrupt and stupid supervising officials and the corrupt and stupid politicians whom they serve. Many homes, schools and other buildings stand empty to this day in New Orleans, over a decade after the devastating impact of Hurricane Katrina. If the rain came from the heavens, the ensuing chaos was made here on earth.

Right: Apartment abandoned due to radioactive construction materials, Guiyang, China.

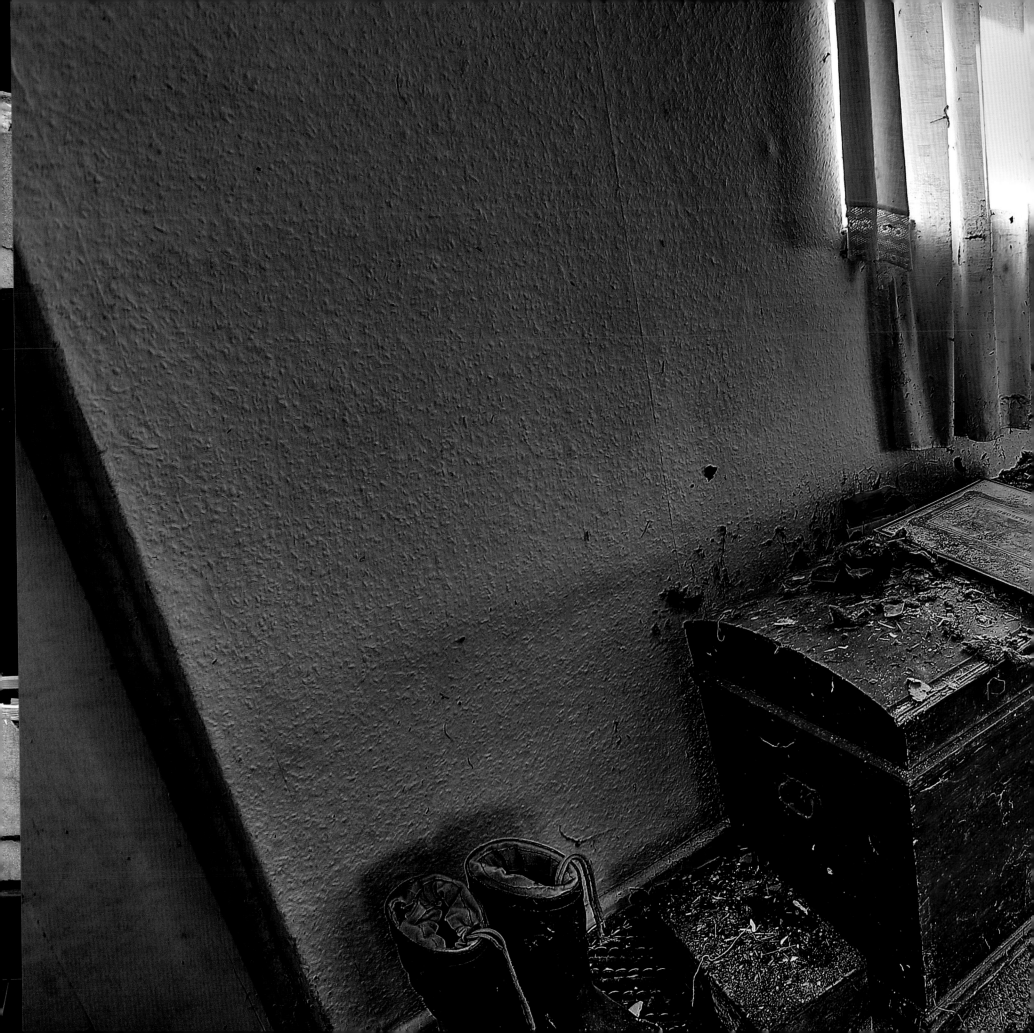

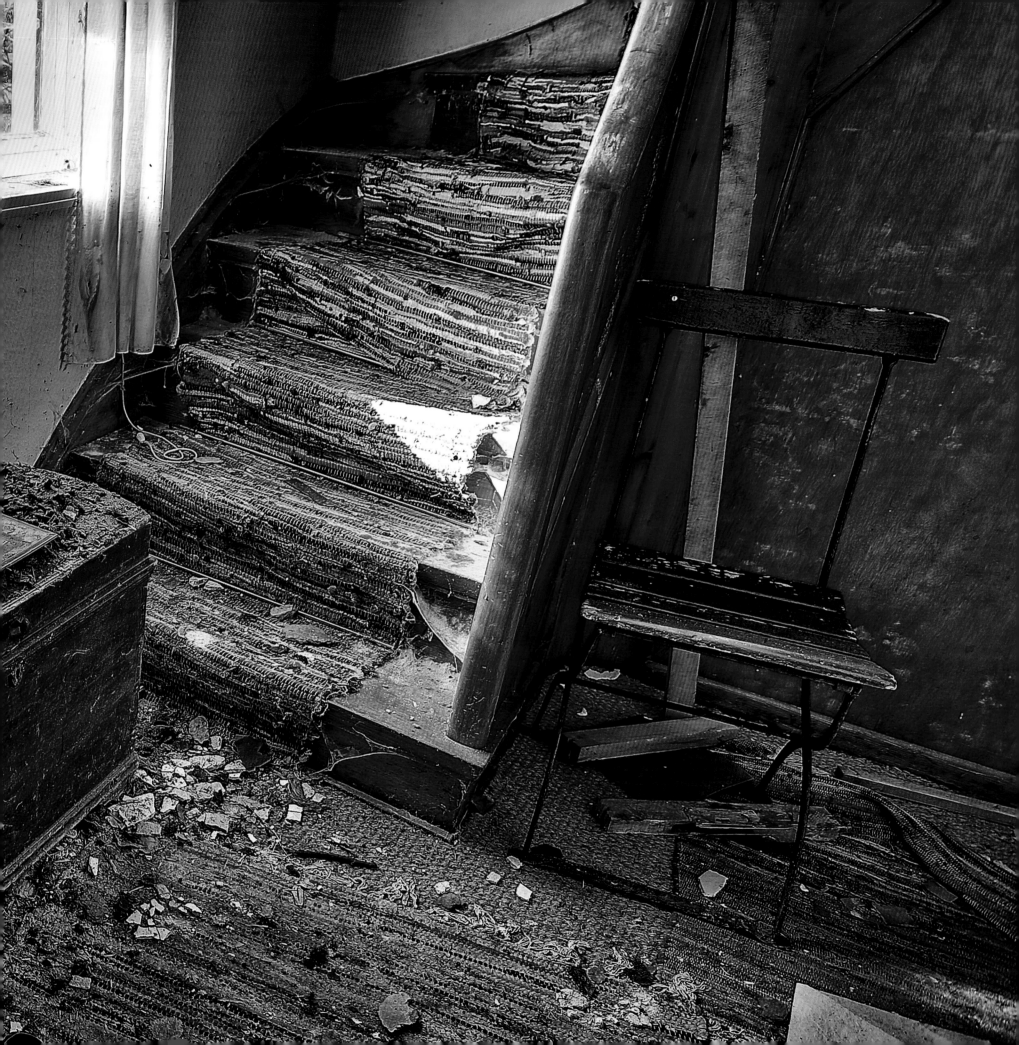

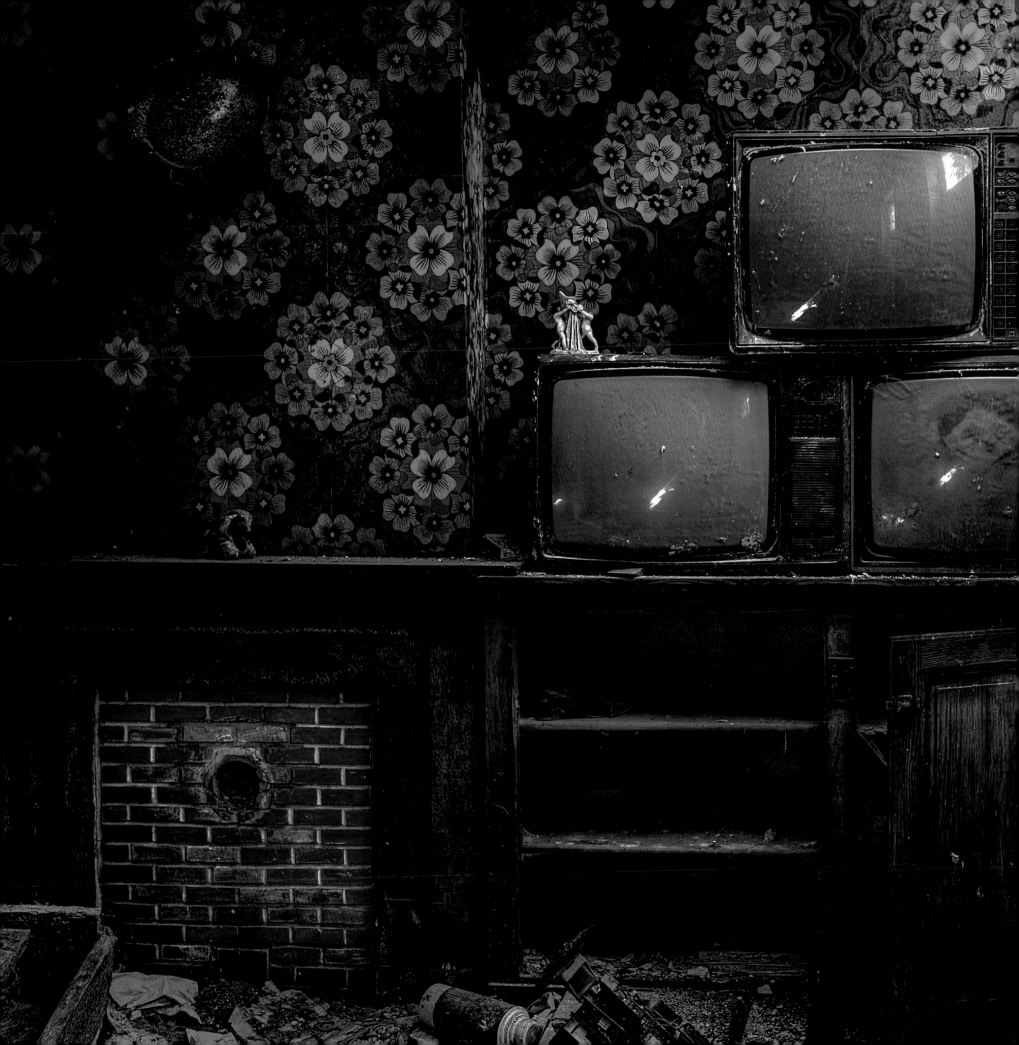

Political & Economic Factors

The conventional idea of the abandoned, rotting, wasting house does tend to encourage a certain pessimism; a view that, left to themselves, things will gradually go to rack and ruin. As Yeats saw though, historical change isn't by any means invariably for the worse. There are states and systems that, once they're gone, won't be much missed. The Soviet Union, for instance – especially in those non-Russian republics, for many of whose people the Communist state seemed little better than an occupier. In Latvia, Skrundra-1 was the name given to a secret city, essentially a Russian colony in the Baltic state.

In East Germany, on the other hand, the onset of freedom was bittersweet. The socialist state had oppressed its people, but at the same time it had provided. Economically and technologically backward, the former-GDR for several years found it hard to thrive in a united Germany.

Market Mirages

Not that life under capitalism has necessarily been an unmixed good in the 'free' West either. The more the market promised, the more it had a way of falling short. It was in the nature of the 'boom-and-bust' cycle that the economy's deepest plunges followed its most vertiginous peaks of apparent prosperity. Hence the hard-working families caught out by the Subprime Mortgage Crisis of 2007–09, encouraged – and enabled – to borrow far

Left: *Chateau Congo in Belgium.*

Above: In the so-called 'Skrundra-1', a glorified Soviet Russian base in Latvia, the stickers in a boy's bedroom show a clear regard for US consumer culture.

beyond their real means. The random items that might be found in a foreclosed house raise haunting questions about the family who lived there, and the dreams they were ultimately forced to abandon when they left. In a view of an abandoned cellar (*see* right), we don't even get a glimpse of such belongings; nothing but a staircase is in view, leading down to a room occupied only by the plants that are creeping in. What became of the family who lived here?

It's the American Way – and, indeed it has been part and parcel of Californian life ever since the first eager prospectors joined the Gold Rush to the state in the nineteenth century. Most were to fail, a few to starve – a minuscule minority to make vast fortunes. Guess which group those who followed them out here in their thousands thought they'd join! What else was the dot-com bubble of the 1990s but a digital gold rush? What was the property bubble but Klondike 2.0?

Right: A cellar staircase in an abandoned house.

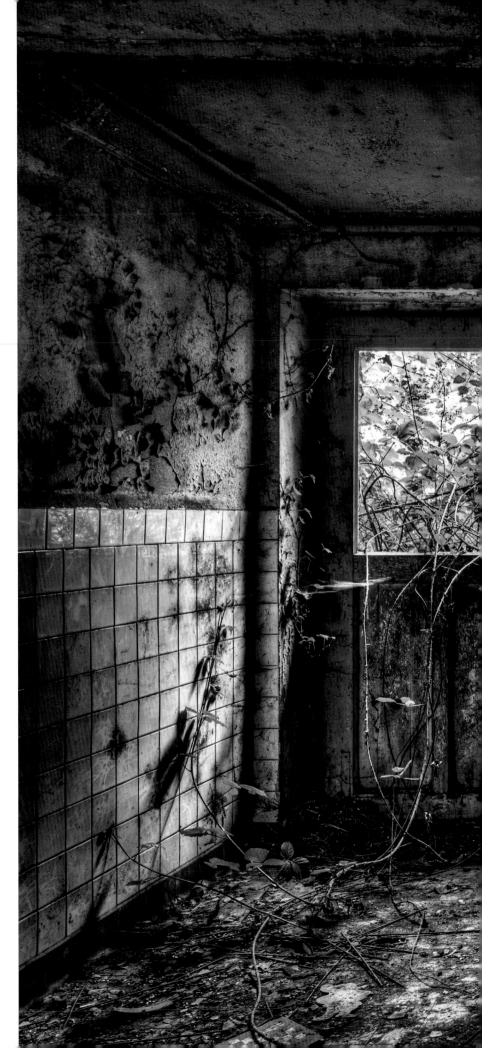

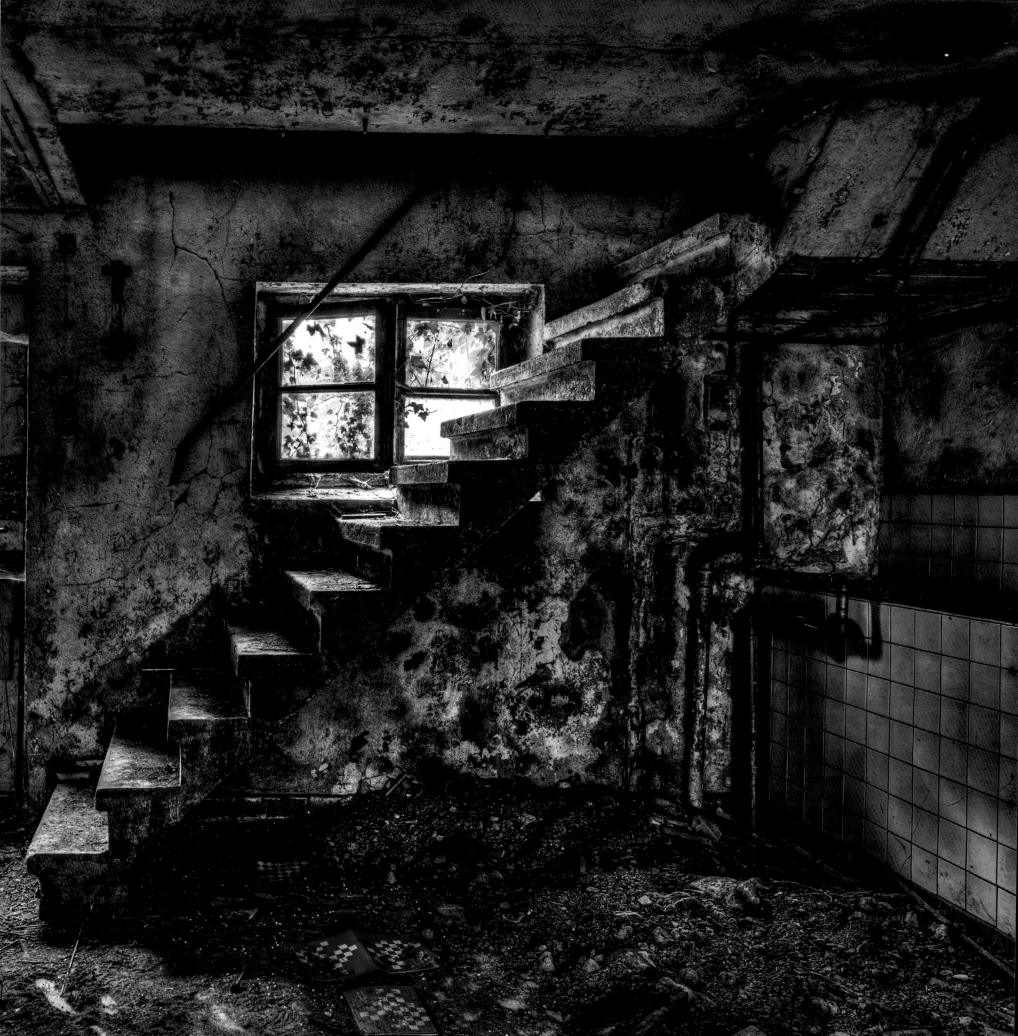

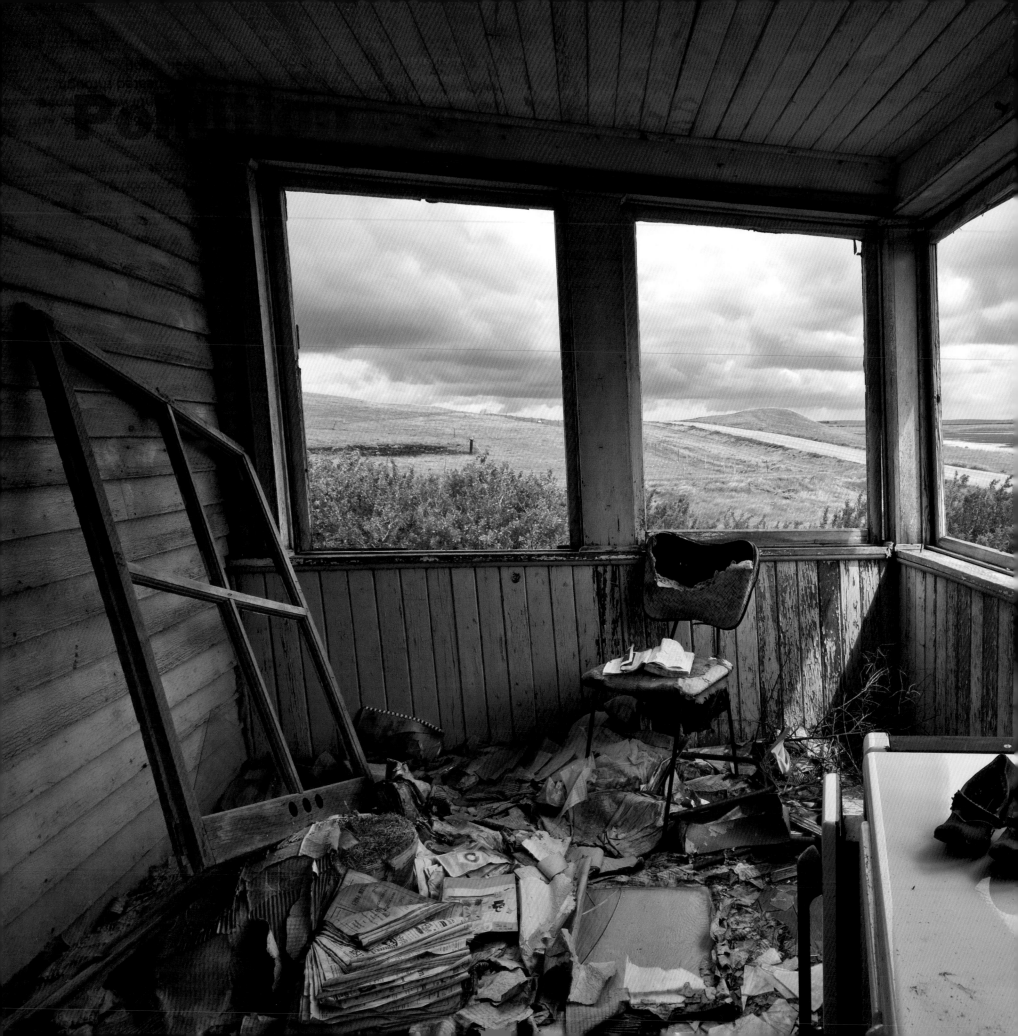

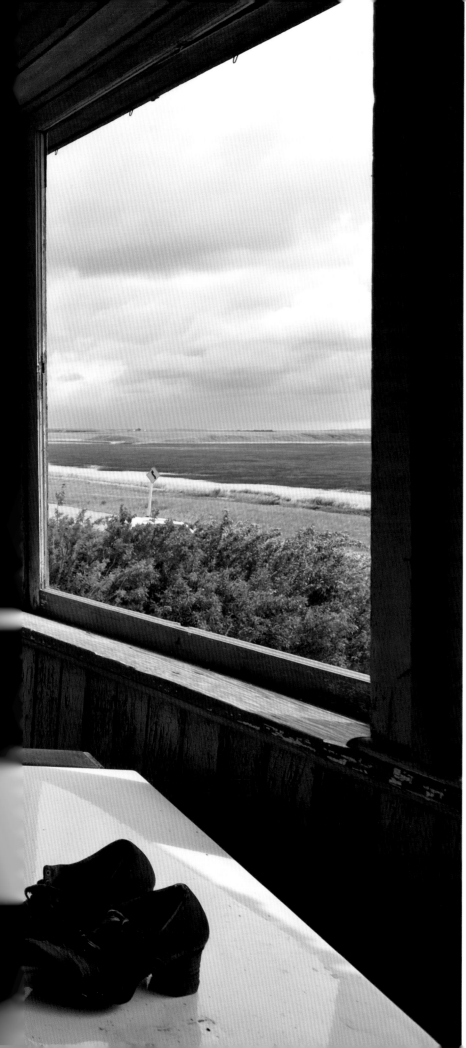

Above: *Empty coat hooks in the cloakroom of the village school in Tyneham, Dorset, stand empty awaiting the new term that never comes.*

Demographic Deserts

In embracing capitalism in its most buccaneering form, Far Eastern countries like China have also taken on some of the associated social and demographic ills. In the south especially, rural village communities, which have endured for centuries in complete stability, have been thrown badly off-balance by the emergence of big new urban centres. For some years now, peasants have been streaming to the cities, glad to leave the guaranteed grind of rural poverty for at least the possibility of a better life. Those left behind – overwhelmingly the elderly and sick – have increasingly struggled to survive, while many villages are now completely deserted.

Left: *Rural house in southern Saskatchewan, Canada.*

It's been a similar story in south-eastern Europe. Countless communities across Romania, Bulgaria and elsewhere in the Balkans have struggled to survive since the drawing of the Iron Curtain. Life in the old days had been harsh yet stable: guaranteed state tyranny, guaranteed poverty and paucity of real opportunity, but also guaranteed sufficiency in food and fuel. Since the 1990s, younger men and women have been heading west to find work in wealthier countries like Britain, France, Germany, Italy, Austria and Switzerland. Countless villages now stand abandoned – or hang on by a thread, with only a handful of residents, all elderly or sick: the kind of 'living ruins' Rosalía de Castro encountered in nineteenth-century Galicia (*see* page 160).

Government Intervention

The Dorset village of Tyneham is as pretty as ever, but it's been empty of people since 1943 when the Ministry of Defence requisitioned the surrounding area as a training ground for troops. The D-Day Landings were on the horizon and Britain's soldiers were going to need to find their way under heavy fire across the Normandy beaches and through all the little Tynehams on the other shore. It *was* supposed to be handed back to its villagers once peace had been restored, but this never actually came about and it remains, a slice of the 1940s, perfectly preserved (*see* page 183).

Romancing the Ruin

But the reality is that, as eloquently as derelict houses speak to us of dispossession, hardship and exile, we can't help seeing them through romanticizing eyes. Chateau Congo is a case in point (*see* page 178). Named for the African theme of some of its wallpaper rather than for Belgium's bloody colonial project (which it predates by a century), this aristocratic pile has been decaying over decades. It's in a pretty poor

Right: *In a beautiful interior in the deserted diamond town of Kolmanskop, Namibia, a wooden staircase sweeps elegantly down to meet not a floor, but a patch of desert sand.*

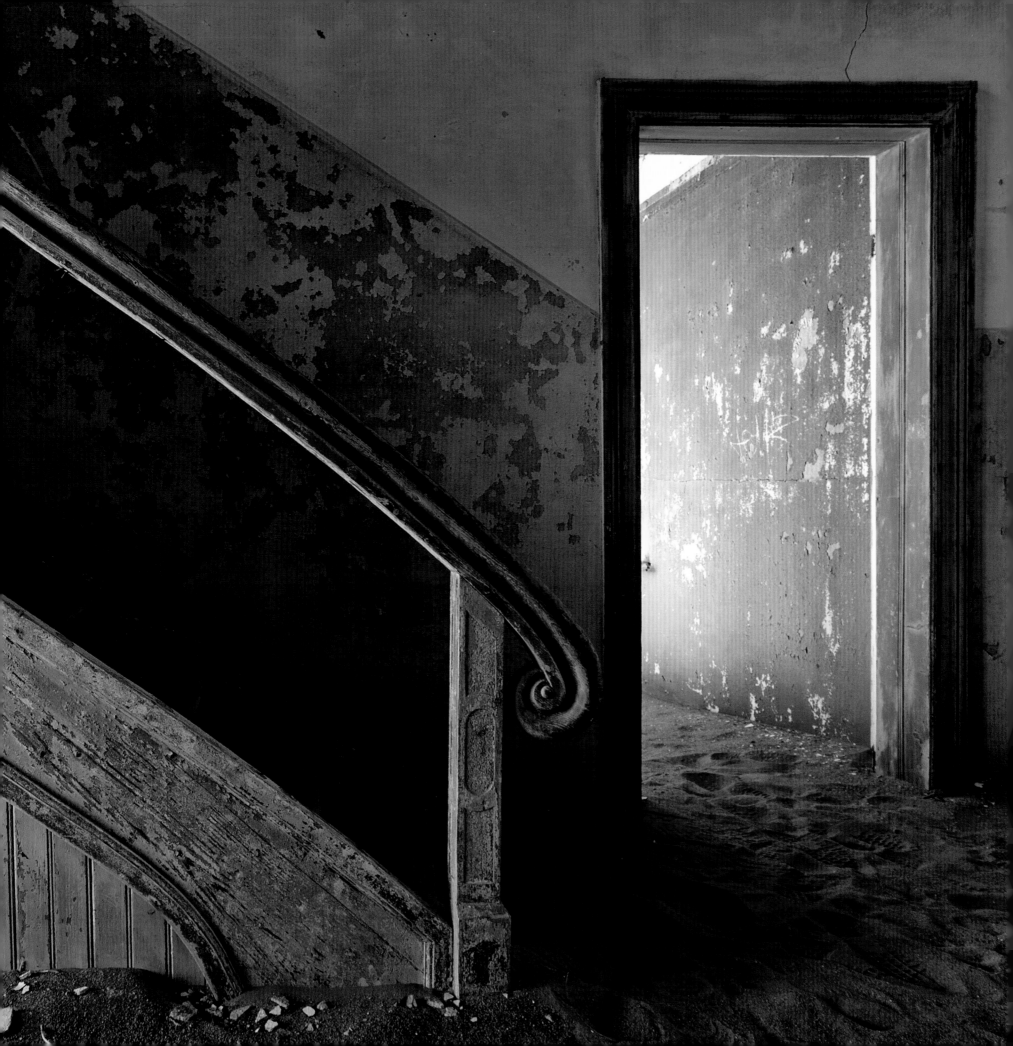

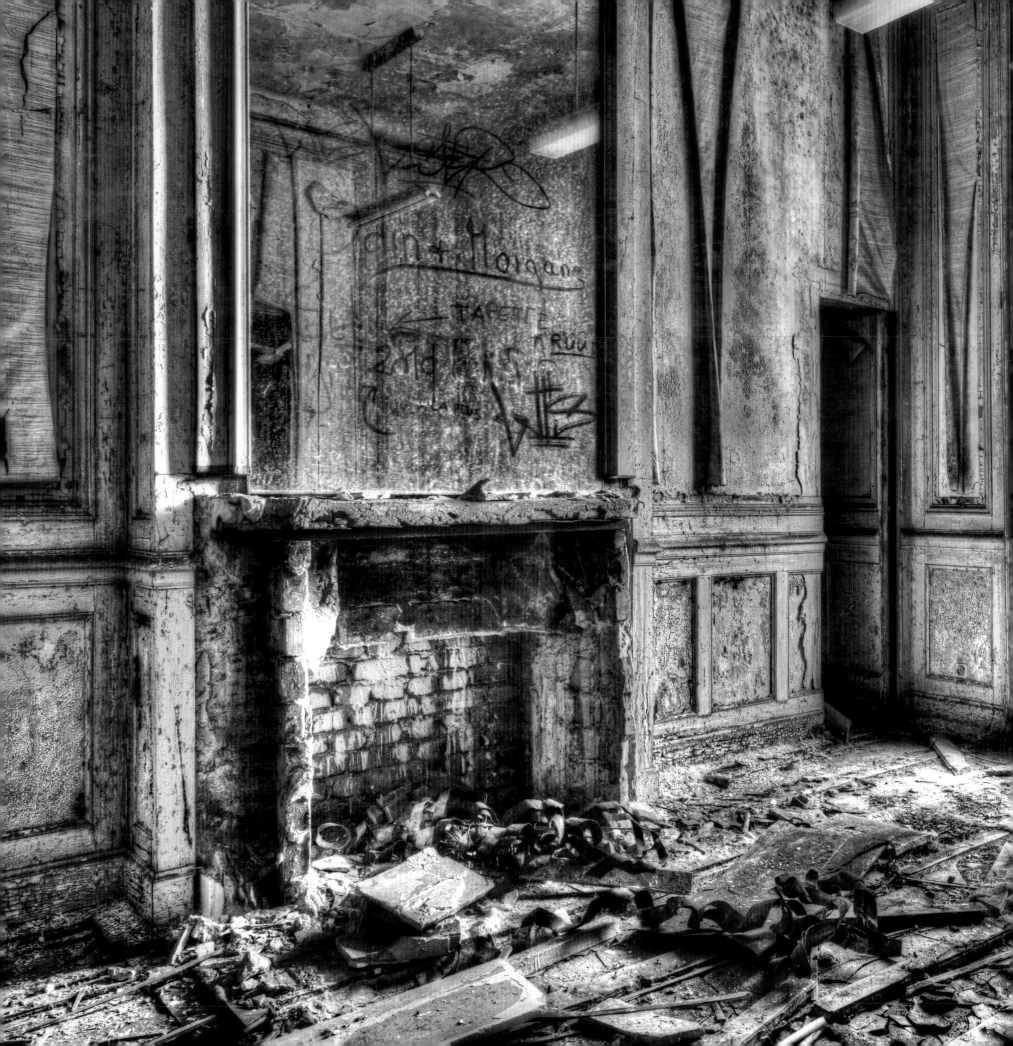

Above: *Iinterior of an abandoned house in Värmland, Sweden.*

state by now – though this only underlines the enthralling counterpoint between elegance and glamour and utter dereliction here.

In the end, we have to question whether any building is really 'ruined', as that word is customarily understood. Just as decaying organic matter doesn't cease to be, but takes on different forms and is chemically restructured, so a derelict building opens itself up to new physical points of access, new imaginative associations, new perspectives. To enter the abandoned house with a broken fireplace (*see* left) is to step into a dream, a fantasy of faded opulence and splendour. It's difficult to feel that this place has really 'lost out' by lying derelict. The Japanese poet Izumi Shikubu realized this as long ago as the eleventh century. 'The wind may blow fearfully through here,' she wrote in one abandoned house, 'but the moonlight seeps through the gaps in the planking too.'

Left: *The broken fireplace of a former home.*
Next page: *The interior of an empty house in South China.*

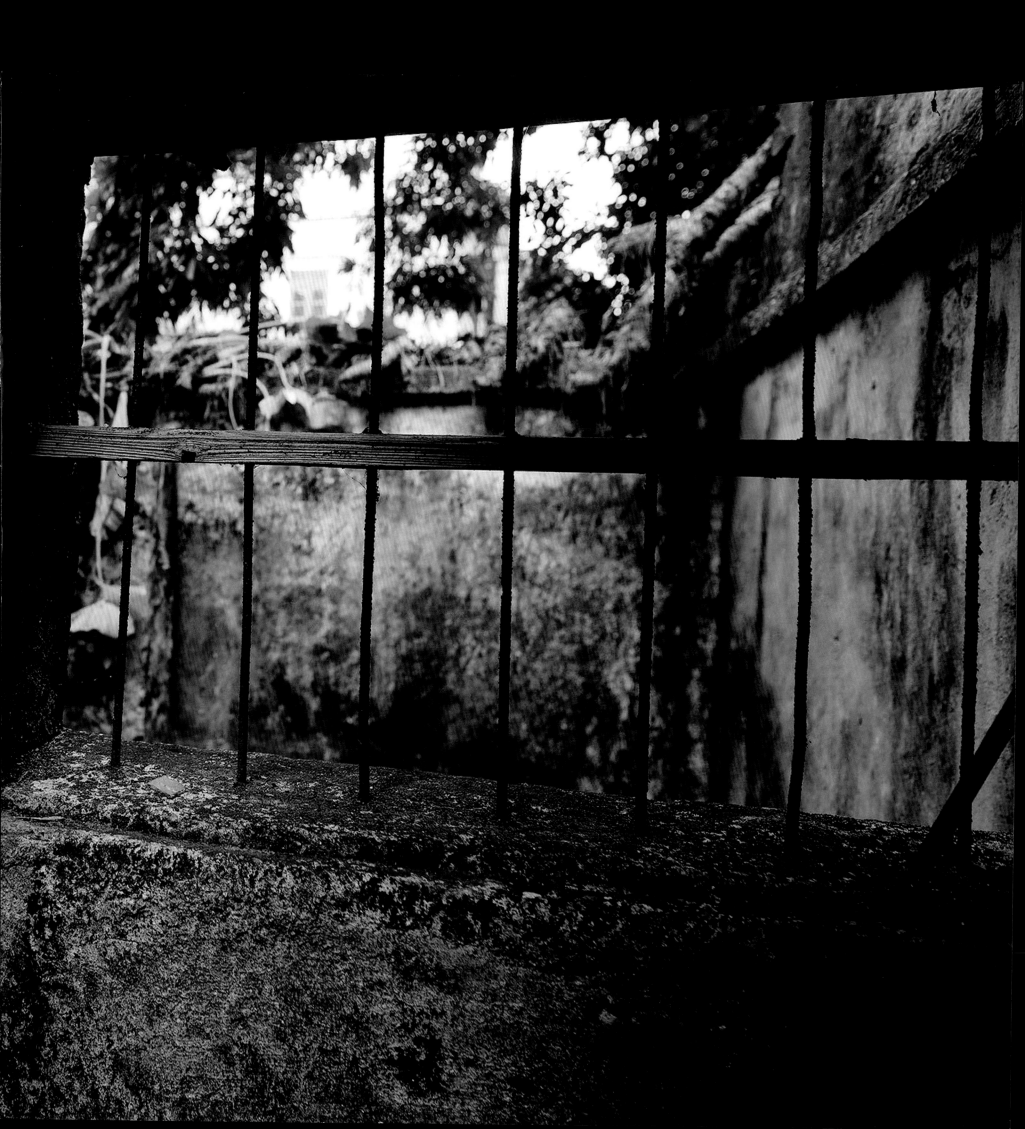

Index

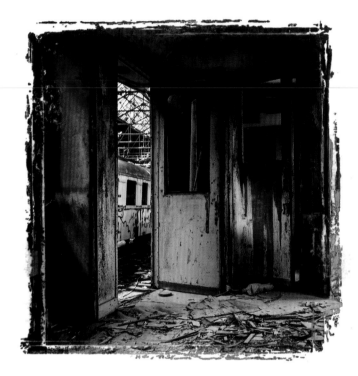

The last passenger, now long departed...

For further illustrated books on a wide range of subjects,

in various formats, please look at our website:

www.flametreepublishing.com